EMBROIDERY MOTIFS FROM DUTCH SAMPLERS

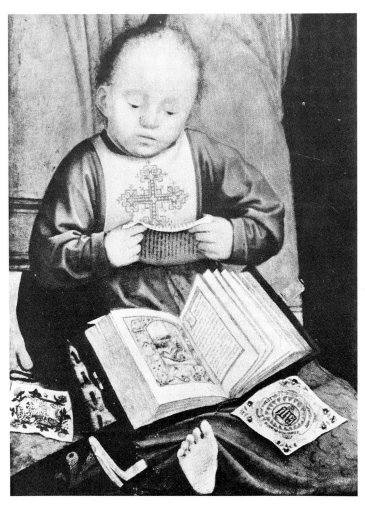

1 Quinten Matsys (1466-1530): St. Anne Altar, detail of the central panel. Brussels Museum

EMBROIDERY MOTIFS

From Dutch Samplers

Compiled by

Albarta Meulenbelt-Nieuwburg

Drawings by

Albarta Meulenbelt-Nieuwburg
Emmy van Vrijberghe de Coningh
Baukje Zijlstra

Translated by

Patricia Wardle
Gillian Downing

B T BATSFORD LIMITED LONDON

Contents

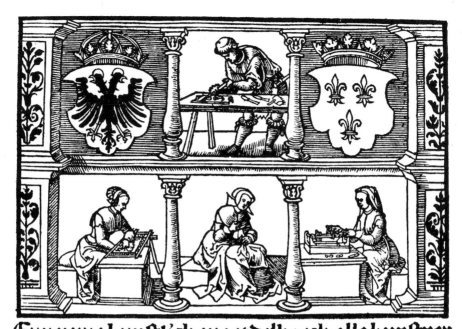

Eyn newe kunstlich moetdelboech alle kunstner zo brauchen fur snytzeller/wapensticker/perlensticker,etc. vnnd ouch fur Jonferen vnd frauwē. kunstlich vff das neuwes gefondē/allen den genē die vpff kunstē verstāt habē. Gedruckt zo Cōllen durch Peter Quentel. Jmiair. M.D.XXIX. im Eucninaent.

Flowers, plants, and fishes, beasts, birds, flies, and bees,
Hills, dales, plains, pastures, skies, seas, rivers, trees,
There's nothing near at hand or farthest sought
But with the needle may be shaped and wrought.

John Taylor, 1634

Dedicated to the memory of
Maria van Hemert.

Foreword

In Holland there has of late been an enormous growth of interest in samplers. This is particularly true of the years after 1968 which have seen one exhibition after another devoted to examples of this essentially popular art form from both museums and private collections. One may put this down to admiration for the unaffected taste and sense of design often displayed by many young girls and women in the past in the way they arranged motifs or combined colours, or it may be the result of an unspoken desire on the part of many women today to practise this indisputably feminine craft once again. It would certainly not be surprising if our own time were to give rise to such longings; one has only, after all, to think how far mechanisation and automation have gone even in house-work.

But quite apart from all this, there was behind these exhibitions another intention, less noticeable but no less important for that, namely to use them as a means of making as good and scholarly an inventory as possible of what samplers there are in Holland. Albarta Meulenbelt-Nieuwburg, the author of this book, was often, in her capacity as Head of the Department of Textiles and Needlework at the National Museum, the Netherlands Open-Air Museum at Arnhem, called in to assist with the preparation, arrangement and scholarly aspects of the exhibitions. Thanks to her great knowledge of the subject she was invariably able to make a valuable contribution to them, while she herself also profited from the opportunity of collecting and studying motifs and documentation.

Nor must we omit to mention that in all this it was her wish to continue the work of Maria van Hemert, to whose memory she has dedicated this book and from whom she had learned so much. In 1943 Maria van Hemert was commissioned by the Open-Air Museum to make a study of the needlework of the islanders of Marken as part of a general survey of the island. In the years between 1940 and 1948 she also made drawings of numerous motifs in cross-stitch, darning, whitework and cutwork. These she bequeathed to the Open-Air Museum shortly before her death on 3 April 1949 and it is indeed a happy thought that Mrs. Meulenbelt-Nieuwburg has been able to work through this

storehouse of information and present a collection of motifs in this book which, thanks to its unique character, will undoubtedly contribute a great deal to the better understanding of a delightful form of needlework.

Let us hope, therefore, that many people will consult this book not only out of interest in the motifs and their symbolic significance, but even more in order to compose a sampler themselves and thus to discover how much pleasure this brings.

J. C. Sloekers
Director, Netherlands
Textile Museum,
Tilburg.

Introduction

The purpose of this book is twofold: to look back at the motifs on old samplers and their symbolism and to look forward from our present standpoint with a definite aim in mind, namely to stimulate the embroidering of old motifs.

In looking back we shall see what beautiful needlework was done by women and girls in past centuries. A great deal of it has been preserved to bear witness to the dedication and patience they devoted to the ornamentation of church, home and clothing and thus to the enrichment of their lives. Indeed, there is so much of it and so much work has been put into it that we tend to think that those who made it must have had a lot of time on their hands which they had to find some way of filling and that needlework was, therefore, a welcome pastime for them. But it seems to me that nothing could be further from the truth. In reality women were every bit as busy in the past, for housekeeping was much more time-consuming, not only because equipment was more primitive, but also because numerous things that we no longer have to think about were done at home. And young girls, who stayed at home until they found husbands, naturally had their share in all this too. On the other hand life was not so restless then; people did not seek amusement away from home so much and they found a quiet satisfaction in sitting peacefully over their needlework. Most of us today no longer have enough inner tranquility to do this. We live at a hectic pace, chasing after all manner of things, and if there are no plans or excitement in the offing we do not know what to do with ourselves. But I doubt if it makes us any happier. In fact the modern housewife has to contend on the one hand with the lack of help and on the other with a whole lot of outside activities which did not exist in the past, such as sport, concerts, the theatre, the cinema and other amusements and diversions. And in addition to all these temptations to go out, there are also the claims of television and the copious homework our children are given to do. Things are certainly not made easy for us. It would therefore seem highly desirable for us to take up needlework once again – and indeed there is no denying that since 1960 there has been an increasing tendency in this direction – not merely because of the satisfaction to be found in the work itself or in order to lend our homes a personal touch, but also because this quiet

9

occupation gives us inner peace and makes for steadiness and can thus have an incalculable influence on both us and our families. Anyone who really tries will somehow manage to make time in which to create something.

Before we look at the beautiful motifs and letters our forbears used on their samplers, I would like to make a few general remarks about symbolism.

What does the word *symbol* mean? It is derived from the Greek *symballein* = to compare, and *symbolon* = sign or token. Thus it signifies a motif that, without going into details, indicates a general idea. For example, wavy lines and meanders are used to indicate flowing water or waves, meander being a derivation of the name of the winding river now known as the Menderes in Asia Minor.

Closely connected with symbolism is *mythology*, albeit in Antiquity the common folk, who offered sacrifices and rites to the gods and goddesses, accepted the myths as historical facts and only the initiated understood their deeper, symbolic meaning. Mythology naturally encompasses not only the myths of Classical Antiquity but also those of other ancient peoples such as the Egyptians, the Assyrians, the Babylonians and the Persians, as well as the Hindu Vedas, the Old Norse *Edda*, Germanic and Medieval legends and folklore.

A similar close connection also exists between symbolism and *heraldry*. Those who have studied the latter find that a considerable amount of history can be deduced from the coats of arms of families and localities.

For symbolism iconography and iconology are indispensable. *Iconography* comes from the Greek word *eikon* = an image or likeness, and means in particular the imagery or set of conventions used in representing mythological persons or the saints of Christendom. *Iconology* is concerned with the significance of the various attributes and emblems traditionally associated with such representations.

It is by no means the intention here to give detailed explanations of the symbolism of all the various motifs; this has already been discussed by numerous art-historians who have often arrived at quite different conclusions. In this book there is room only for a very limited survey both of what we know about symbolism and of the many motifs to be found on samplers. In Chapters II, III, VI, VIII, X, XI and XVII in particular it has not even been possible to give all the motifs a separate number since, especially when it comes to the smaller ones, there is no indication of provenance on those drawn by Maria van Hemert. It must also be borne in mind that some of the motifs are actually rather primitive depictions of the things they are meant to represent, because the embroideresses were often very young and not very skilled with their needles.

I hope, however, that this collection of motifs and letters will prove sufficiently interesting to spur readers on to do some research on their own account if they are near a museum. It is always so much more stimulating and worthwhile to

discover something for oneself. I also very much hope that the book will provide a fruitful source of inspiration for embroideresses. How the motifs are used depends, of course, on each person's own initiative and imagination – it is that, after all, that gives one's needlework the personal touch.

I would like to take this opportunity of expressing my grateful thanks to Professor J. M. M. Timmers of Maastricht for his assistance with the explanation of the iconographical significance of various motifs, to Emmy van Vrijberghe de Coningh of Amsterdam and Baukje Zijlstra of Arnhem for their help in the lengthy task of making the drawings, and to Robert Hofman who, on behalf of the publishers, has given invaluable aid in the preparation of this book.

A. M-N.

I Flowers

In the *Clavis Melitonis*, a work of the ninth or tenth century formerly erroneously attributed to Melito, Bishop of Sardis, there is a chapter devoted to the symbolism of flowers and plants. 'Roses', so it says, 'signify the blood of the martyrs, and it is in this sense that we must interpret the passage in Ecclesiasticus, "…Bud forth as a rose growing by the brook of the field".' The *rose* (Nos. 2-5, etc.) is also the symbol of love, beauty, joy and silence, while five roses on a single bush (Nos. 2 and 5) represent the five wounds of Christ.

The *lily* (*lilium*, No. 30) sometimes stands for the Redeemer, sometimes for the saints, or the splendour of the Kingdom of Heaven, or purity, innocence and virginity. The *fleur-de-lis*, or lily of France, used in heraldry is not a lily, but an iris. In Sumerian, Babylonian, Assyrian and Egyptian mythology the lily was the symbol of fertility.

The *violet* (No. 19) symbolizes modesty, humility and melancholy.

These three flowers, the rose, the lily and the violet, are associated above all with the Virgin Mary. St. Bernard, who founded the abbey of Clairvaux in 1115 and became its first abbot, addressed the Virgin as 'the violet of humility, the lily of purity, the rose of love'.

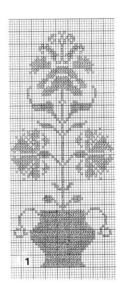

The flower symbolism current in the late Middle Ages is given in a Dutch carol of the period, of which the best known English version is probably that given in *The Oxford Book of Carols* (first published in 1928):

Lord Jesus hath a garden, full of flowers gay,
Where you and I can gather nosegays all the day:
There angels sing in jubilant ring,
With dulcimers and lutes
And harps, and cymbals, trumpets, pipes,
And gentle, soothing flutes.

There bloometh white the lily, flower of Purity;
The fragrant violet hides there, sweet Humility;

The rose's name is Patience, pruned to greater might;
The marigold's Obedience, plentiful and bright:
And Hope and Faith are there; but of these three the best,
Is Love, whose crown-imperial spreads o'er all the rest:
And one thing fairest is in all that lovely maze,
The gardener, Jesus Christ, whom all the flowers praise:
O Jesus, all my good and all my bliss! Ah me!
Thy garden make my heart, which ready is for thee!

The *carnation* (Nos. 11, 12, 14, 16, 18, 21), which originally came from the Near East, has been cultivated for two thousand years. Its name is derived from the Latin *carnis* = flesh, since in its original form it was flesh-coloured. According to Christian legend, it made its first appearance on the earth when the Virgin's tears fell to the ground on the way to Calvary. Hence the pink carnation is the symbol of maternal love.

The *tulip (tulipa)* (Nos. 6, 9, 36, 38) comes from Persia where it grows wild. An oriental legend tells how a Persian youth, Ferhad, fell in love with a young girl, Shirin, but she rejected him and so he betook himself to the desert, there to die of a broken heart. As he wept, his tears fell on to the dry sand and turned into flowers. These were called *lalé* in Persia and became the symbol of perfect love. Tulips were being cultivated in Turkey in 1500, but it was not until 1562 that the first bulbs were shipped from Constantinople to Antwerp, whence they were imported into Holland.

LIST OF MOTIFS ILLUSTRATED

1 Flowerpot with an iris and two carnations – Sampler, 1797, NOM, Arnhem.

2 Flowerpot with five roses – Sampler, 1778, NOM, Arnhem.

3 Flowerpot with five roses, six buds and two doves – Sampler, 1750, Frisian Museum, Leeuwarden.

4 Basket with five roses – Sampler, eighteenth century, private collection.

5 Basket with five roses and two little birds – Sampler, 1785, Zaanland Museum of Antiquities, Zaandijk.

6 Tulip – Undated sampler, private collection.

7 Rose – Sampler, 1692, Zaanland Museum of Antiquities, Zaandijk.

8 Flowerpot with roses – Undated sampler, private collection.

9 Tulip – Undated sampler, private collection.

10 Heart with eleven roses and four doves – Sampler, 1802, private collection.

11 Flowerpot with a carnation and four roses – Sampler, 1878, NOM, Arnhem.

12 Flowerpot with a carnation, two roses and two buds – Sampler, 1778, NOM, Arnhem.

13 Rose and rosebuds – Sampler, 1828, private collection.

14 Flowerpot with six carnations and two birds – Sampler, 1785, Frisian Museum, Leeuwarden.

15 Stylized flower – Sampler, 1828, private collection.

16 Flowerpot with seven carnations – Sampler, 1778, NOM, Arnhem.

17 Flowerpot with a carnation and two roses – Sampler, 1750, NOM, Arnhem.

18 Three carnations – Sampler, 1692, Zaanland Museum of Antiquities, Zaandijk.

19 Flowerpot with three flowers (violets?), three birds and two dogs – Undated sampler, Frisian Museum, Leeuwarden.

20 Basket with three roses – Sampler, 1753, private collection.

21 Basket with five carnations and eight little birds – Sampler, 1731, private collection.

22 Rose – Sampler, 1780, private collection.

23 Flowerpot with rose-tree – Sampler, 1748, private collection.

24 Flowerpot with large rose, two tulips and two smaller roses – Sampler, 1831, NOM, Arnhem.

25 Flowerpot with three tulips – Sampler, 1797, NOM, Arnhem.

26 Sprig of forget-me-nots – Sampler, 1827, M.v.H.B., NOM, Arnhem.

27 Flowerpot with tulip and four small flowers – Sampler, 1824, NOM, Arnhem.

28 Flowerpot with four flowers – Sampler, 1725, NOM, Arnhem.

29 Three roses and two birds – Undated sampler, private collection.

30 Flowerpot with three lilies and two buds – Sampler, 1816, NOM, Arnhem.

31 Carnation – Undated sampler, private collection.

32 Rose – Undated sampler, private collection.

33 Basket of flowers – Sampler, 1855, NOM, Arnhem.

34 Flowerpot with five tulips – Undated sampler, private collection.

35 Carnation border – Undated sampler, private collection.

36 Flowerpot with a tulip – Sampler, 1725, NOM, Arnhem.

37 Flowerpot with a carnation – Sampler, 1750, NOM, Arnhem.

38 Flowerpot with five tulips and buds – Sampler, 1614, private collection.

39 Flowerpot with a rose and four buds – Sampler, 1764, NOM, Arnhem.

40 Flowerpot with a rose – Sampler, 1797, NOM, Arnhem.

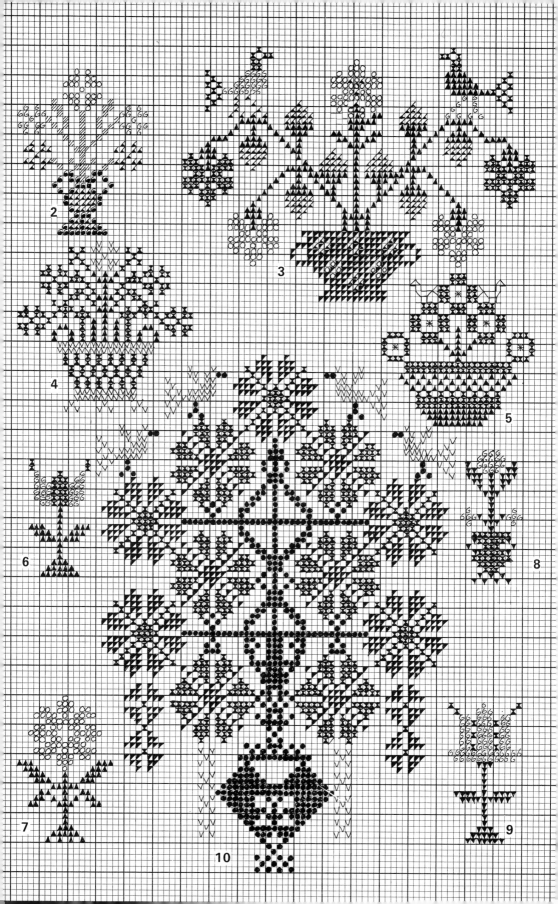

I Sampler, 1782; silk on cotton; cross stitch; 47 × 47 cm. NOM, Arnhem

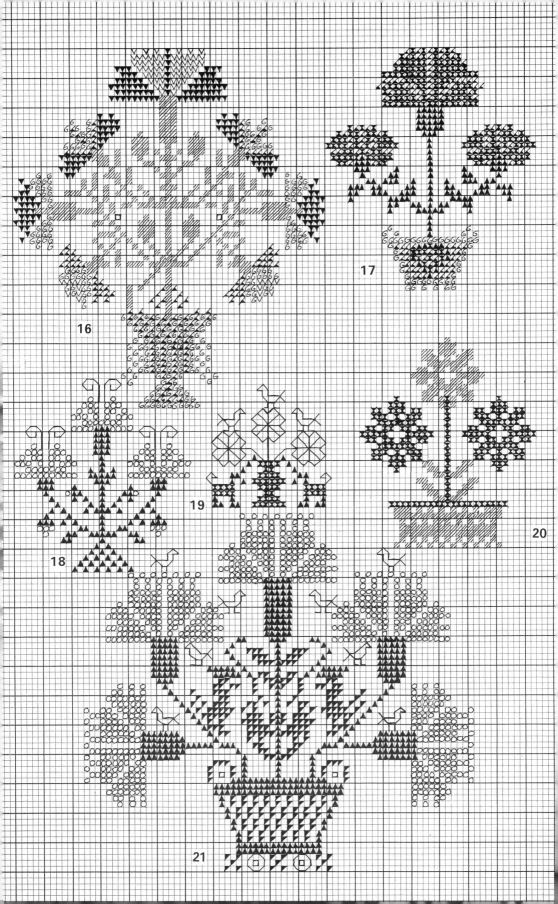

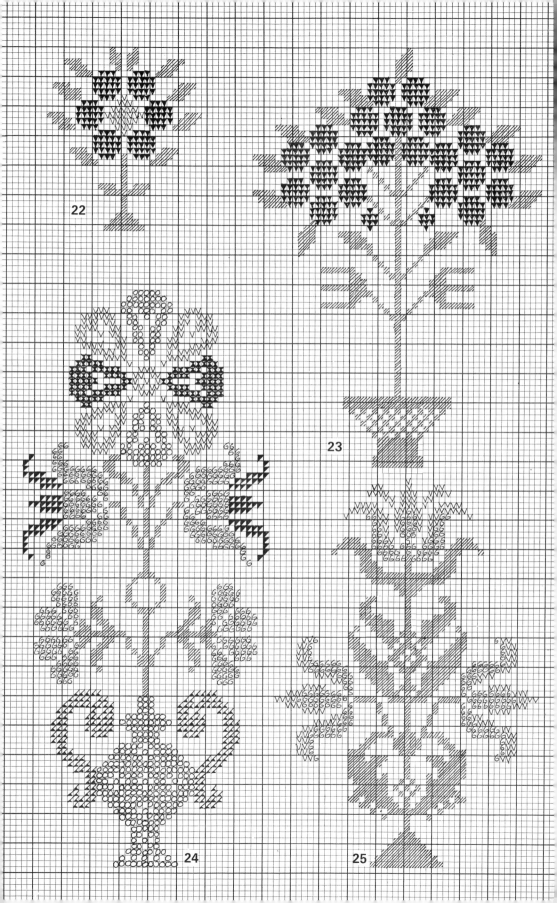

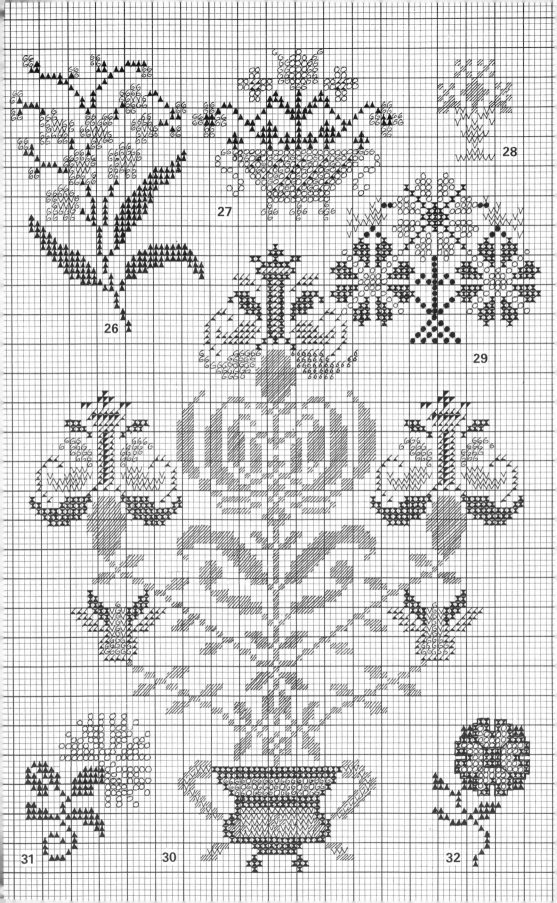

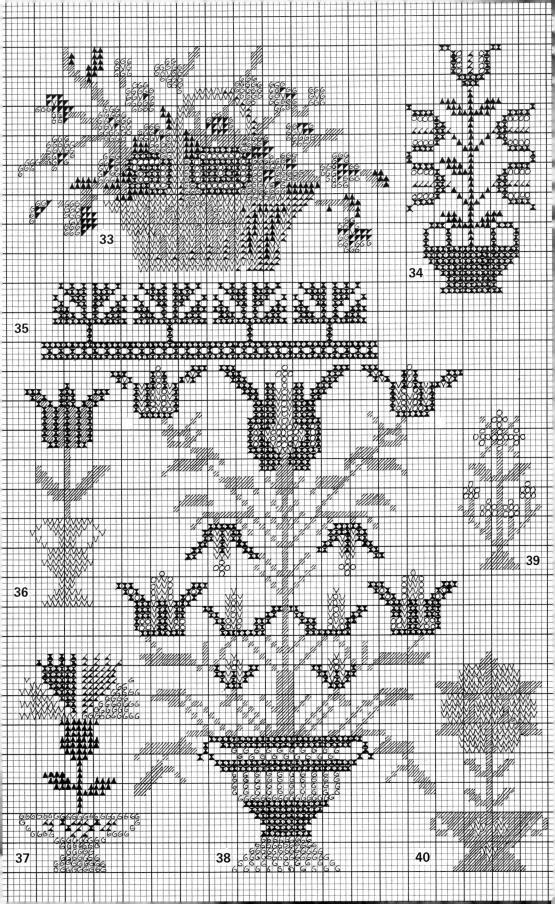

II Biblical motifs

There is a strong tradition of using Biblical motifs on samplers stemming from the days when Christianity was of infinitely more significance in people's lives than it is today. In many households the Bible was the only book to be found. It was read daily and people became steeped in its imagery. Biblical motifs and symbols were thus a normal part of everyday life for the devout young women and little girls who embroidered them, while later generations regarded them as sacrosanct and immutable.

Elijjah in the Wilderness (No. 1) (I Kings 19 : 5) 'And as he lay and slept under a juniper tree, behold, then an angel touched him, and said unto him, Arise and eat.'

The Grapebearers or *Spies of Canaan* (Nos. 2, 11, 15, 24) (Numbers 13 : 2, 23; 14 : 38). Joshua and Caleb, who according to medieval tradition were the bearers of the prodigious bunch of grapes from Canaan, symbolize the Jews and the Gentiles, while the bunch of grapes itself stands for Christ. The first bearer, who has his back to the grapes, personifies the Jews who would not acknowledge Christ, while the second, who is looking at the grapes, represents the Gentiles who turned to the Redeemer. This explains why the first bearer sometimes wears the conical cap of the Jews.

In the *Glossa Ordinaria*, the famous tenth-century book by Walafrid Strabo, which gives allegorical explanations of all the verses in the Bible, the grapebearers are the twelve spies sent by Moses into

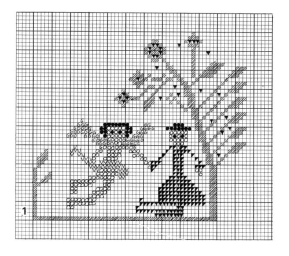

Canaan, the promised land, who, on their return, declared that it would be impossible to occupy it. They also symbolize the Scribes and Pharisees who persuaded the people not to believe in Jesus Christ, but in fact Christ was in their midst in the form of the bunch of grapes, which represents the Redeemer hanging on the Cross. Christ is the mystic bunch of grapes whose blood fills the chalice of the Church.

The Spies of Canaan who appear on a sampler of 1763 (private collection, Hummelo) and on another of 1868 (private collection, Zeddam) are wearing fifteenth-century costume: tight-fitting hose, a loose doublet girt with a belt from which hangs a purse and headgear of a type reminiscent of a thirteenth-century hood or a fifteenth-century cap which was worn a great deal in the East. Both men are shown in profile and have long black hair and beards. Seventeenth-century samplers (Nos. 2, 24) show the spies clad in breeches, a doublet fastened with a row of buttons and a high-crowned, wide-brimmed hat. They are also

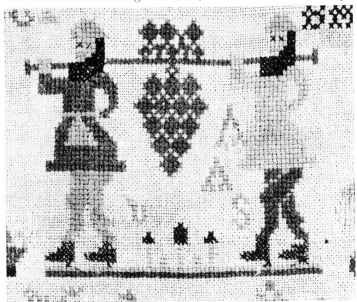

The Spies of Canaan. Detail of sampler, 1763. Private collection, Hummelo

found wearing the costume of the late seventeenth and early eighteenth centuries, which has a decidedly military air: a *justaucorps*, *i.e.* a long coat with long sleeves, a sleeved waistcoat, wide breeches and a tricorne hat (see Pl. I, facing p. 16).

Adam and Eve (Nos. 3, 7; see Pl. I, facing p. 16) with the tree of life whose fruit confers immortality and the tree of good and evil whose forbidden fruit led to the Fall (see also Chapter x). In Genesis 2 : 9-17 it is related how God planted the tree of life and the tree of knowledge of good and evil in the midst of

the other trees in the Garden of Eden, and how out of Eden there flowed a river which divided into four. Adam, the man whom God had appointed to tend and cultivate the garden, was told that he might eat freely of everything except the fruit from the tree of knowledge of good and evil. Then follows the story of the Fall (Genesis 3 : 1-7). The serpent incited the woman to break God's command, putting it to her that God was really afraid lest they should become like Him, knowing good and evil. The woman ate the fruit and also gave it to Adam to eat. As a result they were driven out of the Garden lest they should eat from the tree of life and become immortal, and to enforce this cherubim, members of the second order of angels, were sent to bar the way with a flaming sword.

Adam and Eve are depicted on samplers in various ways. Adam may be shown in breeches, a doublet and a high-crowned, wide-brimmed hat (*cf.* the Spies of Canaan) and Eve in a tight-fitting bodice (with or without a ruff), a wide skirt standing out from her hips and an apron, sometimes with a hat, sometimes bareheaded, or they may be naked, with long or short hair and a loincloth or a figleaf (Nos. 3, 27). On a sampler of 1807 (Fig. 4, facing p. 24, private collection, Hoog-Keppel) the tree of life is a stylized Frisian version. Adam and Eve are clothed and the serpent is placed horizontally across the tree.

The Five Wise and the Five Foolish Virgins (Nos. 4a, b, c) (Matthew 25 : 1-12). Among the figures carved on the west portal of the Liebfrauenkirche at Trier (dating from shortly after 1274) can be seen the Wise Virgins representing the Church, and the Foolish representing the Synagogue. In processions the faithful carry lighted candles so that they may (a) walk in the light, following the Wise Virgins' good example, (b) like the Wise Virgins, of whom the Virgin Mary is the predecessor, go forth to meet Christ, the true Bridegroom, bearing the light of good works and chastity and (c) follow Christ, Who is the Light to lighten the Gentiles.

1 Then shall the kingdom of heaven be likened unto ten virgins, which took their lamps, and went forth to meet the bridegroom.
2 And five of them were wise, and five were foolish.
3 They that were foolish took their lamps, and took no oil with them:
4 But the wise took oil in their vessels with their lamps.
5 While the bridegroom tarried, they all slumbered and slept.
6 And at midnight there was a cry made, Behold, the bridegroom cometh; go ye out to meet him.
7 Then all those virgins arose, and trimmed their lamps.
8 And the foolish said unto the wise, Give us of your oil; for our lamps are gone out.
9 But the wise answered, saying, Not so; lest there be not enough for us and you: but go ye rather to them that sell, and buy for yourselves.
10 And while they went to buy, the bridegroom came: and they that were ready

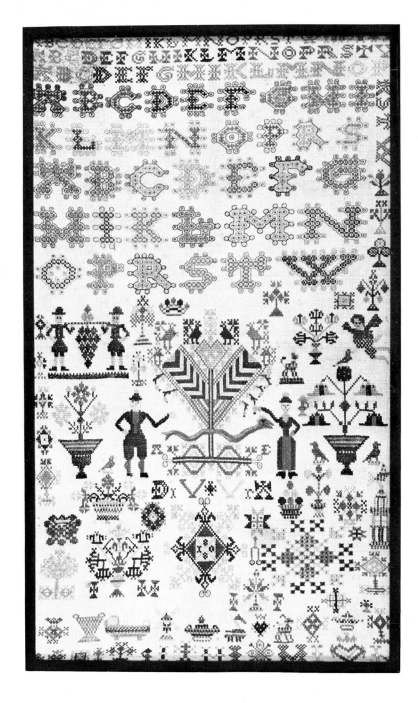

4 Sampler, 1807; silk on linen; cross and flat stitches and eyelet holes; 52.5 × 31 cm. Private collection, Hoog-Keppel (Gld.)

to Christ's death on the Cross. According to the *Physiologus* (see Chapter III) the pelican kills her young when they strike their parents with their wings, but, after three days, pecks open her breast and restores them to life with her blood. It is thus a symbol both of the Resurrection and of Christ, Who shed His blood for mankind on the Cross. Giotto was perhaps the first artist to depict the pelican in connection with the Cross, but the motif probably goes much further back for there are pelicans on Christian lamps of the third century from Carthage.

A *candle or candlestick* (Nos. 12a, b, c; see also Chapter VII). A light or a burning lamp represents active devotion, watchfulness and prayer.

The *Hill of Calvary* with the *Arma Christi* (No. 14) (Matthew 27 : 33-56). The text on the hill reads: *dit is van jesus liefde en lijden* (this is the love and passion of Jesus). Above it appear the Arma Christi, the Instruments of the Passion (see also Nos. 14, 16, 26 and Fig. 5, facing p. 56), the Cross (in this instance all three crosses are shown), the crown of thorns, a chalice, the dice, the hammer, the scourge, the pincers, the ladder, the sponge, the whipping-post, the seamless garment, a lantern, a ewer and basin, a dove, and three nails. Sometimes one also finds with a cross of the *Arma Christi* the inscription INRI: *Jesus Nazarenus Rex Iudaeorum:* Jesus of Nazareth, the King of the Jews (John 19 : 19).

In the fifteenth and sixteenth centuries another version of the *Arma Christi* was current in the Netherlands, Flanders and Germany: instead of the Instruments of the Passion the Five Wounds of Christ were depicted on a heart, two hands and two feet. Sometimes the child Jesus holding the Cross or the scourge, or both, was shown in the heart as well.

AMR: *Ave Maria Regina:* Hail Mary, Queen of Heaven (No. 15). The name of Mary, which according to the most widely accepted tradition, means 'well-made, beautiful', has been venerated in various ways. In the eleventh century, for example, it was honoured by the chanting of the Magnificat and four psalms, the initial letters of all five together spelling Maria: *M*agnificat; *A*d Dominum, Psalm 119 : 1; *R*etribue, Psalm 119 : 17; *I*n convertendo, Psalm 126; *A*d te levavi, Psalm 25. The monogram of Mary occurs as early as the tenth century on a miniature in the Uta Codex.

The *Virgin and Child* (Nos. 15, 21) are already to be found in a painting in the catacomb of St. Priscilla, that probably dates from the beginning of the second century. There the Virgin is shown seated, with the prophet Isaiah in front of her pointing to an eight-pointed star. The types of Virgin current in the early Middle Ages frequently show Byzantine influence, which is not surprising when one remembers the enthusiasm displayed by Eastern Christendom from the middle of the fifth century onward for the veneration of the Virgin as *Panhagia,* the All Holy.

Christ and the Woman of Samaria at the Well (Nos. 17, 18) (John 4 : 4-26). John

4 : 7: 'There cometh a woman of Samaria to draw water: Jesus saith unto her, Give me to drink'.

The *Lamb of God* (No. 25) is undoubtedly the principal symbol in animal form of Christ Whom the Old Testament prophets already saw as the lamb led to the slaughter. It begins to appear in art in the fourth century, sometimes with the monogram of Christ, a halo or the Cross, standing on a hill from which flow the four rivers of Paradise. In the Middle Ages it was commonly represented with blood streaming from its breast into a chalice. At first it was shown simply with the sign of the Cross, but around 1200 this was transformed into a cross with a long pennon ending in three fluttering streamers, this being the form of this motif that is generally found on seventeenth-century samplers. The same form is also found, worked in the *lacis* technique, on a Lenten cloth of *c.* 1650 from Westphalia (Fig. 5, facing p. 56, *cf.* No. 25). Lenten cloths were hung in front of the high altar on Ash Wednesday, at the beginning of Lent. A more primitive form of the motif consists of a lamb with a small square standard rising from its back (No. 7). This occurs on a Westphalian altarcloth (in *lacis* and whitework) of *c.* 1300 at Brandenburg.

LIST OF MOTIFS ILLUSTRATED

16 *The Arma Christi* – Undated sampler, West-Friesland Museum, Hoorn.

17 *Christ and the Woman of Samaria at the Well* – Sampler, 1772, NOM, Arnhem.

18 *Christ and the Woman of Samaria at the Well* – Undated sampler, private collection.

19 *The tree of life with the Pelican in het Piety* – Sampler, 1819, private collection.

20 *The Sacted Heart* – sampler, 1869, Ghulden Roos Museum, Roosendaal.

21 *The Virgin and Child* – Sampler, 1869, Ghulden Roos Museum, Roosendaal.

22 *The Cross* – Sampler, 1869, Ghulden Roos Museum, Roosendaal.

23 *Eight-pointed star* – Sampler, 1775, private collection.

24 *The Spies of Canaan* – Sampler, seventeenth century, private collection.

25 *The Lamb of God* – Sampler, 1768, private collection.

26 *The Arma Christi* – Sampler, *c.* 1870, private collection.

27 *Adam and Eve with the tree of life* – Sampler, *c.* 1870, private collection.

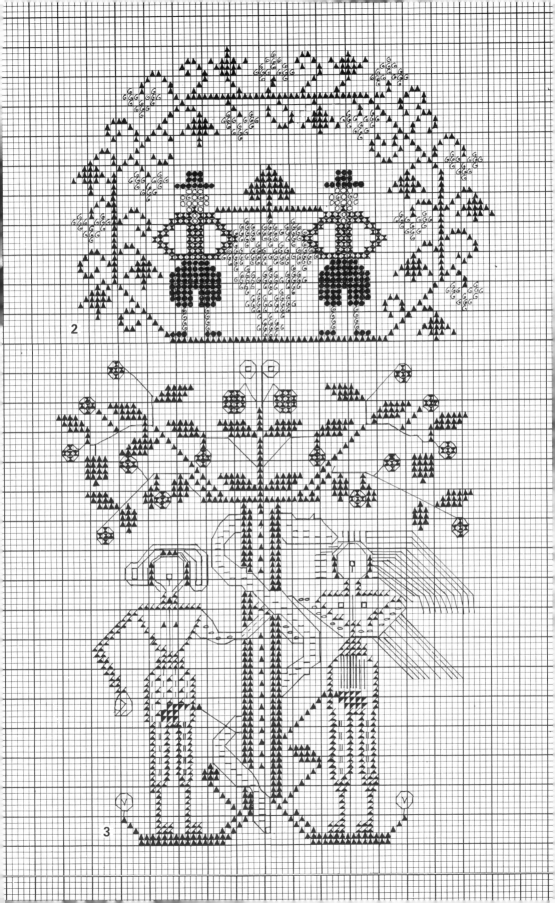

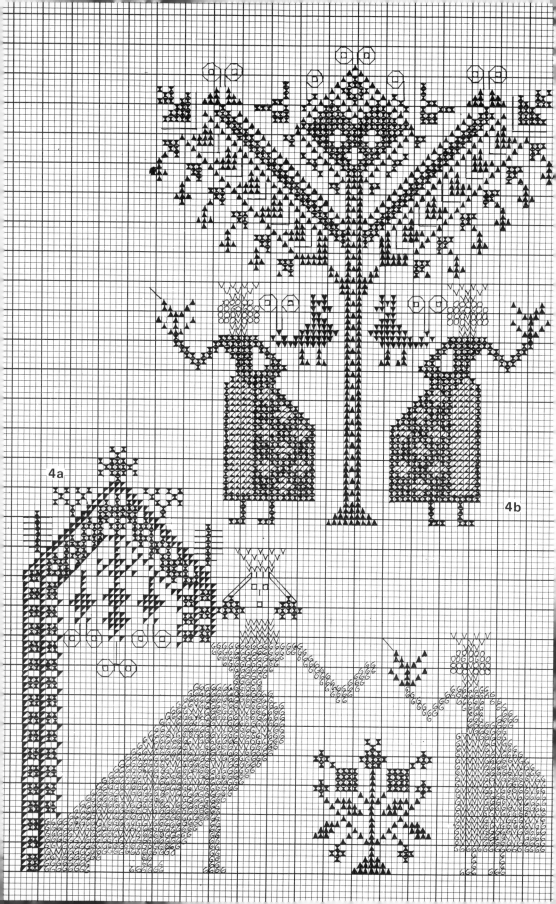

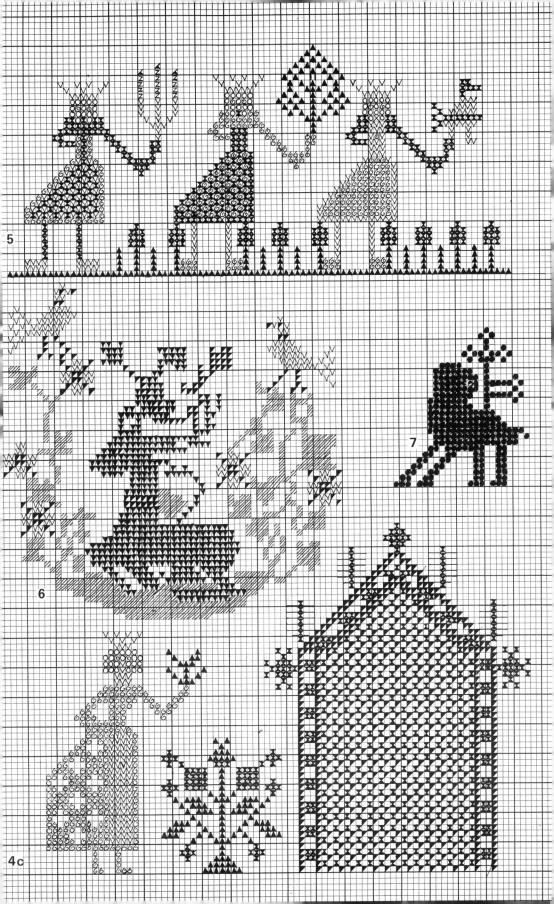

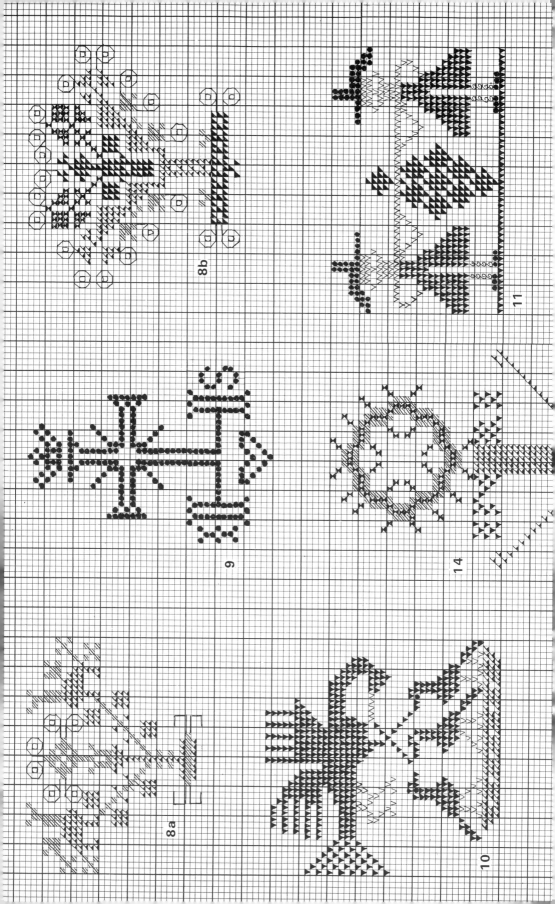

8b

11

9

14

8a

10

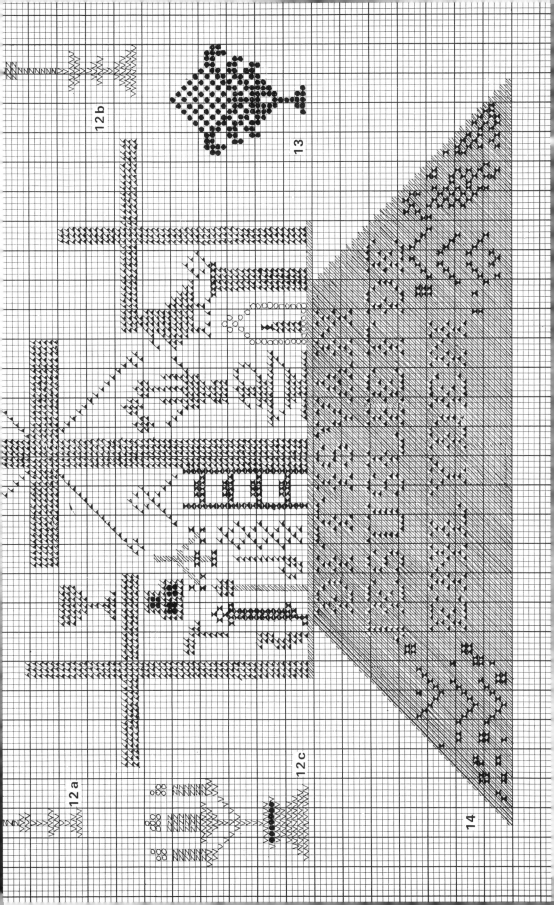

12 b

13

12 a

12 c

14

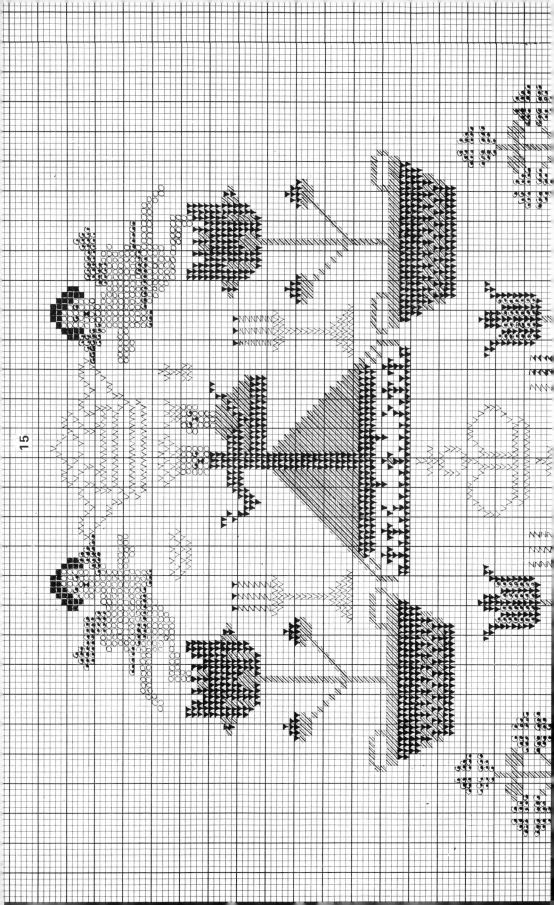

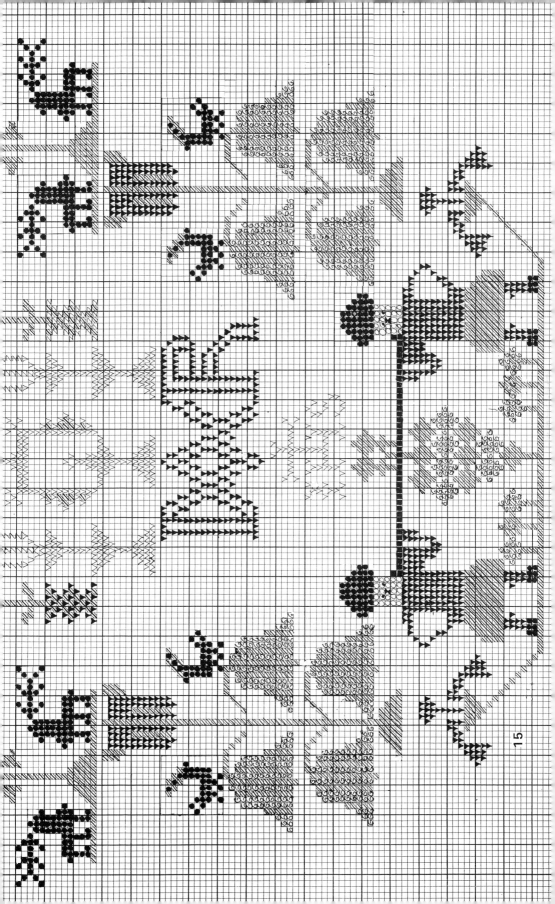

-15

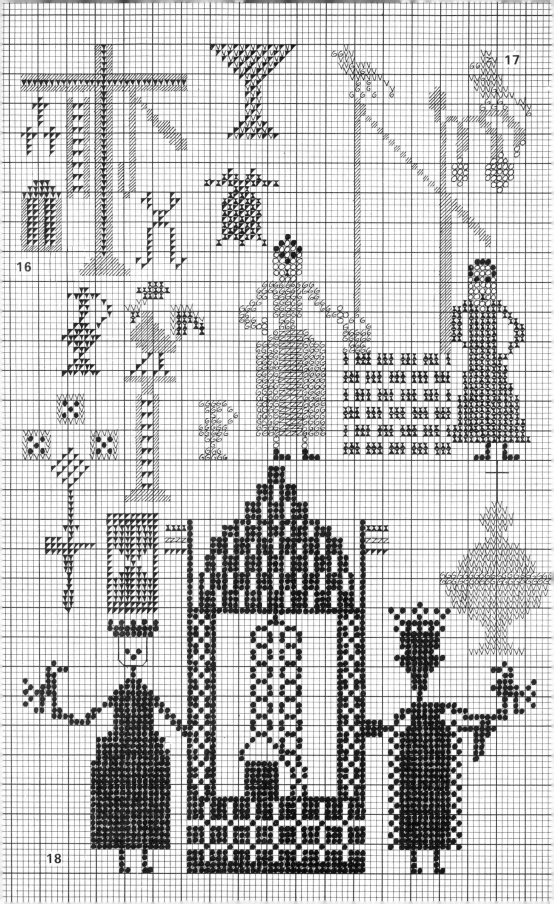

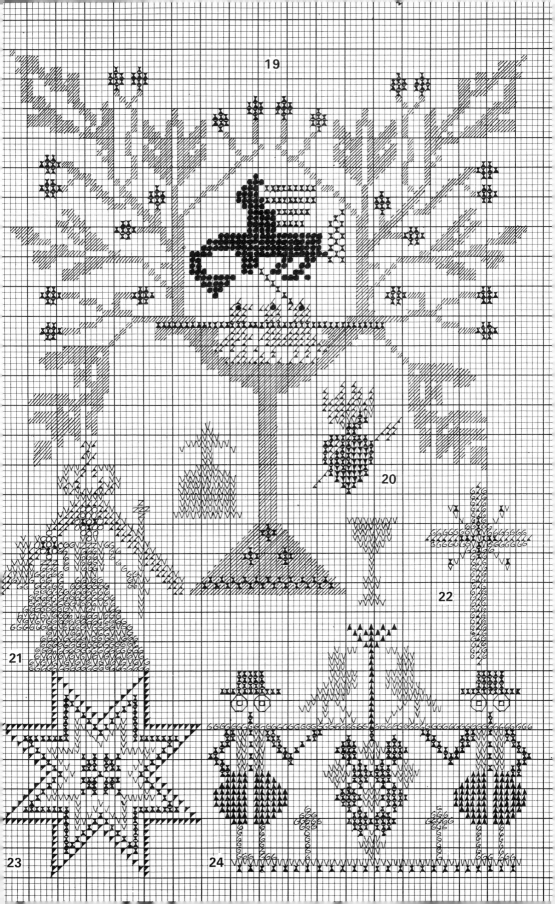

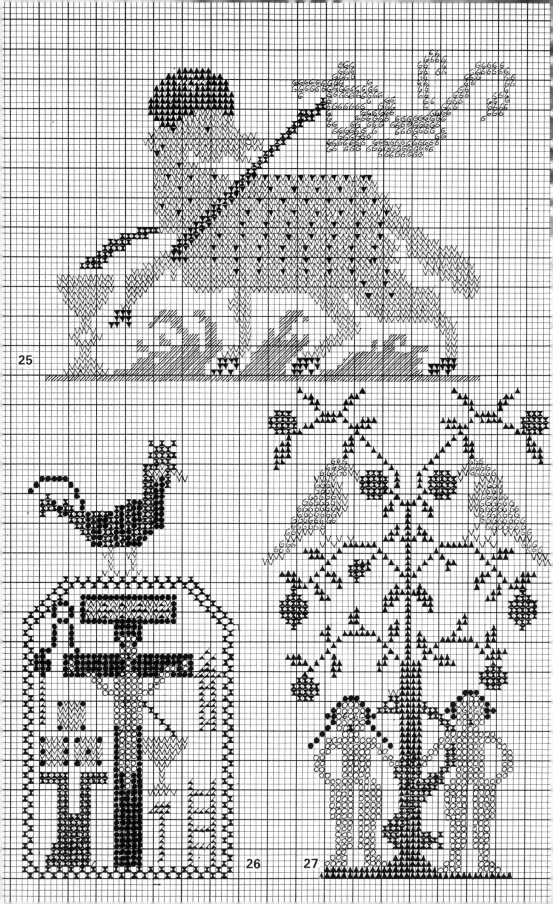

III Birds and animals

The symbolism of birds and animals is as old and as universal as man himself. It arose because people recognized in various creatures certain qualities they or their fellows possessed that were either worth emulating or abhorrent and thus the creatures themselves came to stand for the virtues and vices in question. The principal early source of animal symbolism, apart from the Bible, is the *Physiologus*, a popular theological treatise which attempts to explain the principal truths of Christian doctrine in terms of animal fables. This did not, however, have any influence on the symbols as such, since it was scarcely known, if at all, in the vernacular until a comparatively late date. In all probability it was compiled in Alexandria at the beginning of the second century, but the earliest German version of it did not appear until the eleventh century, while it was never translated into Middle Dutch and the people of the Low Countries knew it only through translated extracts in the form of Bestiaries and Lapidaries (moral treatises on animals and precious stones).

The *eagle* (Nos. 1, 32) is one of the oldest and commonest of emblems, being found in Egypt, Assyria, Syria, Greece and, above all, Rome, where until the time of Constantine (312) it was the symbol of the empire. As such it was later adopted by Napoleon.

In Christian symbolism it represents Christ and in particular the Ascension. This is because it flies higher than any of the other birds and was thought to be the only created thing able to gaze directly at the brightness of the sun. When teaching its young to fly, it protects them with its wings, yet afterwards it bears them aloft on those selfsame wings. Christ, too, is likewise in Heaven, seated at the right hand of God the Father, elevated above all the company of the blessed to an infinite degree, the

symbol of the ideal and of sublime and lofty thought. The eagle is also the attribute of St. John the Evangelist, and, in addition, it symbolizes strength, sublimity, soaring flight, faith, pride (it places itself above all other creatures), the ideal, lofty thought, and keen eyesight.

In heraldry both single- and double-headed eagles occur (Nos. 54, 59). The double-headed form is already found in the decorative art of the ancient East, where it originated merely as a result of a liking for symmetry.

The *goat* (No. 79) was already used in Antiquity as a symbol of sensuality and unchastity, and as such it served as an image of Satan in the early Middle Ages. In the Gospels, where sinners are likened to goats (Matthew 25 : 32), it is the symbol of the damned.

The *dove* is the symbol of the Holy Ghost. In Matthew 3 : 16 we read, 'And Jesus, when he was baptised went up straightway out of the water: and, lo, the heavens were opened unto him, and he saw the Spirit of God descending like a dove, and lighting upon him:'. As early as the end of the fourteenth century we find representations of the Trinity in which the Father and the Son are shown in human form seated side by side, while the Holy Ghost hovers above them in the form of a dove. The dove of the Holy Ghost also appears hovering above the head of the Virgin in depictions of the Annunciation.

The dove also stands for mercy and peace. The dove which brought the olive-branch to Noah as a sign of mercy (Genesis 8: 11) was not only a symbol of peace (No. 27), but was also regarded as a prefiguration of the Virgin Mary, who revived the hope of forgiveness. Concord, often identified with peace, is represented by two doves facing each other.

A dove with a letter in its beak symbolizes a messenger and, in a romantic sense, a messenger of love. The dove also stands for love, sincerity, marital fidelity, humility, simplicity and meekness. Seven doves are analogous to the seven gifts of the Holy Spirit and twelve doves are sometimes used to symbolize the twelve apostles.

The *duck* represents marital fidelity in Greek mythology and is an old hunting motif.

The *unicorn* (No. 84) is the symbol of chastity and purity. It is a fabulous beast with the body of a horse, the bearded head of a goat and a single straight horn in the middle of its forehead. It is usually white, the colour of virginal purity. According to the *Physiologus*, it is so wild that hunters can hardly ever capture it. They can only do so when there is a virgin in the vicinity, for if it sees a virgin, it takes refuge in her lap, thus giving them the chance to overpower it. In this respect it stands for Christ Who took on human form in the womb of the Virgin Mary, thus delivering Himself up to those who were seeking Him. The Angel Gabriel as a huntsman kneels by the Virgin's side blowing a hunting-horn.

40

In addition the unicorn is said to have the power to purify poisoned springs by making the sign of the cross over them with its horn, and in this sense too it is a symbol of the Redeemer.

Purity is also represented on occasion by a Virgin with a lily or a dove in her hand riding on a unicorn.

The *goose* signifies watchfulness, stupidity, gullibility, garrulity.

The *cock* (Nos. 19, 21, 26, 28, 29, 30, 31, 36), as a symbol of Christ, indicates the Conquerer of the powers of darkness and evil spirits, He Who calls men to labour in the light of day, the Judge Who rouses to wakefulness those slumbering in the sleep of the dead. It is also the symbol of watchfulness and penitence because of its part in the Gospel story of Peter's denial and repentance (Matthew 26 : 69-75): it was when the cock crew that Peter first felt remorse.

The cock, perched in the tree of the universe (Yggdrasil), was also sacred to Odin (Wotan) the supreme god of Norse and Germanic mythology.

The *hare* stands for faint-heartedness, timidity and flight.

The *hart* (Nos. 60, 61, 63, 64; see also Chapters II and XVI) symbolizes both gentleness and pride. The stag with spreading antlers is the symbol of the hunt, and with a shining cross between its antlers it is the attribute of St. Hubert, the patron saint of hunters to whom, according to legend, such a stag appeared while he was out hunting.

The *dog* (No. 83) symbolizes fidelity and watchfulness. It quite often occurs on mosaic floors at the entrance to Roman houses with the warning inscription: *Cave Canem* – Beware of the dog. In personifications of loyalty it appears as the companion of a figure carrying a key or a signet ring. It is also used as an attribute of envy and wrath.

The *cat* is the symbol of idleness, love of ease, coquetry and, because of its independent spirit and refusal to be shut in, freedom. In Egypt it was regarded as holy and golden statues were made of it.

The *rabbit* (No. 76) is found along with both the lion and the hart. A lion accompanied by a rabbit has been used as a theme of decoration for thousands of years. Time and again we come across these two creatures in art, either together or singly, immortalized in wood, stone, metal and other materials, including woven and embroidered textiles. As early as the sixth century B.C. the Etruscans, inspired by Eastern art, began painting lions and leaping rabbits in a style that foreshadowed the forms used later in heraldry. A dog chasing a rabbit stands in Christian symbolism for the good soul fleeing before evil.

The *lion* (see Chapter XII).

The *stork* (Nos. 33, 34) symbolizes watchfulness and parental love (its Germanic name *adebar* or *odebar* means bringer of happiness).

The *parrot* (No. 24) signifies talkativeness and gossip.

The *peacock* (Nos. 40, 42, 43, 45, 46, 47, 48, 49, 51; Fig. 6 facing p. 57) is the

41

symbol of ostentation, vanity, luxury and immortality and is also found as the companion or the mount of pride, or rather of haughtiness and vanity, personified as a richly bedecked young woman gazing at her reflection in the mirror she carries in her hand.

In mythology rulers and heroes are often immortalized, *i.e.* raised to the status of gods. This deification was symbolized by an eagle or a peacock, the peacock being a sign for the deification of an empress, bearing witness to her presence among the gods on Olympus.

The peacock is also the symbol of kingly or knightly demeanour. In England in the year 1400 knights took their oaths with their hands on the side of a stuffed peacock.

In the third century the peacock was the symbol of immortality since it was believed that its flesh was proof against decay.

The *tortoise* (No. 77) is a symbol of strength and slowness. In the eary seventeenth century Ripa (an Italian iconologist) depicted *Pudicitia* (virtue, chastity, modesty) as a young maiden dressed in white, with a veil over her face, a lily in her hand and her foot on a tortoise. The tortoise, which always carries its house with it and never leaves it, served as a reminder that a chaste woman should remain within the protecting walls of her house as much as possible.

There is a tortoise worked in the *lacis* technique on a Lenten cloth of *c.* 1580 from the Grevenbroich/Neuss area (see Paul Engelmeier: *Westfälische Hunger-tücher*).

The *Snake* (No. 73) Genesis 3 : 1: 'Now the serpent was more subtil than any beast of the field which the Lord God had made'. In accordance with the account in Genesis, Satan was represented as a serpent with an apple in its mouth in Early Christian depictions of the Fall. Thus the snake came to symbolize both reward and wickedness not only because of its part in the Fall, but also because the Latin word *malum* means evil as well as apple. In antiquity the apple, because of its sweetness and beauty, symbolized love and fertility and the offer or gift of an apple was seen as a declaration of love (*cf.* the Judgement of Paris).

The snake coiled at the foot of the Cross, sometimes with an apple in its mouth, shows that sin and death were conquered by Christ. But Christ compared Himself to the brazen serpent that Moses set upon a pole in the desert (Numbers 21 : 9; No. 73). Thus while one serpent brought sin into the world, another, Christ, brought healing and redemption through the mystery of the Eucharist.

In ancient Eastern religions a snake with its tail in its mouth, forming a circle, was the symbol of eternity.

The *owl* (No. 82) is occasionally used to symbolize the devil and in particular the demon of avarice. It also signifies wisdom and is the attribute of Minerva.

The *falcon* (see Chapter XIV, Nos. 6, 10) is a symbol of pride and nobility (in the Middle Ages falconry was the sport of the nobility). In Egyptian mythology some of the gods have falcon's heads.

The *butterfly* and the *moth* (Nos. 66, 68, 69, 70) are symbols of immortality, joy, playfulness, pleasure and inconstancy. The development from caterpillar to chrysalis and from chrysalis to butterfly or moth is an image of resurrection in general and the Resurrection of Christ in particular. The butterfly symbolizes inconstancy because it flits from flower to flower without ever coming to rest. The moth, which persistently flutters round the bright, shining flame of a candle until its wings are singed and it falls to the ground, epitomizes the frivolity of those who refuse to see the dangers of worldly temptations until the angelic wings of their souls are consumed.

The *swan* (Nos. 4, 7, 11, 50, 52). According to most writers the swan is the bird of love that accompanies Venus and Cupid. In folklore it is also the symbol of a good death because it is supposed to sing sweetly as it dies.

The swan is the emblem of the Lutheran Church. When the Bohemian martyr Johann Hus was burnt at the stake for his faith in 1415, he said, prophesying the coming of Luther, 'Today you are burning a goose [a pun on his name: *husso* is Czech for goose], but in a hundred years' time there will come a white swan that you will not be able to compel to keep silent'.

In Germanic mythology the white swan is the attribute of Wotan (Odin) and, like the white horse and the goose, is a creature of the sun, the bringer of light and life.

Swans crop up frequently on Frisian samplers (see the example of 1760, Pl. III, between pp. 56 and 57), either singly or in pairs arranged symetrically (see Chapter XIX, No. 5).

43

LIST OF MOTIFS ILLUSTRATED

37 *Three birds* – Undated sampler, private collection.

38 *Two ducks* – Undated sampler, private collection.

39 *Two doves* – Undated sampler, private collection.

40 *Peacock* – Sampler, 1705, NOM, Arnhem.

41 *Parrot* – Undated sampler, private collection.

42 *Peacock* – Sampler, 1765, private collection.

43 *Peacock in display* – Sampler, 1775, private collection.

44 *Three swans in a line* – Sampler, 1666, Zaanland Museum of Antiquities, Zaandijk.

45 *Two peacocks* – Undated sampler, Frisian Museum, Leeuwarden.

46 *Tree of life with two peacocks in display* – Sampler, 1787, private collection.

47 *Peacock in display* – Sampler, 1726, NOM, Arnhem.

48 *Girl with two peacocks* – Undated sampler, private collection.

49 *Peacock* – Sampler, 1670, private collection.

50 *Swan* – Undated sampler, private collection.

51 *Tree of life with two peacocks, the initials PC and LK and two birds* – Pillowcover, Marken, eighteenth century, private collection.

52 *Swan* – Undated sampler, Zuider Zee Museum, Enkhuizen.

53 *Border of birds, hearts and flowers* – Probably from a pillowcover, Marken, private collection.

54 *Double-headed eagle* – Undated sampler, NOM, Arnhem.

55 *Peacock* – Sampler, 1677, private collection.

56 *Dove* – Undated sampler, private collection.

57 *Bird* – Undated sampler, private collection.

58 *Peacock* – Sampler, 1661, Frisian Museum, Leeuwarden.

59 *Double-headed eagle* – Sampler, 1661, private collection.

60 *Stag lying in the Garden of Holland* – Sampler, 1707, private collection.

61 *Tree of life with two harts* – Sampler, 1772, private collection.

62 *Tree of life with bird* – Undated sampler, private collection.

63 *Stag* – Undated sampler, private collection.

64 *Hart border* – Undated sampler, private collection.

65 *Plant with flowers, two birds and two eight-petalled flowers* – Undated sampler, private collection.

66 *Butterfly* – Undated sampler, private collection.

67 *Rabbit* – Sampler, 1692, Zaanland Museum of Antiquities, Zaandijk.

68 *Butterfly* – Darning sampler, 1771, private collection.

69 *Butterfly* – Sampler, 1833, private collection.

70 *Butterfly* – Sampler, 1845, NOM, Arnhem.

71 *Bird in a cage* – Undated sampler, private collection.

72 *Bird in a cage* – Undated sampler, private collection.

73 *The Brazen Serpent* – Sampler, 1778, NOM, Arnhem.

74 *Border with dogs* – Undated sampler, private collection.

75 *Squirrel* – Sampler, 1834, Zuider Zee Museum, Enkhuizen.

76 *Rabbit* – Sampler, 1778, NOM, Arnhem.

77 *Tortoise* – Undated sampler, private collection.

78 *Squirrel* – Sampler, 1778, NOM, Arnhem.

79 *Goat eating the leaves of a tree* – Sampler, 1855, NOM, Arnhem.

80 *Hare* – Sampler, 1809, KMA, Beverwijk.

81 *Hare* – Sampler, 1816, NOM, Arnhem.

82 *Owl* – Sampler, first half of the nineteenth century, NOM, Arnhem.

83 *Two dogs fighting over a bone* – Sampler, 1640, private collection.

84 *Unicorn* – Sampler, 1790, NOM, Arnhem.

85 *Cow* – Sampler, 1720, NOM, Arnhem.

86 *Horse* – Undated sampler, private collection.

87 *Horse* – Sampler, 1827, private collection.

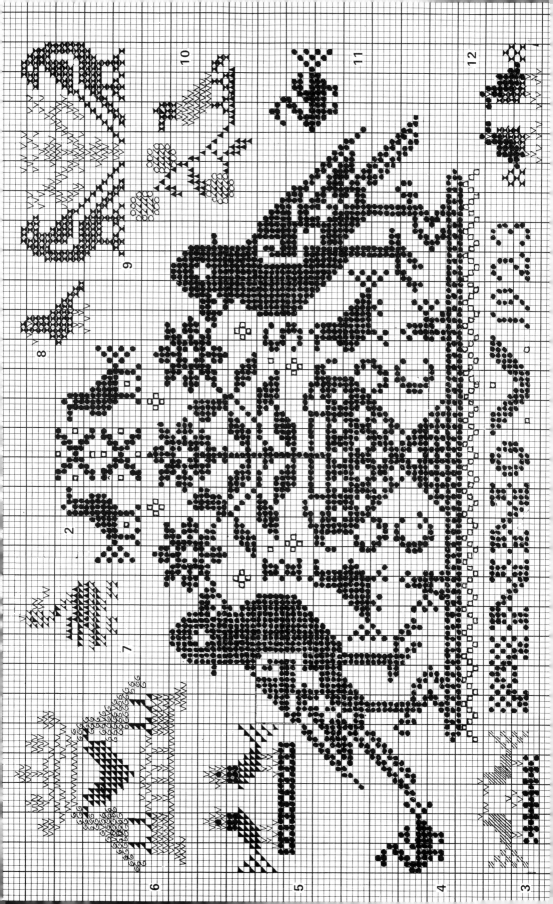

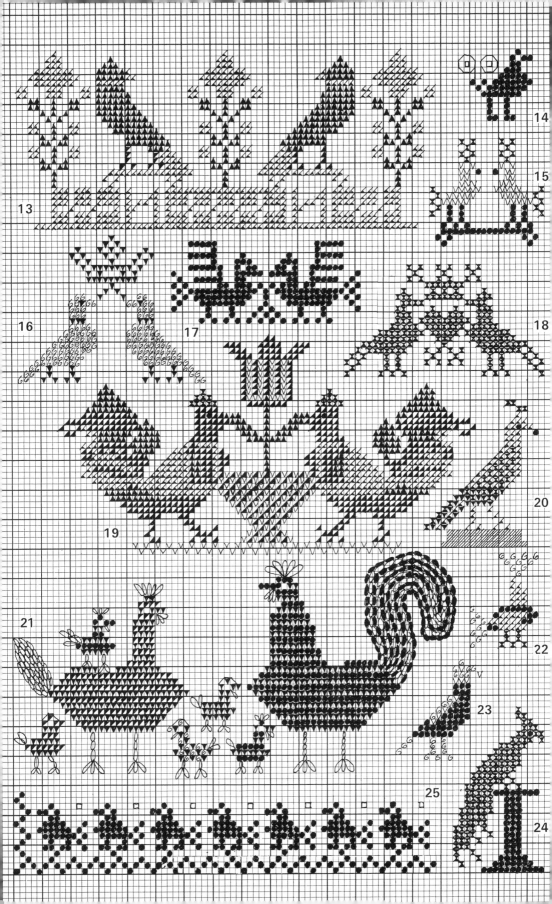

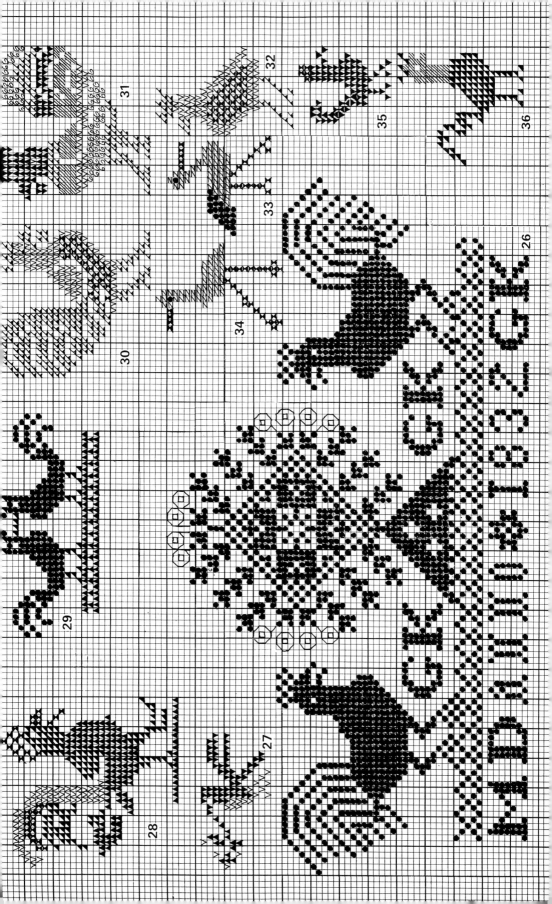

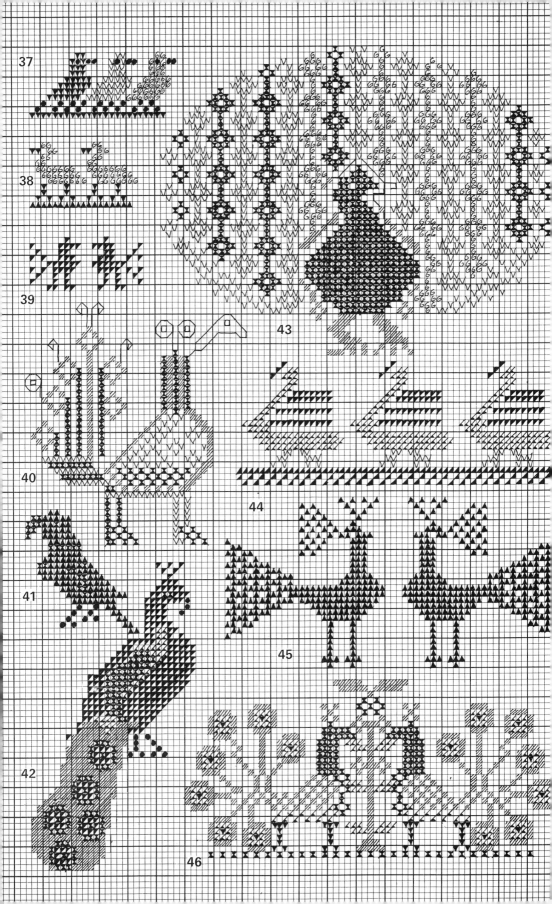

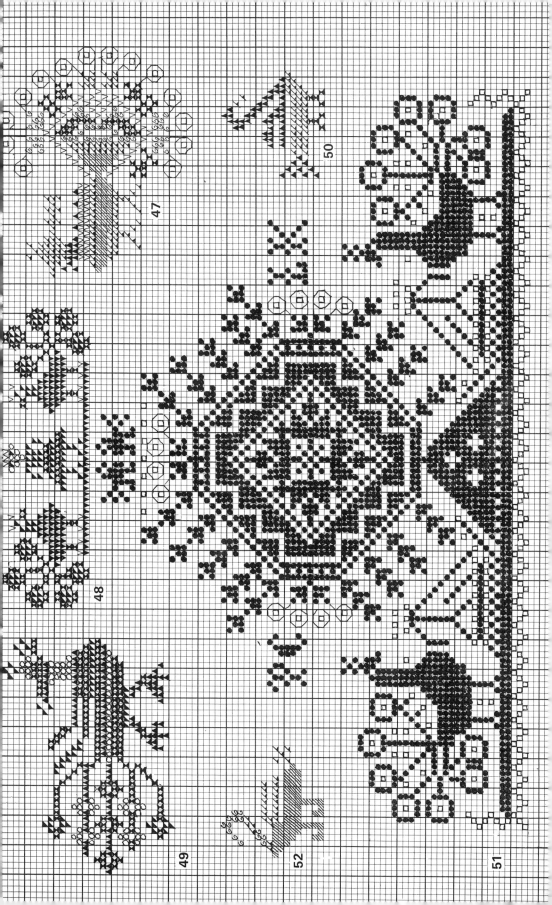

47

50

48

49

52

51

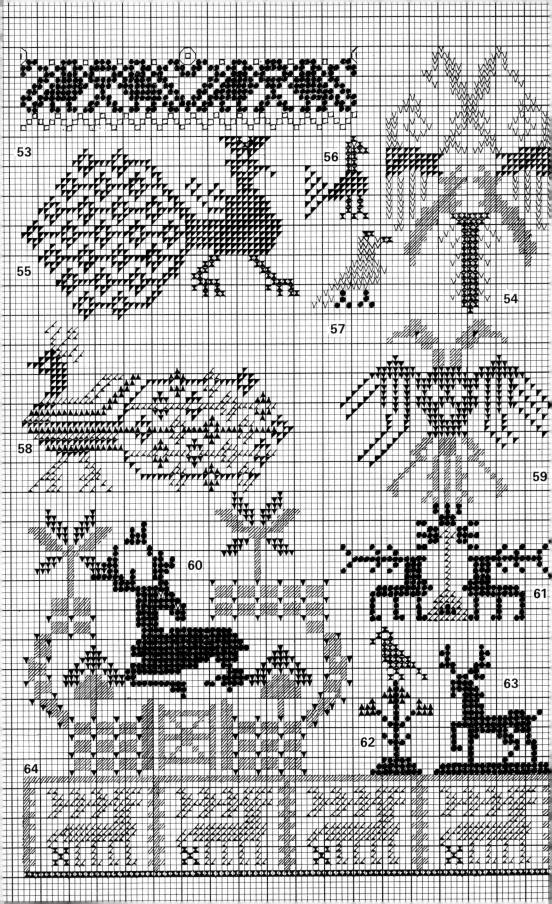

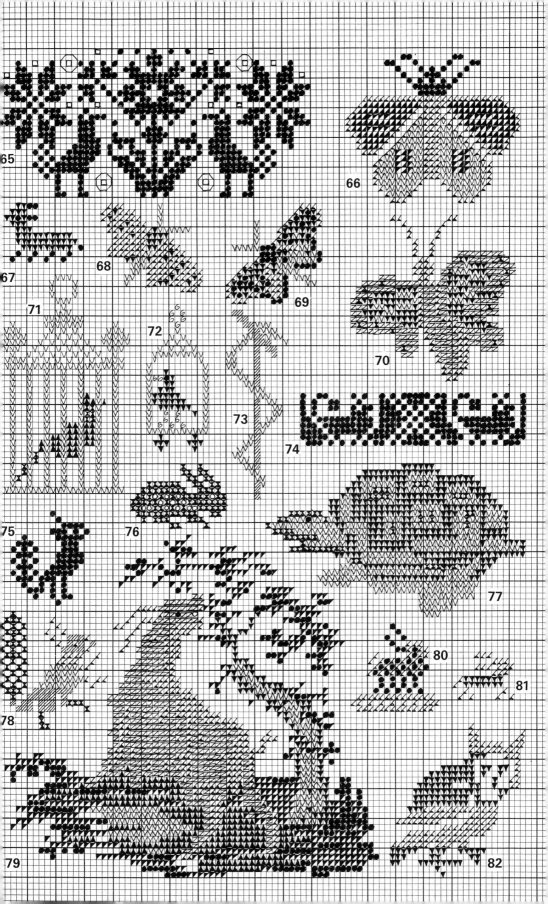

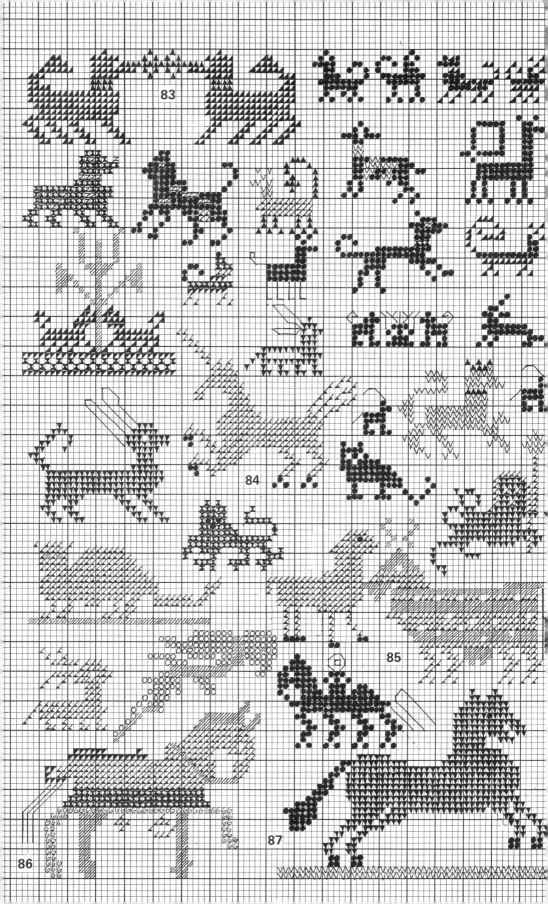

IV Hearts

In about 1600 a series of 18 small copper engravings was published by Anton Wirix under the title *Cor Jesu Amanti Sacrum*. Its theme is the various stages in the development of the spiritual life. Jesus appears as a child, in the form of *Amor Divines*. He opens the heart and with a broom sweeps out all the iniquity accumulated in its innermost recesses by the world, the flesh and the devil. On the walls of the heart He paints a picture of the four last things. He pierces the heart with the arrows of His love. Finally He takes possession of it and as the Divine Bridegroom takes up the harp, the angels rejoice. Then comes the moment for the heart to receive its reward: Divine love sets a crown upon it, while the heavenly host adorn it with palms and garlands of flowers.

The Sacred Heart at the moment when it was pierced is the most concrete symbol of Divine Love. In the Middle Ages it was sometimes depicted with the Instruments of the Passion, in which case it was not accompanied by the four other wounds in the form of pierced hands and feet. The Instruments of the Passion are the instruments of Love and the Sacred Heart the source from which flowed the blood that redeemed the world. The concept of the glowing furnace of love was not linked with the Sacred Heart until much later on, but thereafter it was always depicted in flames.

Over the years the Congregation of Rites has issued various instructions and directives as to how the Sacred Heart should be represented. It may not be depicted naturalistically or realistically, it should be ringed by flames or rays of light and the wound must be visible. The crown of thorns should encircle it vertically and not horizontally, and it may be surmounted by a cross enveloped in flames. The Sacred Hearts of Jesus and Mary may be shown alongside one another (see

Nos. 10 and 15).

During the period of the Counter Reformation a winged heart, a heart flying upwards to God, was used to represent prayer, and prayer was personified as a figure with a flaming heart, a prayer book and a rosary.

The *mystic winepress* (Nos. 30, 31, 32; see Pl. III, between pp. 56 and 57) symbolizes the soul's victory over itself, the contrition of the heart that makes the tears flow.

Christ in the winepress. Christ, wearing a loin-cloth and the crown of thorns and with the impression of the nails in His hands and feet, treads grapes in a trough and is himself forced down through the beams of the press as the mystic bunch of grapes (*cf*, the Spies of Canaan), so that the wine, His Sacred Blood, streams from His wounds.

LIST OF MOTIFS ILLUSTRATED

1 Crowned heart with four fleurs-de-lys and two doves – Sampler, 1802, private collection.

2 Winged and crowned heart pierced with arrows – Sampler, 1801, private collection.

3 Crowned heart pierced with arrows, with three fleurs-de-lys and four birds – Sampler, 1688, Zaanland Museum of Antiquities, Zaandijk.

4 Heart pierced with arrows, with a fleur-de-lys – Sampler, 1817, NOM, Arnhem.

5 Tree of life with heart and flowers – Undated sampler, private collection.

6 Heart – Sampler 1788, NOM, Arnhem.

7 Crowned heart with three crosses – Undated sampler, private collection.

8 Winged and crowned heart pierced with arrows, with two fleurs-de-lys – Sampler 1801, NOM, Arnhem.

9 Crowned heart with three flowers – Sampler, 1801, NOM, Arnhem.

10 The Sacred Heart of Mary – Sampler, 1852, NOM, Arnhem.

11 Crowned heart – Sampler, eighteenth century, private collection.

12 Heart with eight fleurs-de-lys – Sampler, 1664, private collection.

13 Crowned heart with three fleurs-de-lys and four birds – Undated sampler, private collection.

14 Heart pierced with arrows and encircled by roses – Sampler, seventeenth century, private collection.

15 The Sacred Heart of Jesus – Sampler, 1852, NOM, Arnhem.

16 Heart with bird – Darning sampler, 1787, NOM, Arnhem.

17 Heart with cross – Sampler, 1852, NOM, Arnhem.

18 The heart of Mary, crowned and pierced with arrows, with two doves – Sampler seventeenth century, private collection.

19 Crowned heart with two birds – Sampler, 1852, NOM, Arnhem.

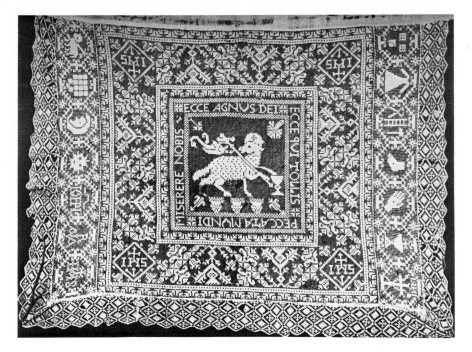

5 *Lenten cloth from Westphalia (exact provenance unknown), c. 1650; lacis. (From: Paul Engelmeier 'West-
fälische Hungertücher vom 14. bis 19. Jahrhundert'. Published in 'Westfälischen Museeen', Vol. 4. Verlag
Asschendorff, Münster Westfalen, 1961)*

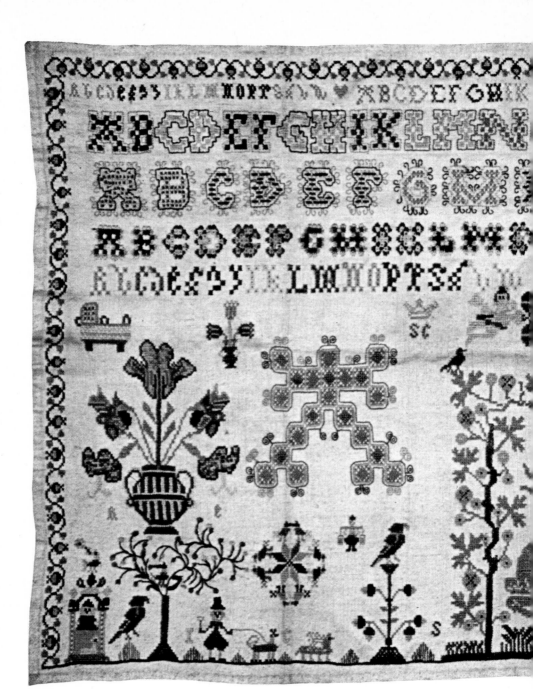

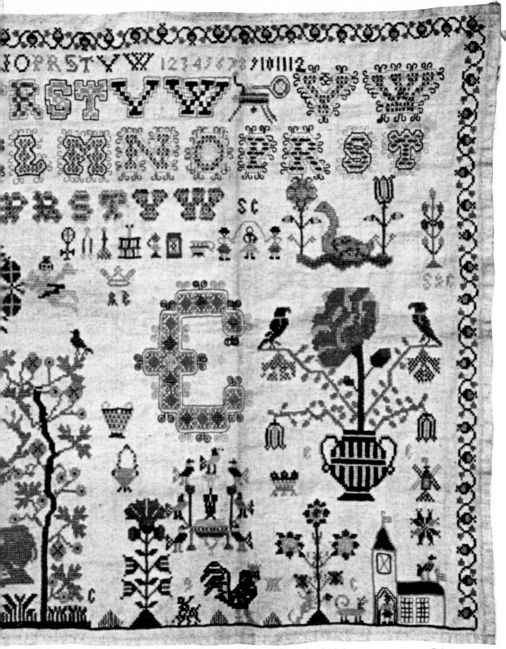

III Sampler, *1760, Friesland; silk on linen; cross and back stitches and eyelet holes; 32.7 × 55.5 cm. Private collection, Leerdam.*

Samplers with alphabets and figures are very common in Friesland. Their makers had to be proficient at embroidering letters, initials and figures as these were widely used on shirts and household linen. The figures were used both for dating and for numbering the shirts and sheets young women made for their trousseaux –

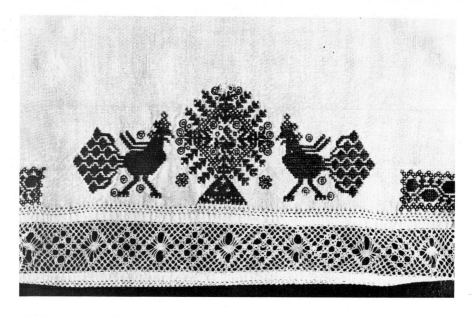

6 Pillowcover, 2nd half of the nineteenth century, Marken; yellow wool on linen with bobbin lace insertion. NOM, Arnhem

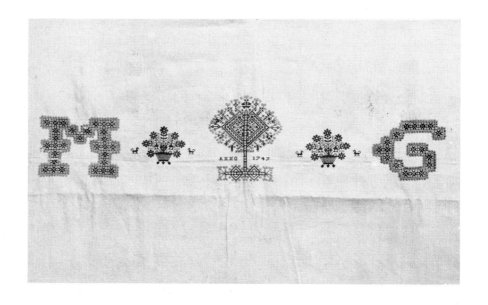

6a Sheet, 1747, Friesland (Workum). Private collection

20 *Heart pierced with arrows* – Sampler, 1852, NOM, Arnhem.

21 *Crowned heart* – Sampler, 1801, private collection.

22 *Heart with four fleurs-de-lys* – Undated sampler, private collection.

23 *Heart pierced with arrows* – Sampler, 1852, NOM, Arnhem.

24 *Heart surrounded by four crowns and pierced with arrows* – Sampler, 1801, private collection.

25 *Two hearts, crowned and pierced with arrows, with two birds* – Undated sampler, private collection.

26 *Crowned heart* – Sampler, 1801, private collection.

27 *Two hearts side by side, pierced with arrows* – Sampler, 1852, NOM, Arnhem.

28 *Heart with three flowers* – Sampler, 1688, Zaanland Museum of Antiquities, Zaandijk.

29 *Crowned heart with two birds* – Sampler, 1852, NOM, Arnhem.

30 *The mystic winepress in an eight-pointed star* – Undated sampler, private collection.

31 *The mystic winepress with seven birds* – Undated sampler, private collection.

32 *The mystic winepress with five birds* – Undated sampler, private collection.

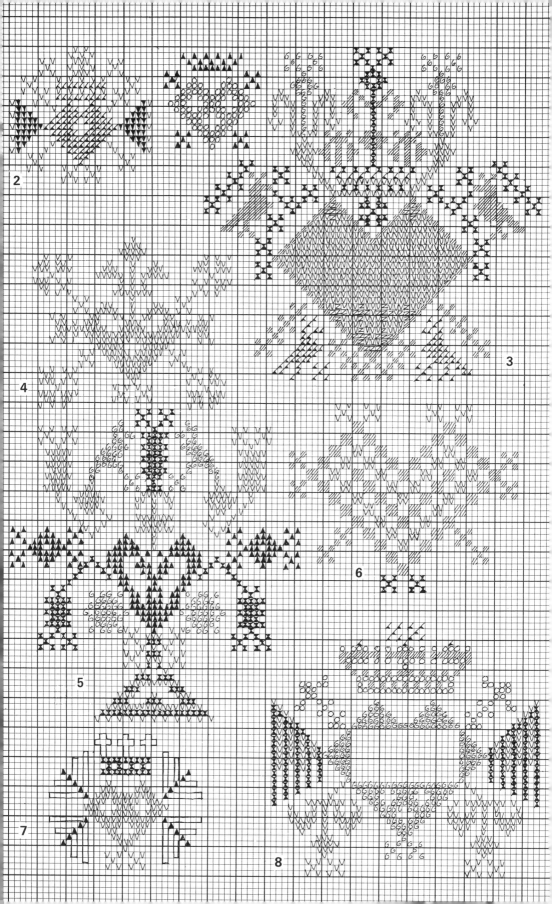

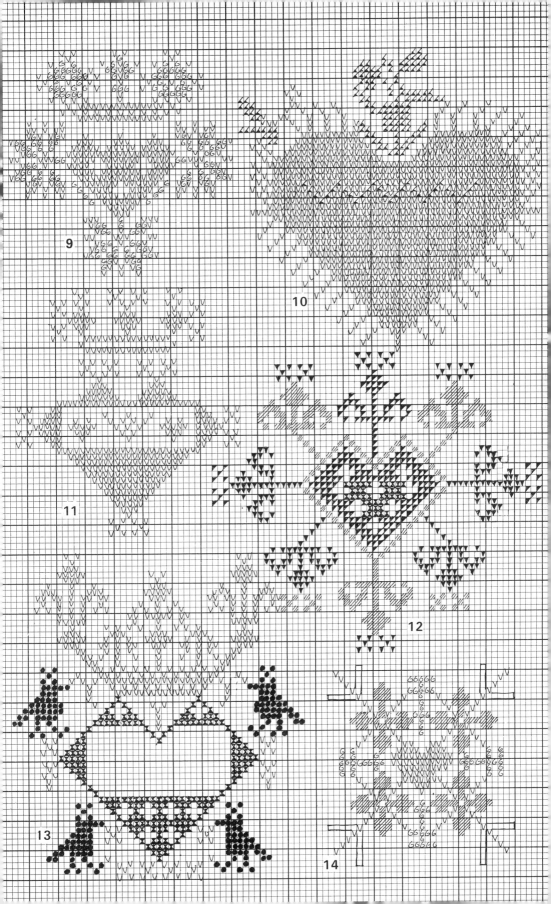

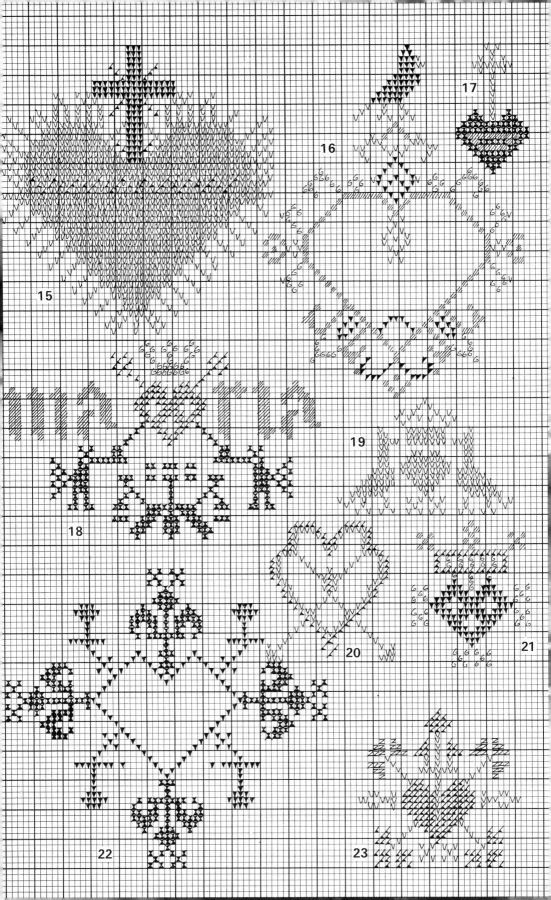

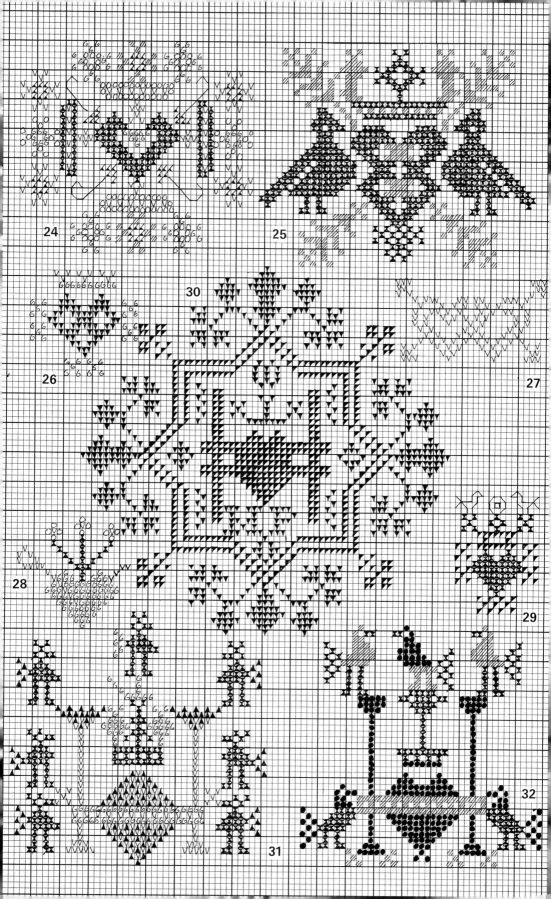

V Corner motifs

On seventeenth-century samplers corner motifs may be placed anywhere, instead of being in their proper place in the corners as part of the border as they are on eighteenth-century and later samplers. There is, however, one type of seventeenth-century object on which they do occur in the corners and that is the *knottedoek*, a square linen cloth or kerchief embroidered in cross stitch which was used to hold the dowry (100 silver sixpences) when a girl's hand was asked in marriage. The kerchief, embellished with an appropriate rhyme, was offered to her loosely knotted. If she pulled the knot tight, then it meant that her answer was 'yes'. In the northern provinces of the Netherlands in the seventeenth and eighteenth centuries a bridegroom would offer his bride the dowry (20 gold ducats) in a special little silver box, usually in the form of a chest, which was called a *knotte-kistje*. Later on in the eighteenth and nineteenth centuries the money gift was often replaced by a marriage-medal.

A dowry kerchief of 1671 (NOM, Arnhem, see Fig. 7 facing p. 102) bears the rhyme:

GOD GREET YOU, SWEETHEART, IN ALL HONOUR.
YOU ARE THE DEAREST OF ALL TO ME AFTER GOD THE LORD.
MY EYES MAY LOSE SIGHT OF YOU, BUT IN MY HEART
THERE IS NO ONE I WOULD RATHER CHOOSE.

 Hendrick Gautkes 1671.

The same thyme occurs on another dowry kerchief, dated 1656 (Frisian Museum, Leeuwarden). An undated kerchief of the seventeenth century (Frisian Museum, Leeuwarden) bears the verse:

PRETTY LOVE, PRAY ACCEPT
THE GIFT I GIVE YOU HERE.
ALTHOUGH THE GIFT IS SMALL
YOU KNOW WELL ENOUGH WHAT I MEAN.

 Ian Direks.

1

LIST OF MOTIFS ILLUSTRATED

1 Dowry kerchief, seventeenth century, Frisian Museum, Leeuwarden.

2 Samplers, 1640, private collection.

3 Undated sampler, Zuider Zee Museum, Enkhuizen.

4, 6, 7, 12, 13 Undated sampler, private collection.

5, 18 Undated sampler, Town Museum, Zutphen.

8 Undated sampler, Zaanland Museum of Antiquities, Zaandijk.

9, 17 Undated sampler, NOM, Arnhem.

10 Sampler, 1778, NOM, Arnhem.

11, 16 Undated sampler, private collection.

14, 15 Undated sampler, Zuider Zee Museum, Enkhuizen.

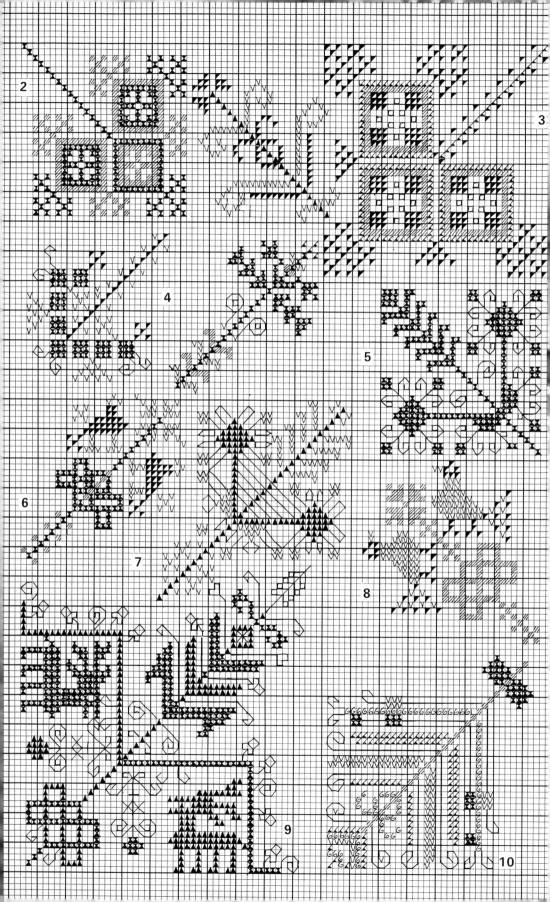

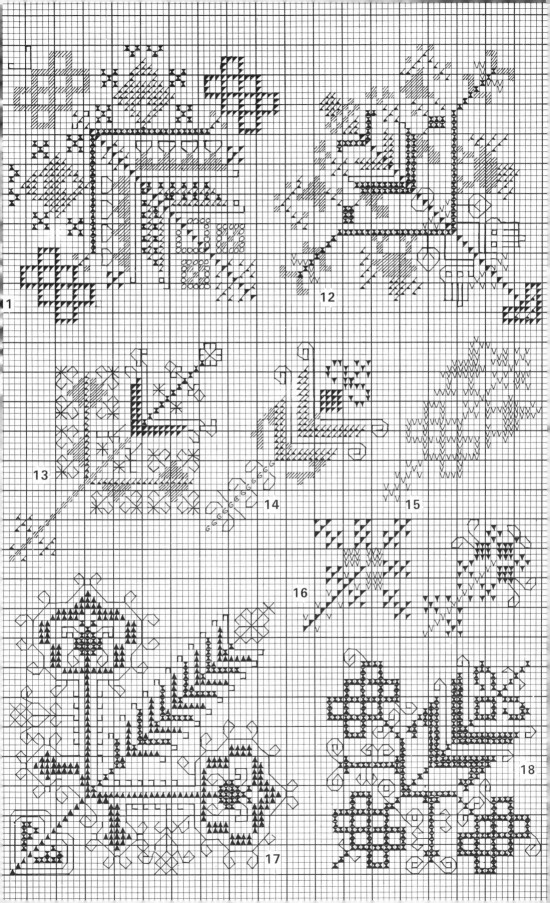

VI House and household goods

Houses and household goods on samplers have no symbolic meaning in my view, with the possible exception of the pothanger. Houses with step-gables or cornices occur frequently and may represent the home of the embroideress. Furniture and other objects, which are connected with the housewife's domestic duties and signify contentment, diligence, domesticity, and hospitality, include a table with a tea-service on it, spinning-wheels and chairs.

Among the various inplements for use on the hearth that are depicted is the pothanger, which was fixed to a beam in the chimney and on which a kettle or a cooking pot could be hung at different heights over the fire. (No. 35). According to an Indo-Germanic custom the bridegroom used to lead his bride round the hearth three times when she first took possession of her new home. Later on, when the hearth was placed against the wall, the pothanger was pulled forward or was hung from a beam in the middle of the room so that they could walk round it. This ancient custom was long kept up in Limburg and Brabant. There are some old rhymes connected with it:

I bring you in the name of the Lord.
What you don't know we'll certainly teach you.
That's for you (the first time), that's
for us (the second time)
That's for the whole company (the
third time).
For a quart of fusel oil you may go free.

I bring you in the name of the Lord.
In this house you will live
Not as a maid but a wife
And so be faithful to your husband.

The pothook or hanger also sym-
bolized the head of the household
and it was thus called 'the lord of
the house' in Iceland and *le maître de*

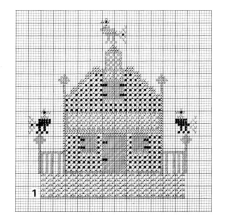

la maison in France. When the head of the household died it was handed down through the male line. Priests were excluded from this, however, since their link with their families was severed when they were ordained.

LIST OF MOTIFS ILLUSTRATED

1 House with pavement, fence and three doves – Sampler, 1787, private collection.

2 Sewing basket – Sampler, seventeenth century, private collection.

3 Top – Sampler, seventeenth century, private collection.

4 House with pavement, fence, tulips and a stork on the chimney – Sampler, 1817, NOM, Arnhem.

5 Summer-house in a garden – Sampler, 1844, NOM, Arnhem.

6 House with trees – Undated sampler, nineteenth century, private collection.

7 House with step-gable, fence, plants and three birds – Sampler, 1802, NOM, Arnhem.

8 House with a stork's nest on the chimneypot – Undated sampler, private collection.

9 Cradle with mother and daughter – Sampler, 1729, private collection.

10 Woman in a house – Undated sampler, private collection.

11a, b Cooking pots – Sampler, seventeenth century, NOM, Arnhem.

12 House with a cornice and two lanterns – Sampler, 1801, private collection.

13 House with its master – Undated sampler, NOM, Arnhem.

14 Teapot on a tea-warmer – Sampler, 1824, NOM, Arnhem.

15 House with step-gable – Undated sampler, private collection.

16 Tea-table – Sampler, eighteenth century, private collection.

17 Table with ball feet and cloth – Sampler, 1773, NOM, Arnhem.

18 Chair – Sampler, 1842, Zuider Zee Museum, Enkhuizen.

19 Chair – Sampler, 1778, private collection.

20 House with fence and flowerpots with carnations – Sampler, 1824, NOM, Arnhem.

21 House with cornice – Sampler, 1801, private collection.

22 Pagoda – Undated sampler, nineteenth century, NOM, Arnhem.

23 Spinning-wheel – Sampler, eighteenth century, private collection.

24 Reel – Sampler, eighteenth century, private collection.

25 Spinning-wheel – Undated sampler, private collection.

26 Press – Undated sampler, private collection.

27 Folding table – Sampler, 1802, private collection.

28 Pipe – Sampler, nineteenth century, private collection.

29 Grandfather clock – Sampler, 1780, private collection.

30a, b, c Domestic scene – Undated sampler, Frisian Museum Leeuwarden.

31 Frisian wall-clock – Sampler, 1778, private collection.

32 Cupboard – Sampler, eighteenth century, private collection.

33 Lantern – Sampler, eighteenth century, NOM, Arnhem.

34 *House with step-gable, street lamp and lamp-lighter* – Sampler, eighteenth century, Frisian Museum, Leeuwarden.

35 *Pothanger or pothook* – Sampler, 1780, private collection.

36 *Firescreen* – Sampler, 1816, NOM, Arnhem.

37 *House with pavement, fence and five doves* – Undated sampler, NOM, Arnhem.

38 *House among trees* – Sampler, 1844, NOM, Arnhem.

39 *House* – Sampler, 1732, NOM, Arnhem.

40 *Scales* – Sampler, 1718, private collection.

41 *Town hall* – Sampler, 1817, NOM, Arnhem.

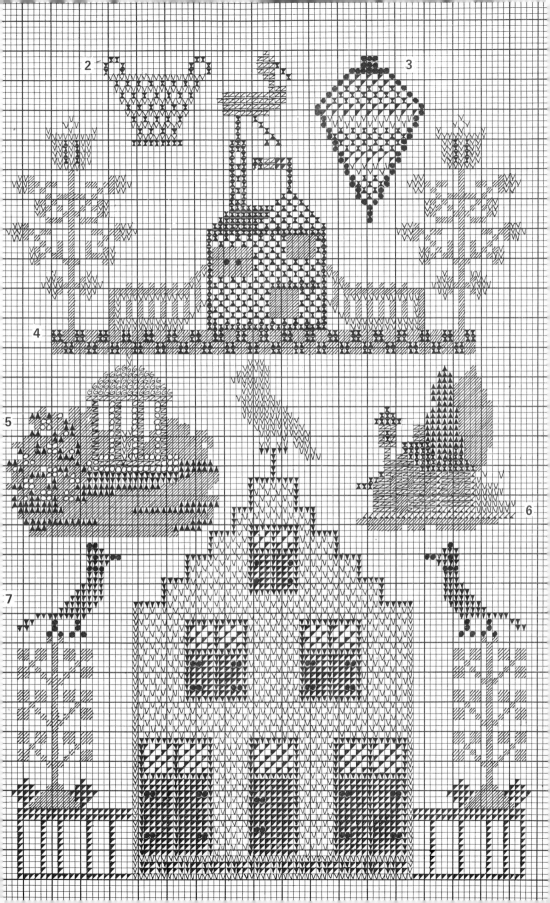

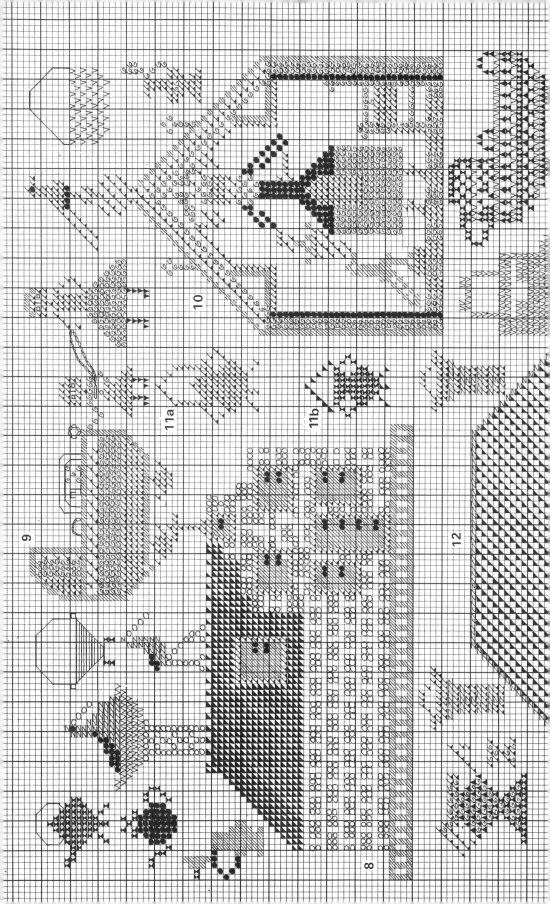

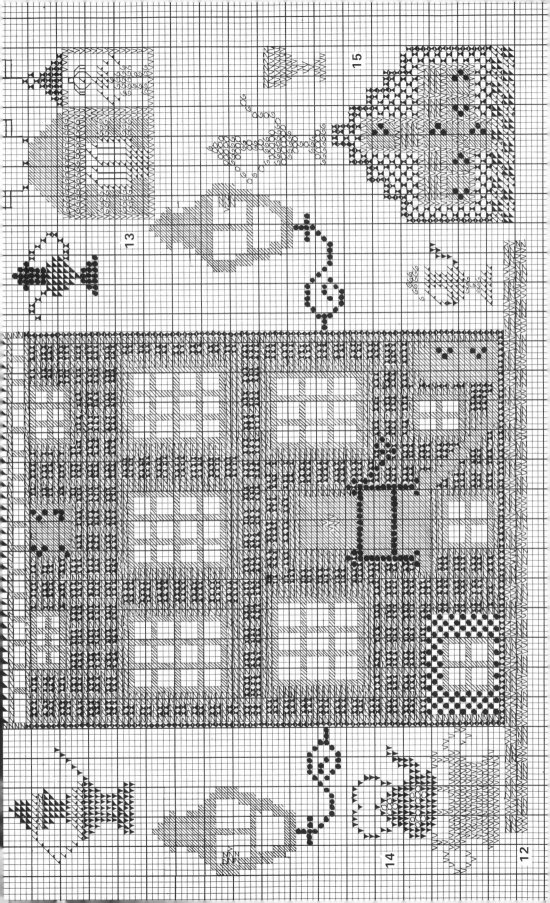

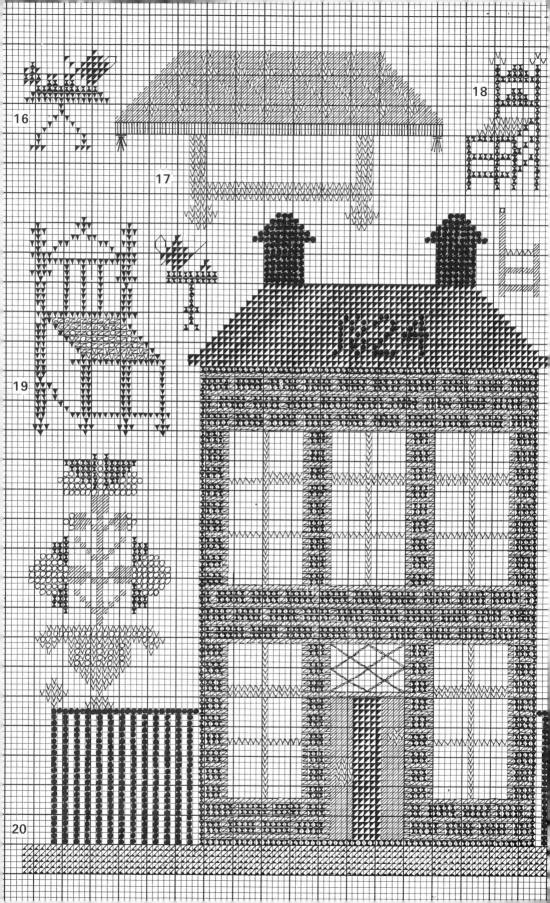

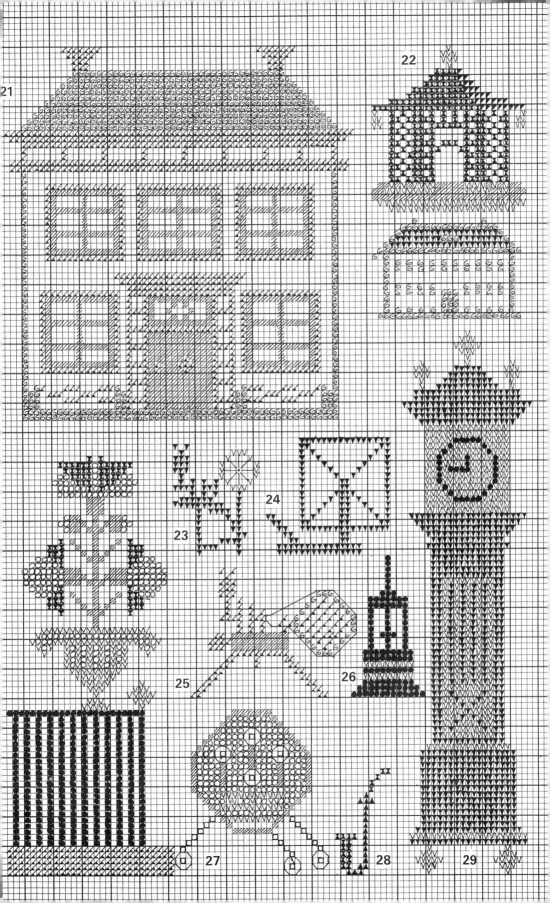

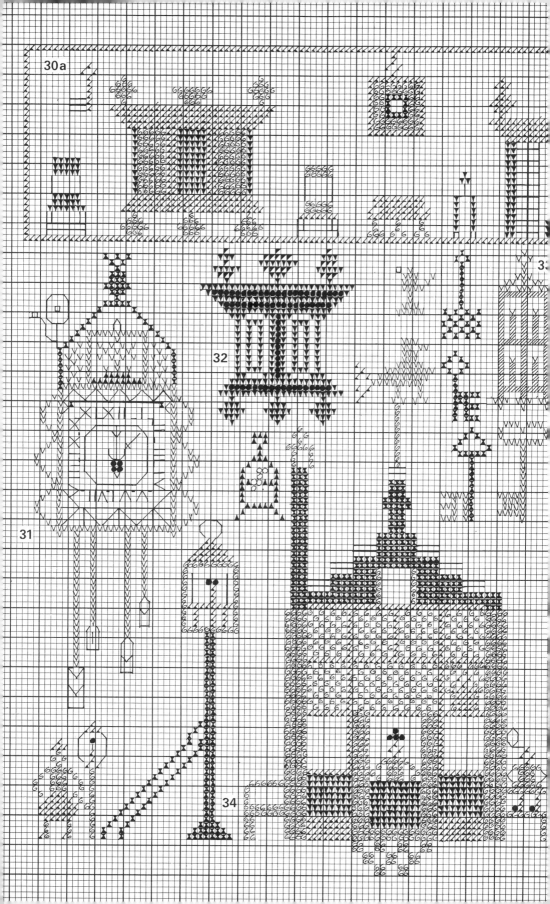

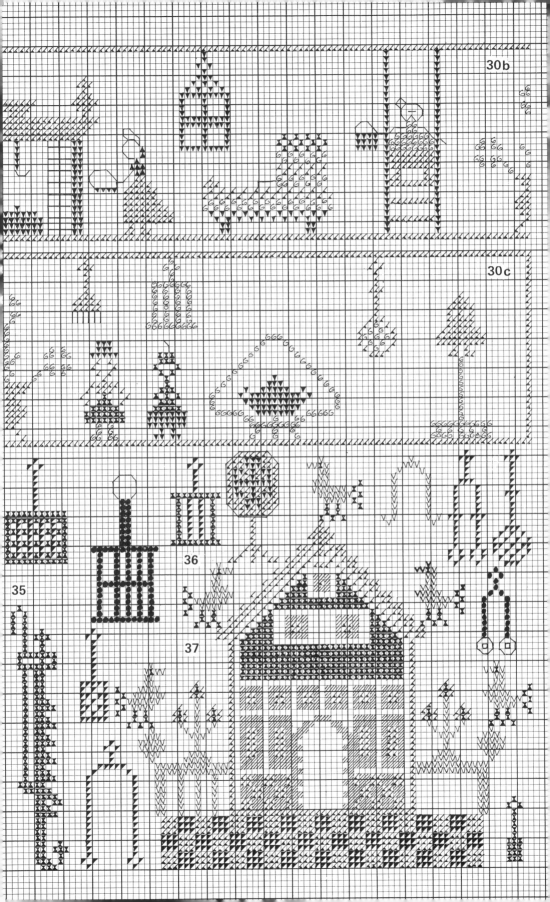

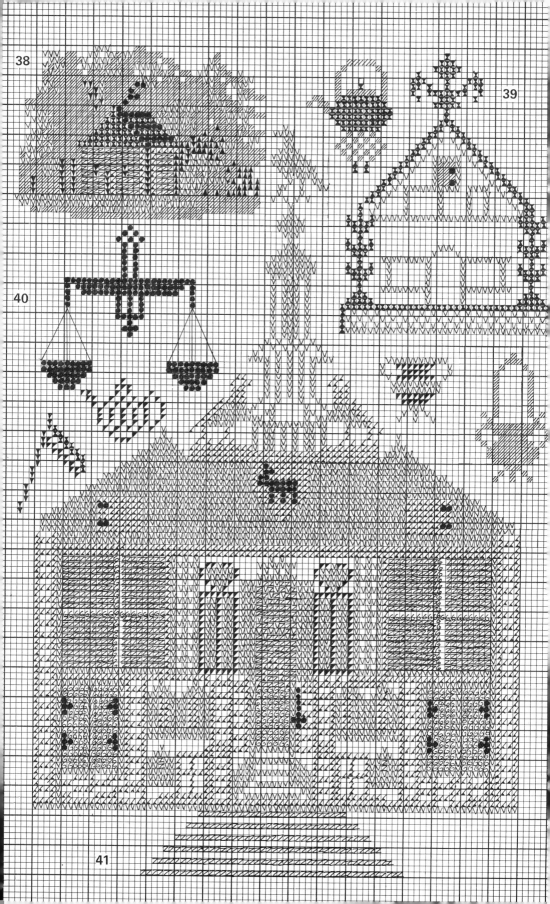

VII Churches, church towers and ecclesiastical objects

Each part of a *church* has a symbolic meaning: the foundations signify faith which accepts without seeing; the roof is love which covers a multitude of sins; the door is obedience; the floor, which allows itself to be trodden underfoot, is humility; the walls are the four natural virtues of justice, prudence, temperance and fortitude; and the windows are cheerful hospitality and liberality.

According to Hugo of St. Victor (a twelfth-century mystic) and Herrad of Landsberg (a late twelfth-century writer) the *dove* (see Chapter III) is a symbol of the Holy Church. The dove has two wings, and the Christian has two ways of life open to him, the *vita activa* (active life) and the *vita contemplativa* (contemplative life); the dove's blue-tinted feathers and its wings represent heavenly thoughts, while the varied and changing hues of the other feathers, reminiscent of a troubled sea, are a symbol of the ocean of human passions on which the ship of the Church is tossed. As for the meaning of the dove's beautiful golden-yellow eyes, yellow is the colour of ripe fruits, of experience and of mature consideration and thus they remind us of the wise gaze with which the Church surveys the future. Finally, the dove's red feet indicate how the Church strides through the world, its feet red with the blood of martyrs.

According to Honorius of Autun (a twelfth-century scholar), the *church tower* rising aloft (Nos. 13, 19) symbolizes clearly audible preaching, which points the way to heaven, or those in high places in the Church, whose duty it is to preach. The tower is also regarded as a symbol of the Holy Church and of the Blessed Virgin.

The *round ball* below the cross on the tower reminds us that the Catholic faith must be promulgated and lived out in all its perfection and integrity

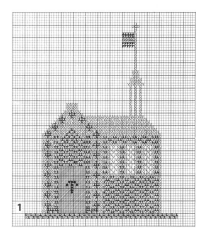

since he who falls short of this ideal is lost.

The *cross* that crowns the tower indicates that the preacher preaches in vain if he does not believe in a mediator who lends him support. At the same time it warns us that we must not glory in anything but the Cross of Christ.

The *weathercock* (Nos. 19, 22, 25, 27, 31) on the tower is a symbol of the preacher, for just as it always turns into the wind, so the preacher turns on rebels, recalcitrants and the enemies of the Church.

The symbolism of *bells* is similar to this, for they stand for the preachers who call the faithful to believe, while their ringing is the doctrine the preachers proclaim.

The *altar-cross* (No. 32a) between two candles shows how Christ stands in the church as the mediator between Jews and Gentiles, uniting them as the True Cornerstone.

The *candlestick* (Nos. 6, 7; see also Chapter XIX, No. 1) represents Christ, Who is a Light to everyone who comes into the world.

The *candle* (Nos. 3, 6, 7) is also a symbol of Christ: the wax is the pure flesh of the Redeemer born of a Virgin, the wick is the soul of the God-man, and the light of the candle is His divinity.

The *monstrance* (Nos. 3, 5, 8, 11, 12, 26, 32b). If the sun was in pagan eyes the godhead itself, in Christian iconology the sun's rays were the attribute of the Supreme Being. Thus the form of a radiant sun is frequently used for monstrances, vessels of precious metal in which the Host is exposed supported on a holder in the form of a crescent moon (symbol of the Mother of God).

LIST OF MOTIFS ILLUSTRATED

1 Church with a flag flying from the tower – Sampler, 1816, NOM, Arnhem.

2 Church – Undated sampler, private collection.

3 Monstrance, candlesticks, chalices and flagons – Sampler, 1780, private collection.

4 Church – Undated sampler, private collection.

5 Monstrance – Sampler, 1801, private collection.

6 Candlestick – Sampler, 1852, NOM, Arnhem.

7 Candlestick – Undated sampler, NOM, Arnhem.

8 Monstrance – Sampler, 1852, NOM, Arnhem.

9 Church with weathercock – Sampler, 1765, West Friesland Museum, Hoorn.

10 Church with the sexton, a flag on the tower and a dove on the roof – Sampler, 1822, NOM, Arnhem.

11 Monstrance – Sampler, 1789, NOM, Arnhem.

12 Monstrance – Sampler, 1852, private collection.

13 Church tower and church – Sampler, 1782, L.v.M.M., Delft.

14 Bible, missal, chalice and cross – Sampler, nineteenth century, NOM, Arnhem.

15 Church – Sampler, 1709, NOM, Arnhem.

16 Church – Sampler, nineteenth century, NOM, Arnhem.

17 Church (see Pl. ii, facing p. 25) – Sampler, 1670, private collection.

18 Candlesticks and vases of flowers – Sampler, 1853, NOM, Arnhem.

19 Church tower with weathercock – Sampler, 1640, private collection.

20 Church and rectory – Sampler, nineteenth century, NOM, Arnhem.

21 Church among trees – Sampler, 1844, NOM, Arnhem.

22 Church with weathercock and bird – Sampler, 1787, private collection.

23 Church among trees – Sampler, 1844, NOM, Arnhem.

24 Church with the sexton ringing the bells – Sampler, 1780, private collection.

25 Church with a weathercock on the tower – Sampler, seventeenth century, Zaanland
 Museum of Antiquities, Zaandijk.

26 Monstrance with the dove of the Holy Ghost – Sampler, 1798, NOM, Arnhem.

27 Church with a weathercock on the tower – Undated sampler, Zaanland Museum
 of Antiquities, Zaandijk.

28 Church – Sampler, 1852, NOM, Arnhem.

29 Church – Sampler, 1828, NOM, Arnhem.

30 Church – Sampler, 1789, NOM, Arnhem.

31 Church with weathercock – Sampler, 1789, NOM, Arnhem.

32a, b Altar cross and monstrance – present whereabouts of this sampler unknown.

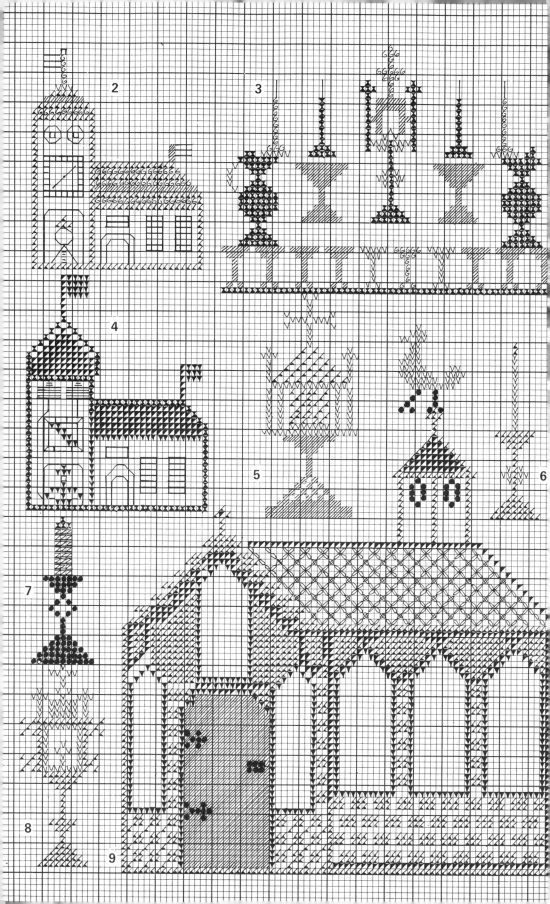

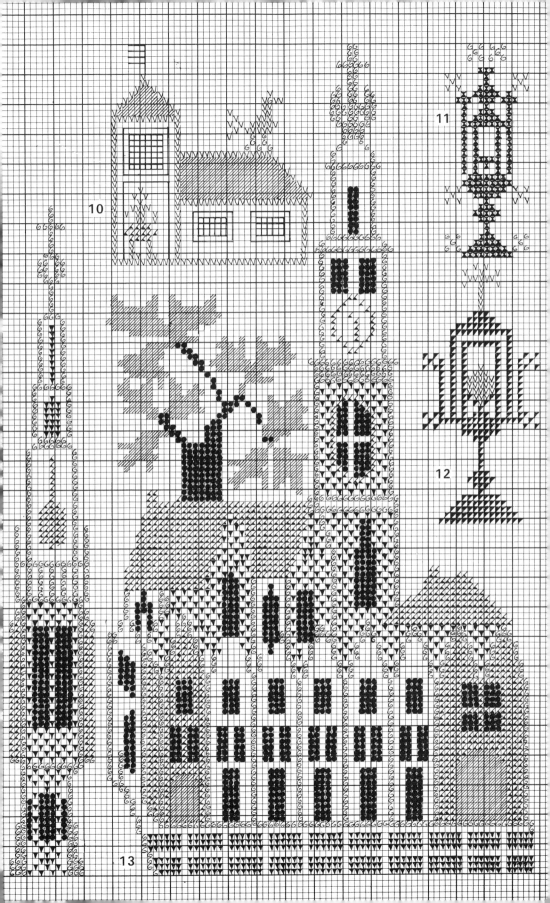

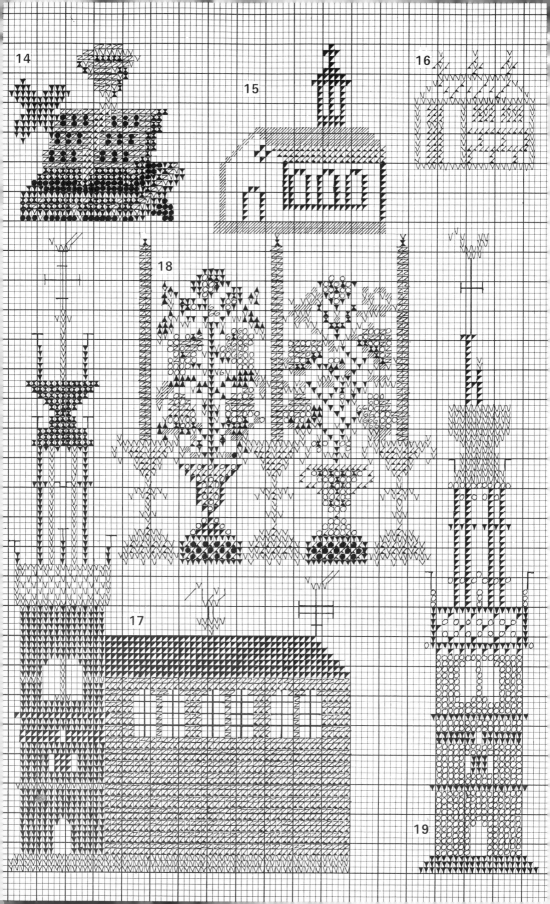

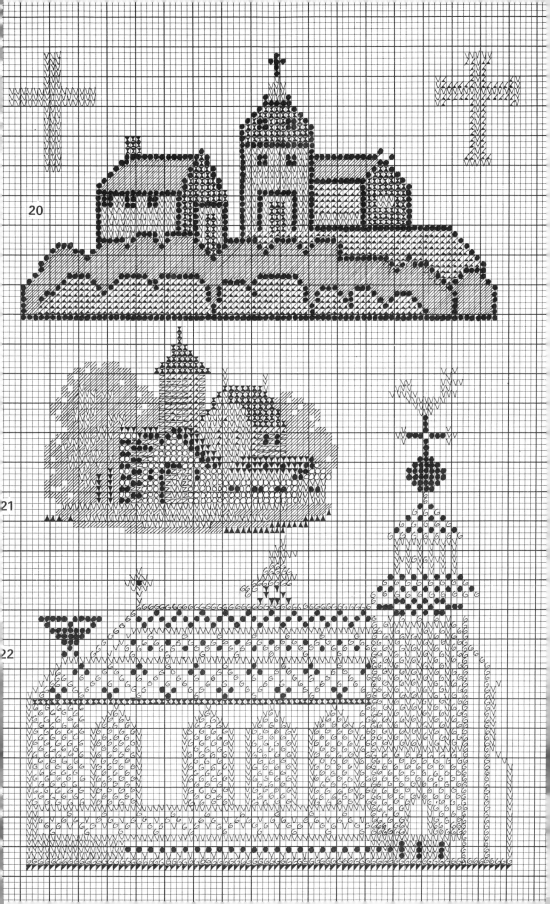

20

21

22

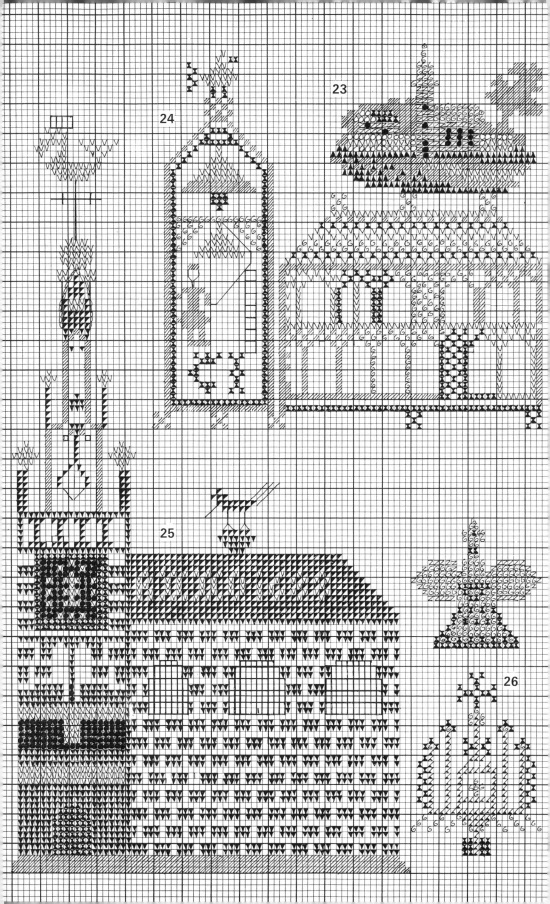

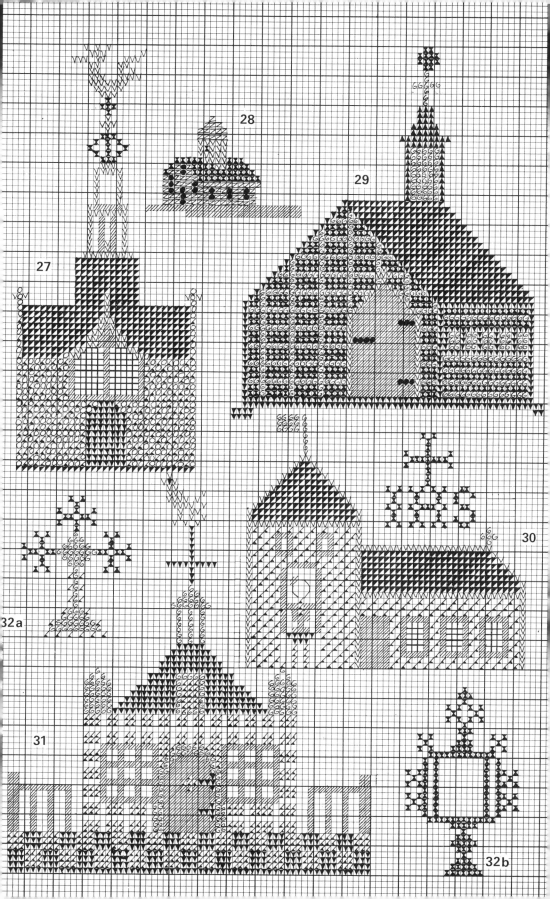

VIII Garlands, garlands with angels, crowns and cartouches

Garlands. In early Christian art marriage was sometimes represented by a couple holding out their hands to each other across a book, with Christ standing behind them and crowning them both with garlands. On samplers we frequently find a man and woman holding a garland between them (see Chapter XVI, No. 11 and Pl. II, facing p.25). The garland is also used as a symbol of victory, while a garland of roses is the symbol of highest merit.

Until the time of Constantine *angels* were depicted simply as men or youths without any attributes, but from the end of the fourth and beginning of the fifth century we find angels with wings. The earliest occur on North African reliefs. Angels with trumpets represent the voice of God announcing the Day of Judgement (No. 6; Revelations 8). On samplers we also find angels holding palm-branches (No. 9), which in early Christian art simply symbolised victory in the sence of the successful completion of life, only later coming to stand for martyrdom. The winged cherubs' heads, which became so popular at the beginning of the Renaissance, probably originated as far back as early Christian times.

A *crown*, like a garland, a ring or a circle symbolizes eternity. It would probably make a child brought up on the Bible recall the words of Revelations 2 : 10: '...be thou faithful unto death, and I will give thee a crown of life', but its great popularity as an ornament arose from the earliest pattern-books and later on from the veneration of the Virgin. For the devout young daughters of the household the crown and the garland were symbols of the innocence both of the heavenly bride and of earthly brides.

On samplers we often find crowns of different kinds, comparable to heraldic crowns: *Crowns of rank:*

1

1 Prince's crown

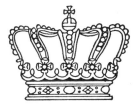

2 King's crown

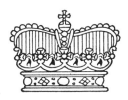

3 Duke's crown

4 Marquis' crown

5 Count's crown

6 Viscount's crown

7 Baron's crown

8 Knight's crown

9 Squire's crown

Cartouches frequently occur on darning samplers. They are derived from the cartouche-shield of the time of Henri II of France (second half of the sixteenth century) (Nos. 14, 15, 16, 17, 18, 19).

LIST OF MOTIFS ILLUSTRATED

1 Garland of rosebuds – Sampler, 1852, NOM, Arnhem.

2 Oval garland – Sampler, 1827, NOM, Arnhem.

3 Garland in the form of an eight-pointed star – Sampler, 1827, NOM, Arnhem.

4 Garland of roses – Undated sampler, private collection.

5 Garland of rosebuds and bell-like flowers – Darning sampler, 1871, NOM, Arnhem.

6 Garland of roses with angels blowing trumpets – Sampler, 1841, NOM, Arnhem.

7 Two birds in a garland of roses with crowned angels – Sampler, 1834, Zuider Zee Museum, Enkhuizen.

8 Garland of rosebuds – Sampler, 1750, NOM, Arnhem.

9 Crowned heart with crowned angels with palm-branches – Sampler, 1827, private collection.

10 Garland of roses – Sampler, 1822, Museum of the Province of Overijssel, Zwolle.

11 Cartouche – Undated sampler, private collection.

12 Crown with angels – Undated sampler, NOM, Arnhem.

13 Garland of rosebuds – Darning sampler, 1825, NOM, Arnhem.

14 Cartouche in four-sided stitch – Darning sampler, 1843, NOM, Arnhem.

15 Cartouche – Sampler, 1802, private collection.

16 Garland of roses – Sampler, 1817, NOM, Arnhem.

17 Cartouche – Undated sampler, private collection.

18 Cartouche – Darning sampler, 1790, NOM, Arnhem.

19 Cartouche in four-sided stitch – Darning sampler, 1843, NOM, Arnhem.

IX Alphabets and letters

There is part of an alphabet in Schönsperger's second pattern-book, published in 1524, while in Peter Quentel's pattern-book, published in 1529, there are two alphabets, one very similar to Dürer's Gothic lettering, and the other in plain Roman characters. There is also a Roman alphabet in *La vera perfettione del disegno* (Venice, 1591), a pattern-book by the Italian, Giovanni Ostans. Two alphabets for working in cross stitch are given by Rosina Helena Fürst in her *Das neue Model Buch*, Nuremberg, 1666-1728 (there is an original edition of this book in the Röhsska Konst Slöjdmuseet, Goteborg). So far, however, none of these alphabets has been found on any samplers in Holland. This is something that needs to be studied.

The letters x, y and z are often missing on samplers and a single letter is used for u and v (see Nos. 2, 3 and 16) and for I and J (see Nos. 2, 3, 4, 5, 7, 8, 10, 13 and 16). In Nos. 3, 5, 7, 8, 10, 13 and 16, however, the letter q is omitted and the letters x, y and z are included, and in No. 2 the q is a reversed p and y and z are included. The omission of letters can usually be explained on practical grounds. The letters u or v, for example, were left out since they could be worked out from the w.

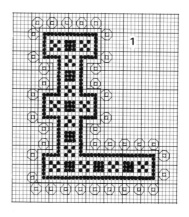

LIST OF MOTIFS ILLUSTRATED

1 Letter L – Sampler, 1708, private collection.

2 Alphabet and figures 1 to 0 – Sampler, 1670, private collection.

3 Alphabet (minus q and x) – Sampler, seventeenth century, NOM, Arnhem.

4 Alphabet – Sampler, 1874, private collection.

5 Alphabet (minus q) – Sampler, 1664, private collection.

6 Tree of life with the initials B and J – Sheet, 1717, private collection.

7 Alphabet (minus q) – Sampler, 1802, private collection.

8 Alphabet (minus q) – Sampler, 1664, private collection.

9 Tree of life with initials PK and BT – Sampler, 1802, private collection.

10 Alphabet (minus q) – Sampler, 1691, private collection.

11 Border – Sampler, seventeenth century, private collection.

12 Tree of life with the initials A and H – Sampler, undated, private collection.

13 Alphabet (minus q) – Sampler, 1664, private collection.

14 Initials P.D. – Sampler, 1810, private collection.

15 Tree of life – Sampler, first half of the eighteenth century, NOM, Arnhem.

16 Alphabet (minus q) – Sampler, 1764, private collection.

17 Three motifs – Sampler, eighteenth century, Zuider Zee Museum, Enkhuizen.

18 Border – Undated sampler, Zaanland Museum of Antiquities, Zaandijk.

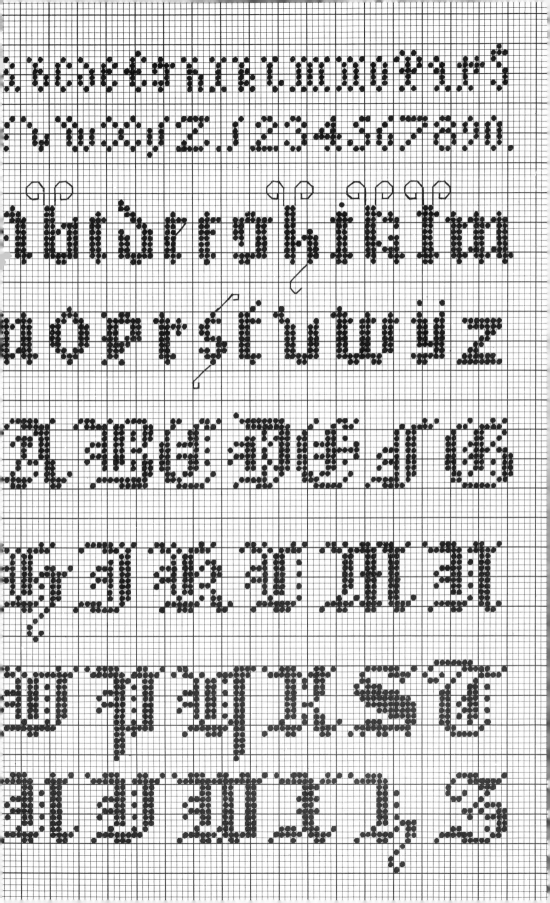

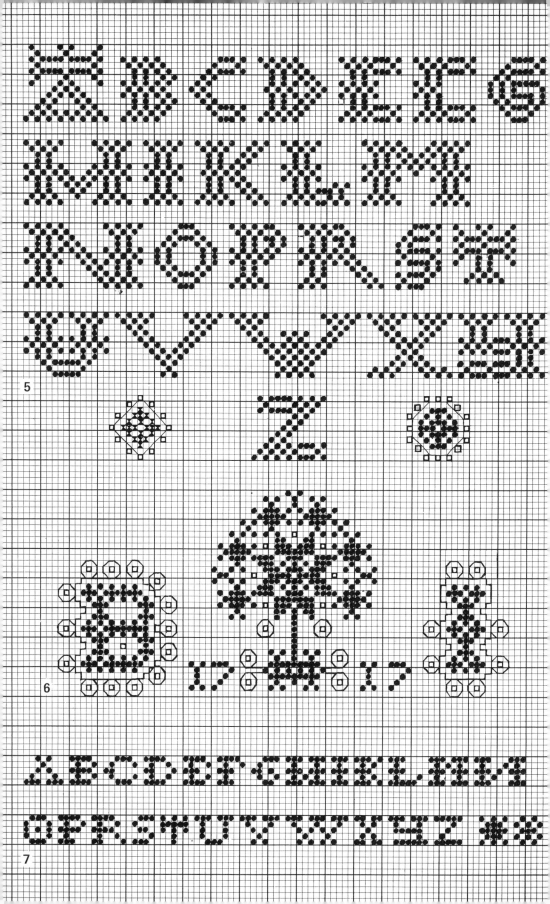

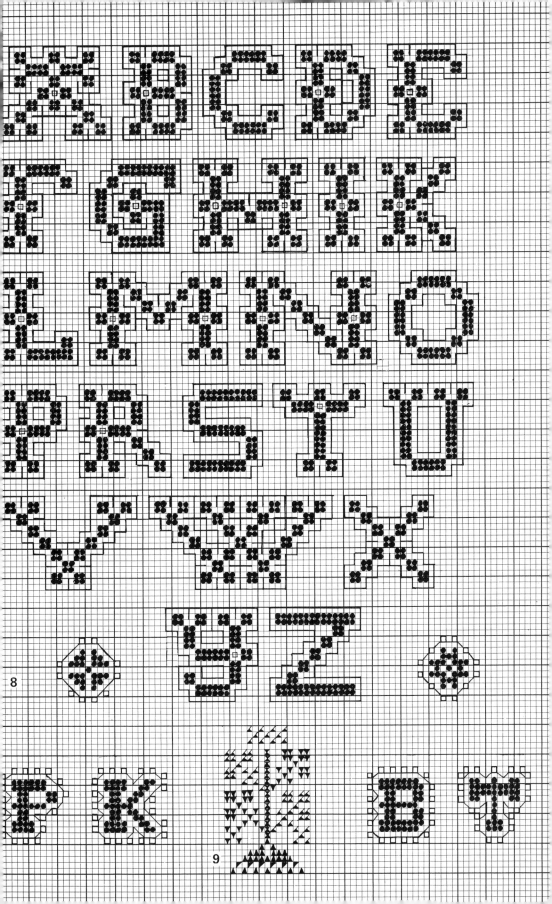

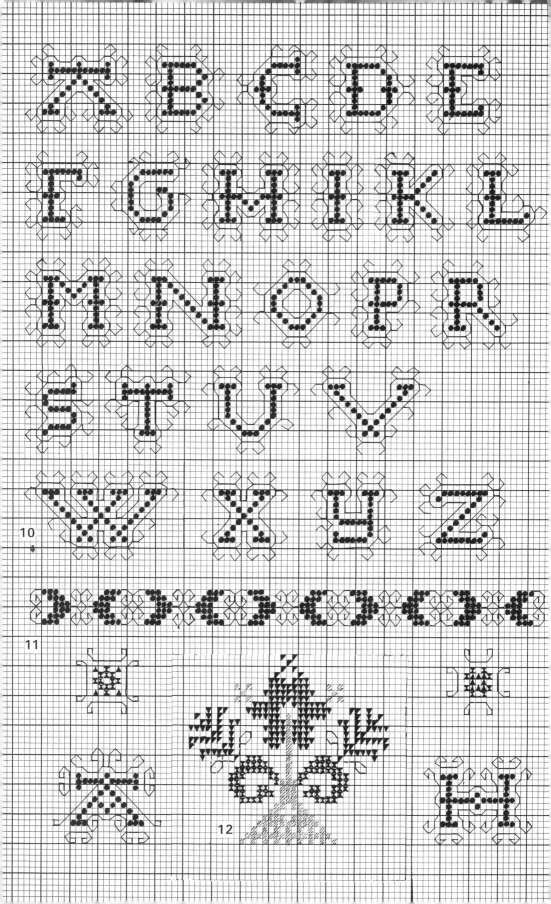

10

11

12

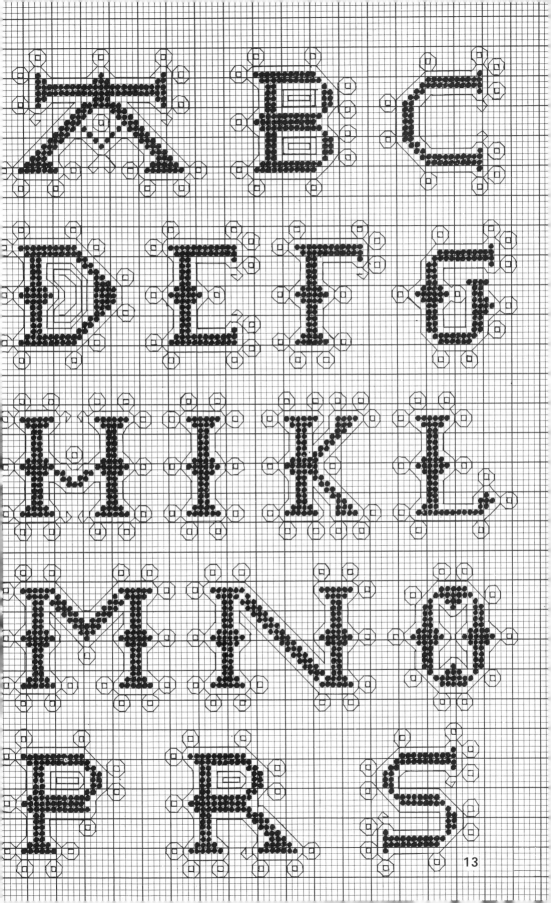

13

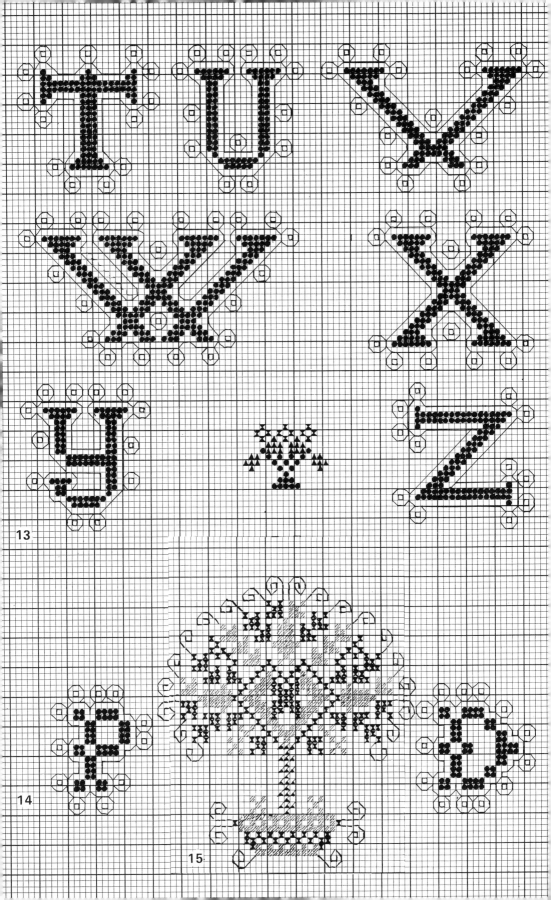

13

14

15

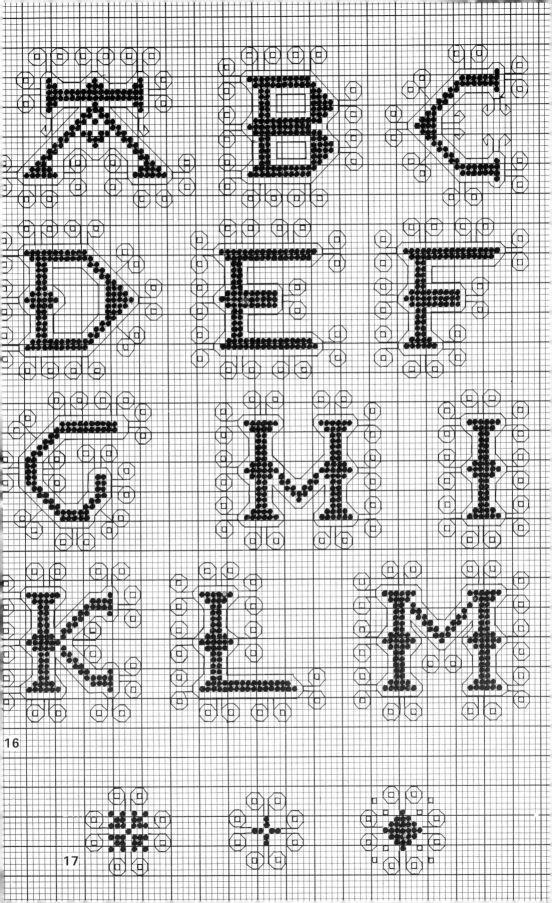

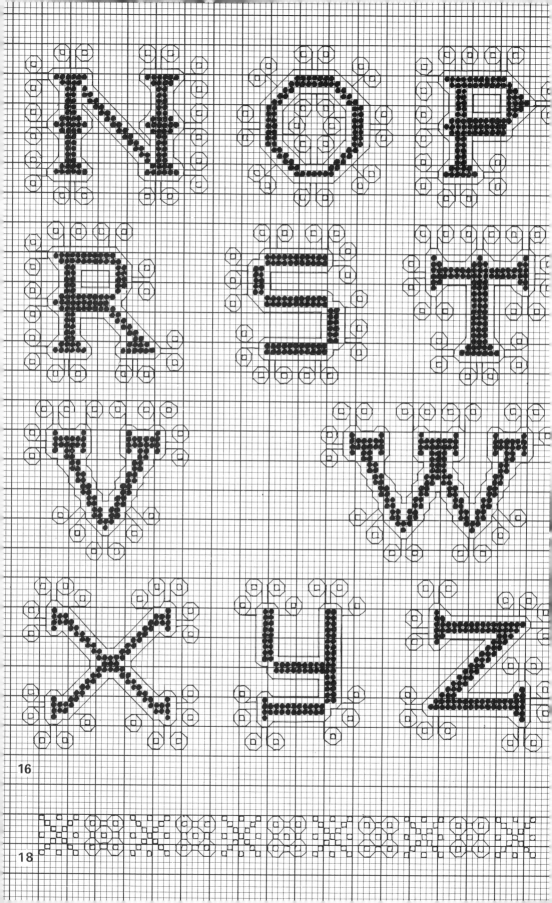

16

18

X The tree of life

The *tree of life* has for centuries been one of the commonest motifs on samplers. It is found in all manner of forms, sometimes on its own, sometimes flanked by animals, human figures or initials, sometimes with a heart in the centre or with its crown encircled by birds, sometimes growing out of a triangular base, or in a pot or urn. Something of its history and symbolism is given below.

In Egypt the tree of life was identified with the tall sycamore, a type of wild fig tree that grows there and in Asia Minor. The gods lived in its branches and its fruit was eaten by them and by dead kings and the blessed, for whom it was literally the bread of life. In Mesopotamian literature we find a tree of a different kind, which has its origin in light: it stands at the eastern edge of the world where the sun rises. It sometimes occurs flanked by goats, a motif that is also found among the Hittites. In Assyrian art this solar tree is often depicted with supernatural winged figures on either side. The fruit tree was also regarded as sacred. In Persian legend there was a tree which bore the seeds of all living plants, thus maintaining plant life on earth; the seeds were carried away and scattered by birds, which perhaps explains why the tree of life is so often flanked by birds.

It is sometimes shown being revered or guarded by other figures, either animal or human, but birds are certainly the most common, particularly on samplers. In fact this age-old motif can nearly always be found even today in places where any sort of folk art still persists. It was not, however, very common in the East, at least, as far as we can tell from the few Egyptian and Sassanid woven textiles that have survived and from the Byzantine textiles influenced by them, though we might think very differently if we could see, for instance, a Babylonian weaver's pattern-book. The tree flanked by birds is, nonetheless, the oldest form. It has survived because of its simplicity and be-

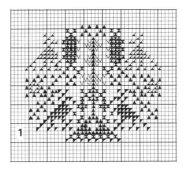

cause the form of the tree itself is rather vague and it can thus be adapted to suit any design.

In Classical times the tree was depicted with a goat greedily stretching up to its branches round which a snake was coiled. This is a piece of oriental symbolism: goats turn up beside a tree with a snake on a Sassanid dish, but it is by no means unusual to find oriental motifs in Classical art. The tree flanked by goats in fact reached Europe at the beginning of the Iron Age. Somewhat later in Classical times we find trees standing on a little mound which has a scale-like pattern, indicating that it is a mountain. This was an old way of representing rocky terrain, which was also used in Mesopotamia. On samplers the tree of life often has a triangular base. The tree is, of course, always stylized and it is rarely, if ever, possible to say what kind of tree the artist had in mind, though sometimes he seems to have been thinking of a palm tree.

In Greek mythology we find the tree of life in the Garden of the Hesperides, *i.e.* in the West (*hesperia* = west), which was the Kingdom of the Dead, being also equated with the Land of the Living. There the tree is depicted with the golden apples that confer immortality. We also come across the tree of life with fruit that confers immortality in the Bible story of Paradise, together with the tree of the knowledge of good and evil, the forbidden fruit of which led to the Fall. In Revelations 2:7 St. John writes: '...To him that overcometh will I give to eat of the tree of life, which is in the midst of the paradise of God,' and in Chapter 22 we read of 'the river of the water of life, ...proceeding out of the throne of God...' and of '...the tree of life, which bare twelve manner of fruits' growing on the bank of the river.

These religious and magical associations of the tree must arise from some profound inner need in man who sees that even under apparently adverse conditions it manages by some hidden means to survive. At the time of the French revolution the tree became a focus of revolutionary fervour as a symbol of liberty and of the dawn of a new era for which people were engaged in what seemed a kind of holy war. They expressed their joy and their new feeling of community by dancing round the tree of liberty. In so doing they were unconsciously carrying on the ancient tradition of religious dances round sacred trees found among people of different ages and cultures. In the *Rig Veda*, the most important of the early sacred writings of the Hindus, trees are called 'divine mothers'. They are the bearers and renewers of life and the lives of people and trees were thought of as being closely bound up together. In fact, the religious feeling for nature is much older than the aesthetic. When a child was born a tree was planted and its growth or decay determined the progress or otherwise of the child.

The tree of the universe (Yggdrasil) is also one of the oldest emblems of life. It was an ash tree which had its roots in the underworld, while its branches

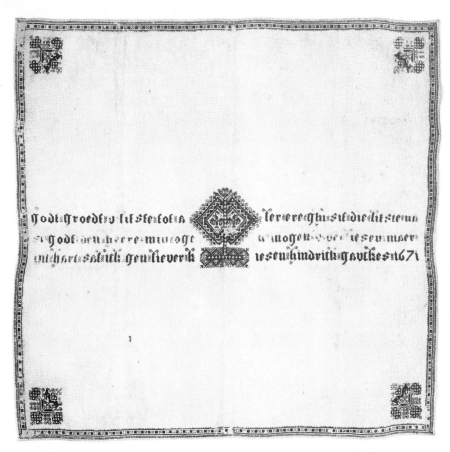

7 *Dowry kerchief, 1671; dark-brown silk on linen (30 threads to the square centimetre) ; cross stitch; 45 × 48 cm.*
NOM, Arnhem

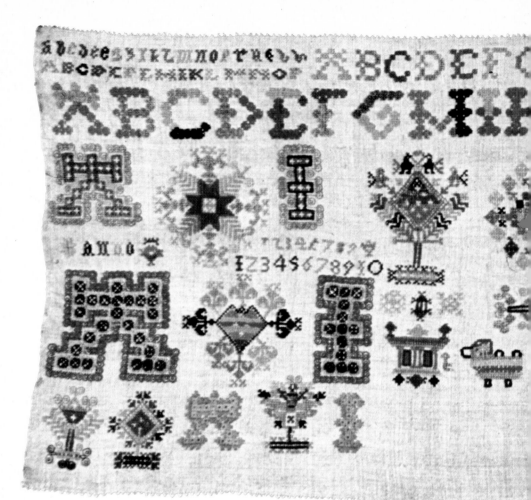

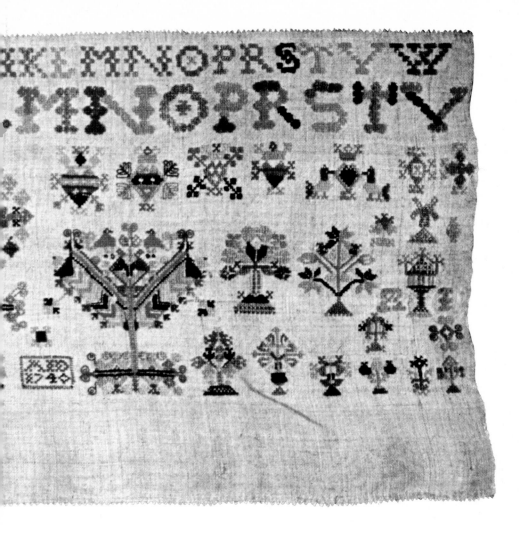

IV Sampler, 1740; wool on linen; cross and flat stitches, eyelet holes and overcasting. Frisian Museum, Leeuwarden

8 Unknown artist: 'Woman from Hensbroeck', 2nd half of the sixteenth century; panel; 43.5 × 31.5 cm

reached up to the highest clouds. Our forefathers regarded it as a symbol of the universe and as the symbol of life *par excellence*. Between them and this sacred tree there was a strong bond which even the advent of Christianity has not been able to sever completely. Many people still cherish in their hearts an unspoken reverence for some ancient oak or lime on an old village green. The may tree and the Christmas tree take us back to the tree of life and so, too, does the weeping willow which, with its drooping branches, so movingly symbolizes the sorrow and dejection of the bereaved (see Chapter XIX, No. 7).

In many cases the tree of life rises out of a vase or an urn (the source of life). Sometimes, however, it grows out of a heart, an old symbol for mother earth, and is accompanied by birds and stags as 'animals of the sun'.

LIST OF MOTIFS ILLUSTRATED

1 Tree of life with four birds – Sampler, 1670, private collection.
2 Tree of life with two doves – Undated sampler, private collection.
3 Tree of life – Sampler, 1670, private collection.
4 Tree of life with two birds – Sampler, 1670, private collection.
5 Tree of life with flowers (representing the wild fig tree or sycamore) and six birds – Sampler, 1692, Zaanland Museum of Antiquities, Zaandijk.
6 Palm branch – Sampler, 1822, NOM, Arnhem.
7 Tree of life – Undated sampler, private collection.
8 Tree of life – Sampler, eighteenth century, NOM, Arnhem.
9 Tree of life – Sampler, seventeenth century, private collection.
10 Tree of life with four birds – Sampler, seventeenth century, NOM, Arnhem.
11 Tree of life – Undated sampler, NOM, Arnhem.
12 Tree of life – Sampler, 1664, private collection.
13 Tree of life with two birds – Sampler, 1670, private collection.
14 Tree of life with two birds – Undated sampler, Zuider Zee Museum, Enkhuizen.
15 Tree of life – Sampler, seventeenth century, NOM, Arnhem.
16 Tree of life with two carnations and six birds – Pillowcover, 1816, private collection.
17 Tree of life with roses and two birds – Sampler, seventeenth century, NOM, Arnhem.
18 Tree of life – Sampler, 1788-90, NOM, Arnhem.
19 Tree of life – Undated sampler, Zuider Zee Museum, Enkhuizen.
20 Tree of life with flowers and two dogs – Sampler, 1703, Frisian Museum, Leeuwarden.
21 Tree of life – Sampler, 1670, private collection.
22 Tree of life – Sampler, 1810, private collection.
23 Tree of life – Sampler, 1832, private collection.

24 *Tree of life* – Undated sampler, private collection.
25 *Tree of life* – Undated sampler, NOM, Arnhem.
26 *Tree of life with a flower and leaves* – Undated sampler, NOM, Arnhem.
27 *Tree of life* – Tablecloth, 1872, NOM, Arnhem.
28 *Tree of life with flowers* – Undated sampler, NOM, Arnhem.
29 *Tree of life* – Undated sampler, Zuider Zee Museum, Enkhuizen.
30 *Tree of life* – Sheet, nineteenth century, NOM, Arnhem.
31 *Tree of life with three leaves on stalks* – Sampler, 1670, private collection.
32 *Tree of life* – Sampler, 1670, private collection.
33 *Tree of life* – Undated sampler, NOM, Arnhem.
34 *Tree of life* – Undated sampler, NOM, Arnhem.
35 *Tree of life with flowers* – Sampler, 1638, private collection.
36 *Tree of life* – Undated sampler, NOM, Arnhem.

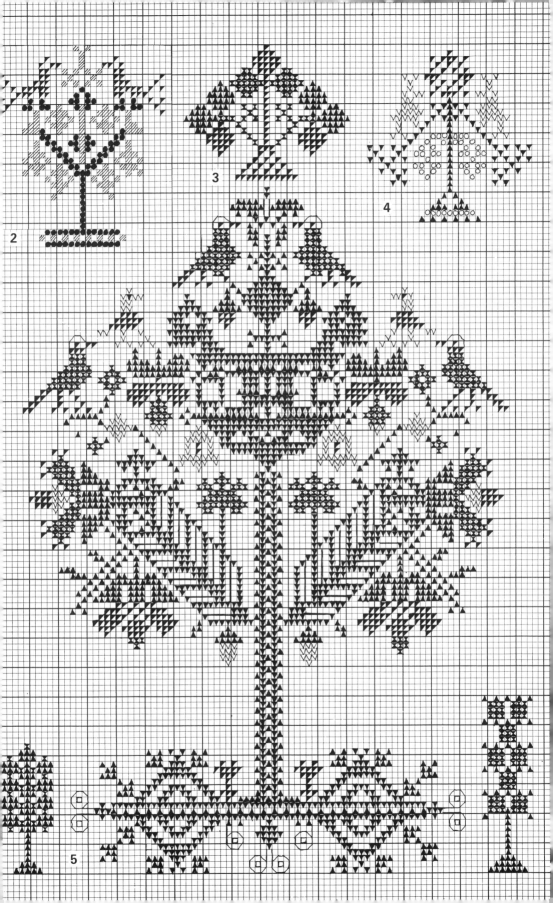

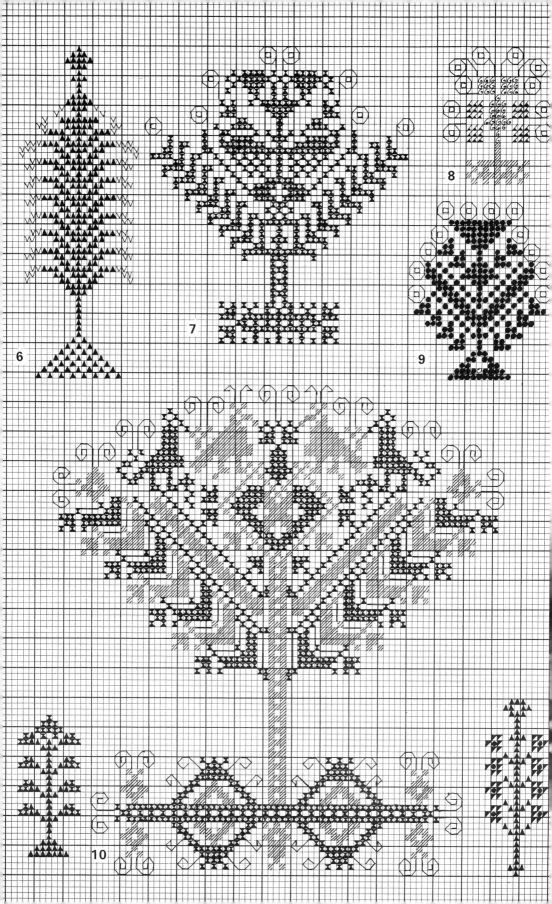

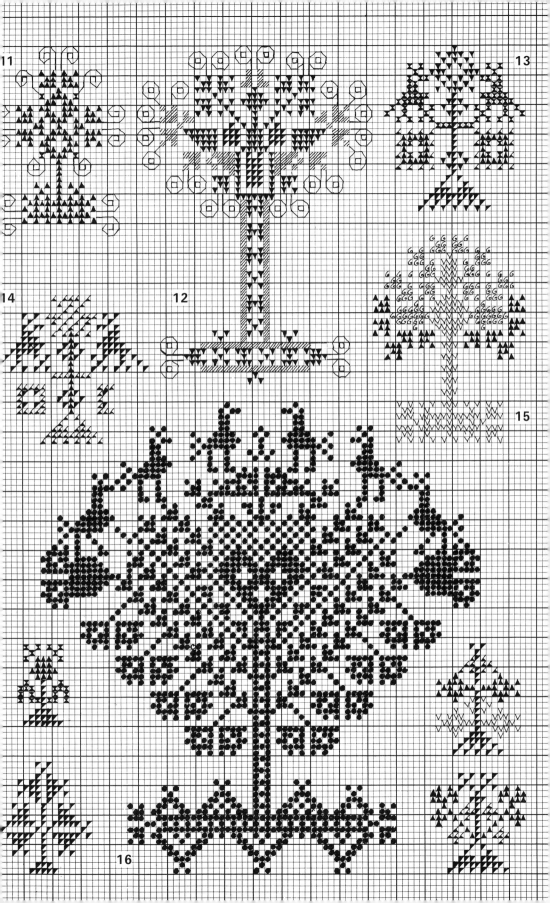

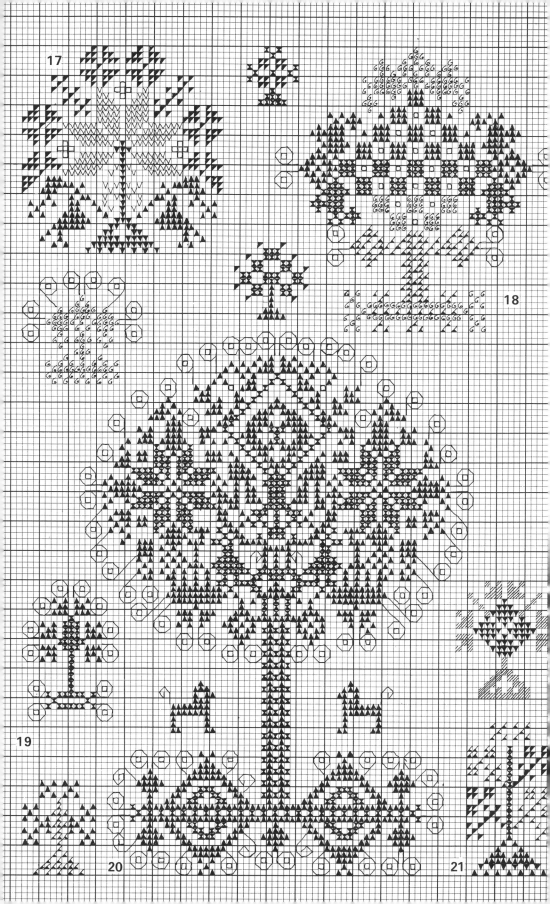

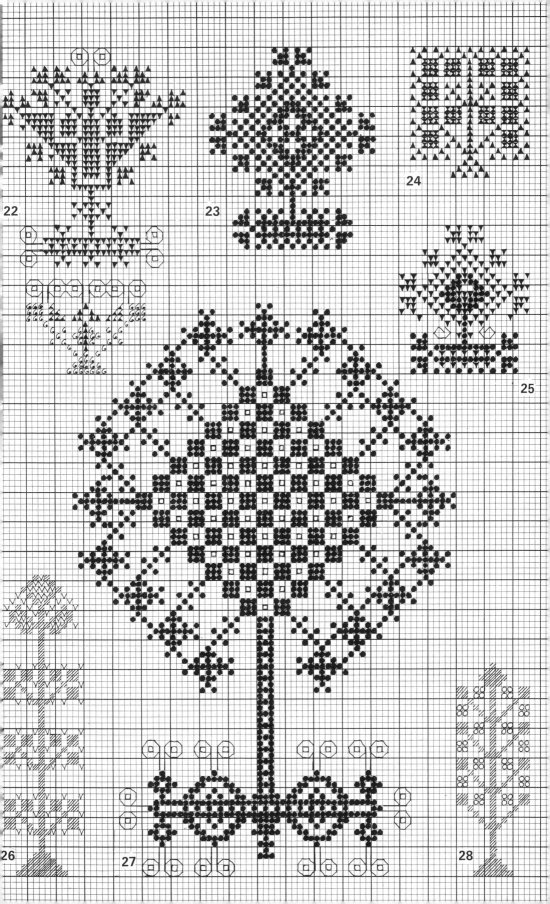

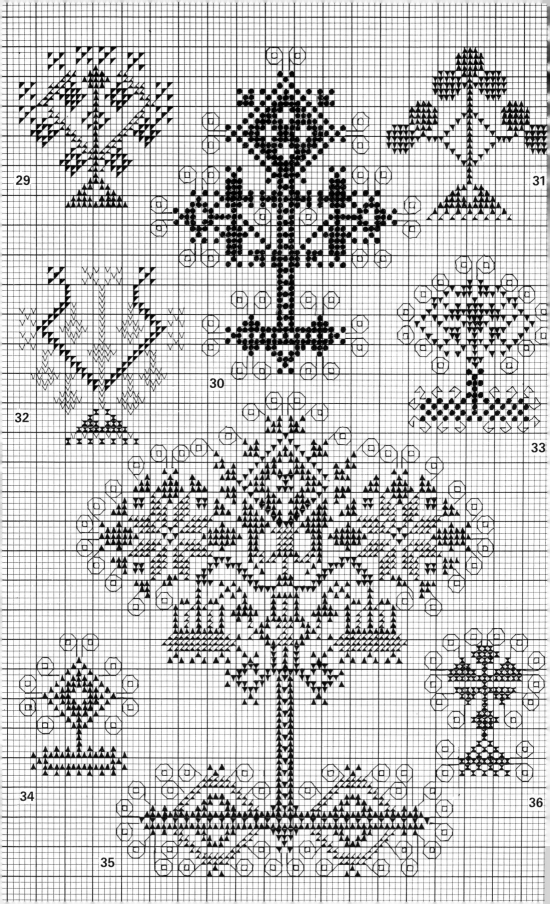

XI Windmills

How the windmill originated or when it came into being cannot be said for certain. There are, however, records of windmills in Haarlem in 1274, in Lochem in 1294 and in St. Oedenrode in 1299. The earliest type of windmill was the post mill, a wooden structure supported on a single, stout, vertical post, which was used for grinding corn. A variant of this was the hollow post mill, the earliest example of which dates from as far back as 1414. A completely different type of mill, which appeared in the fifteenth century, was the stone tower mill.

After 1450 hollow post mills were found mainly in the province of South Holland and it was not until the sixteenth century that these and other types of mill spread to the rest of the Netherlands. In the first half of the seventeenth century the windmill was developed to such an extent that it became possible to use it for other purposes as well as grinding corn.

On samplers the most common types of windmill, usually shown with sails spread out crosswise, are the post mill, either open or closed, and the hollow post mill. In the northern provinces horse mills were often depicted on samplers, with the farmer's wife attending to her churn, while the horse gets on with his share of the work (see Chapter XVI, Nos. 5 and 9). There are all sorts of popular rhymes about mills, for example:

How it hums and rustles in my ears
When I hear it grinding once again.
The sails swing round, cleaving the air,
The cogs fly through the staves.
Oh, how a miller has to slog and slave
When everything's going at such a lick.

Four great lords
In long white robes
They run till they're out of breath
But they can't catch each other.

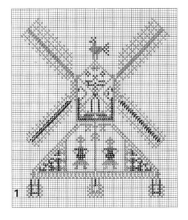

LIST OF MOTIFS ILLUSTRATED

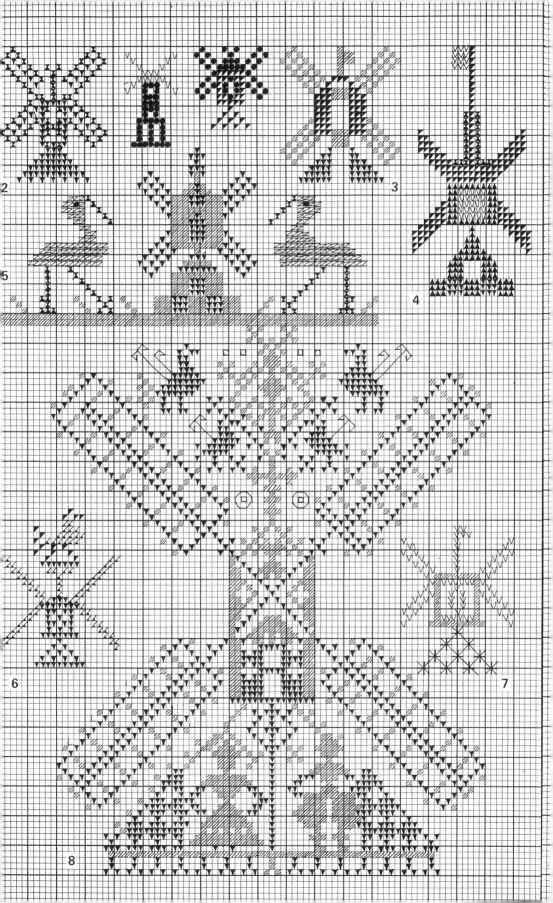

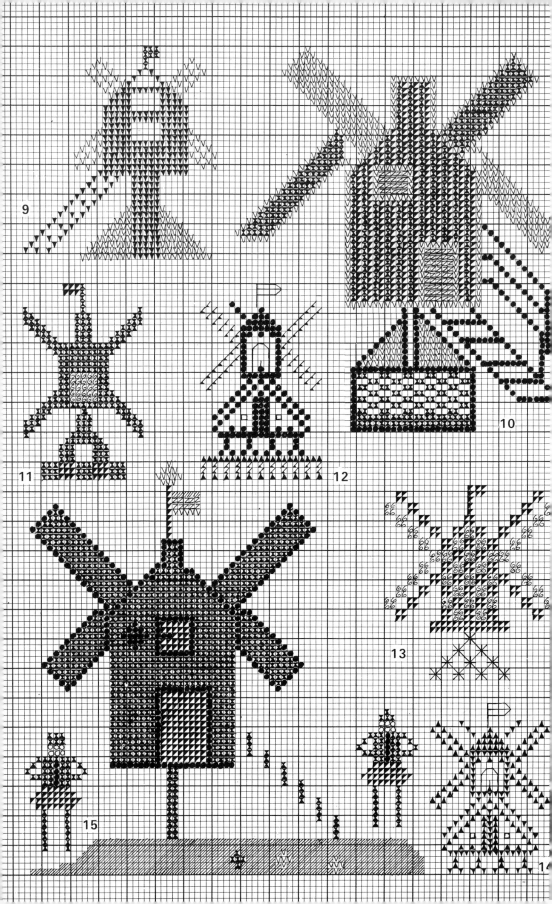

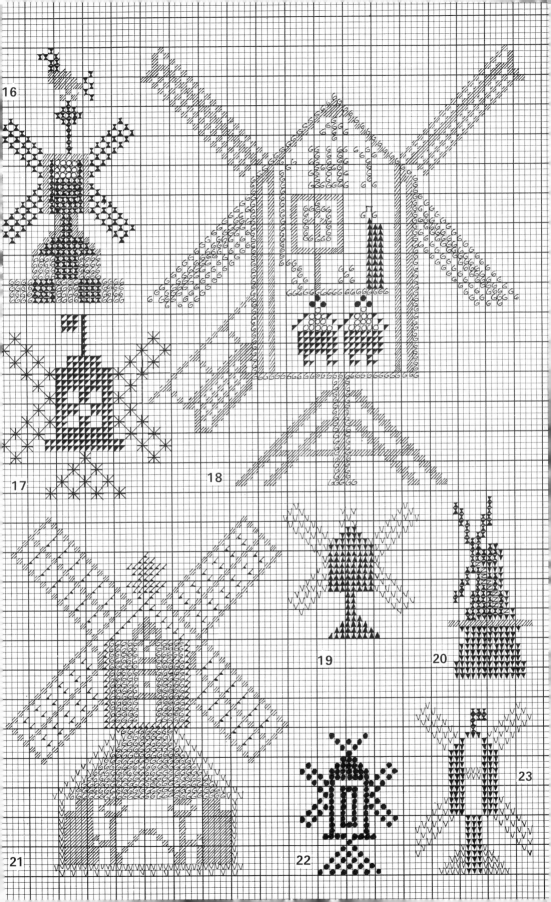

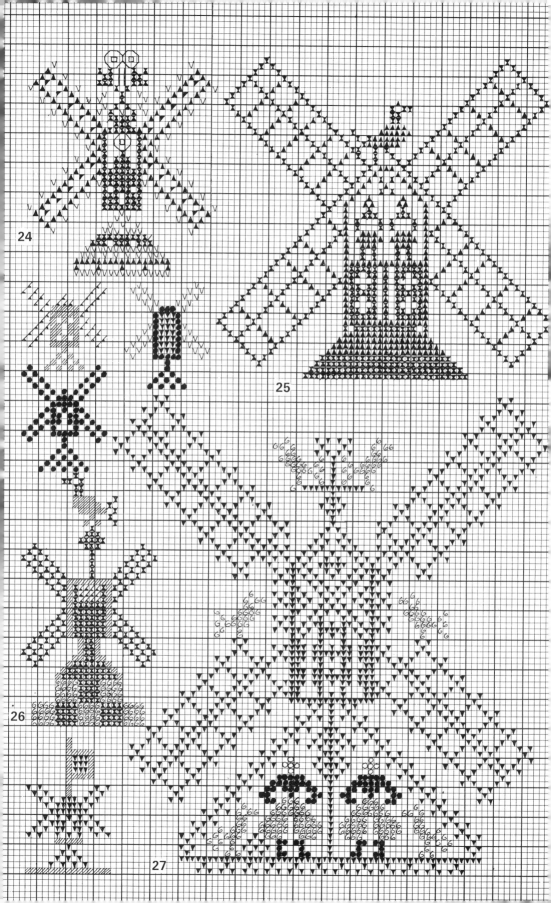

XII The Dutch Maiden and the Dutch Lion in the Garden of Holland; the spinning monkey

The *Dutch or Free Maiden* (Nos. 3, 4, 6; see Pl. II facing p. 25). Liberty is represented as a maiden clad in white and holding a sceptre in one hand and a hat or cap in the other. At her feet stands a cat, an animal that never gives up its independence. On samplers the Dutch or Free Maiden in the Garden of Holland holds in her right hand a stick or spear with a hat on it or a hat by itself. The hat is encircled by a long ribbon with fluttering ends in the national colours.

The *Garden of Holland*, symbol of the House of Orange, is shown as circular and enclosed by a fence. This emblem is supposed to date from 1405-6 and to be connected with the siege of Hagestein, a place protected by a hedge of interwoven branches.

The *Dutch Lion* (Nos. 1, 7, 11). Under Philip II of Spain the Seventeen United Provinces of the Netherlands had as their emblem a lion holding in its right paw a sword and in its left a bunch of seventeen arrows with their tips upwards and bound by a band inscribed *Concordia*.

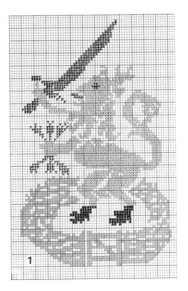

After the Union of Utrecht in 1579 the seven provinces of the United Netherlands adopted a similar lion, with seven arrows only and the motto 'Union is strength'. In 1815 when, after the defeat of the French, all the provinces were joined together to form a single kingdom, the gold lion rampant of Nassau in the national arms also acquired a bundle of arrows as an attribute and has remained unaltered until the present day.

The *lion* (the king of beasts) symbolizes strength and steadfastness. A lion beneath the feet of recumbent figures on tombs signifies the victory over sin and death. In the Scriptures the lion is an emblem of

1

savage strength, courage and beauty, qualities which can inspire admiration as well as fear, and for this reason it is used as an image of both good, God and Christ, and evil, the Devil (*e.g.* in 1 Peter 5:8). It is also found as a guardian of entrances.

The *spinning monkey* (Nos. 2, 5, 8, 9, 10). According to the *Physiologus* the monkey is a symbol of the Devil. It also stands for all sorts of undesirable qualities such as folly, laziness, lechery, vanity, mimicry and other vices, in contrast to all the good qualities of the Virgin. Dürer, too, used the monkey as the antithesis of the Virgin.

In Books of Hours of the first half of the fifteenth century by, among other artists, the Master of Catherine of Cleves (see bibliography under A. J. Bernet Kempers), the monkey is shown in various guises, *e.g.* with a barrow on which lies a cat, walking on stilts, blowing bubbles or spinning. A spinning monkey occurs on samplers, too, but there is a difference, for the monkey on the samplers is always shown sitting in a chair. A. Wassenberg (see bibliography) sees the spinning monkey as linked with the Three Fates, who foretell the lot of men and spin out the threads of their lives: Clotho, who wields the spindle, Lachesis, who measures the threads, and Atropos, who cuts them off.

LIST OF MOTIFS ILLUSTRATED

1 The Dutch Lion in the Garden of Holland – Sampler, 1845, private collection.

2 Spinning monkey* – Undated sampler, Town Museum, Zutphen.

3 The Dutch Maiden with the cap of liberty in the Garden of Holland – Undated sampler, private collection.

4 The Dutch Maiden with the cap of liberty in the Garden of Holland – Sampler, 1748, private collection.

5 Spinning monkey – Sampler, 1663, NOM, Arnhem.

6 The Dutch Maiden, crowned and with four birds – Sampler, 1753, private collection.

7 The Dutch Lion with the cap of liberty in the Garden of Holland – Sampler, 1782, NOM, Arnhem.

8 Spinning monkey – Sampler, 1670, private collection.

9 Spinning monkey – Sampler, 1691, NOM, Arnhem.

10 Spinning monkey – Sampler, 1748, private collection.

11 The Dutch Lion with the cap of liberty in the Garden of Holland – Sampler, 1811, private collection.

* This sampler was lost in the Second World War.

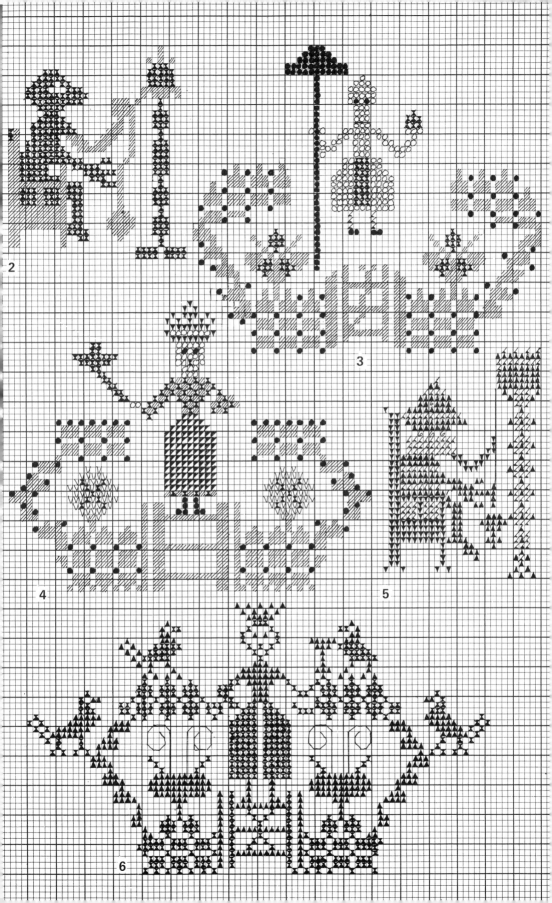

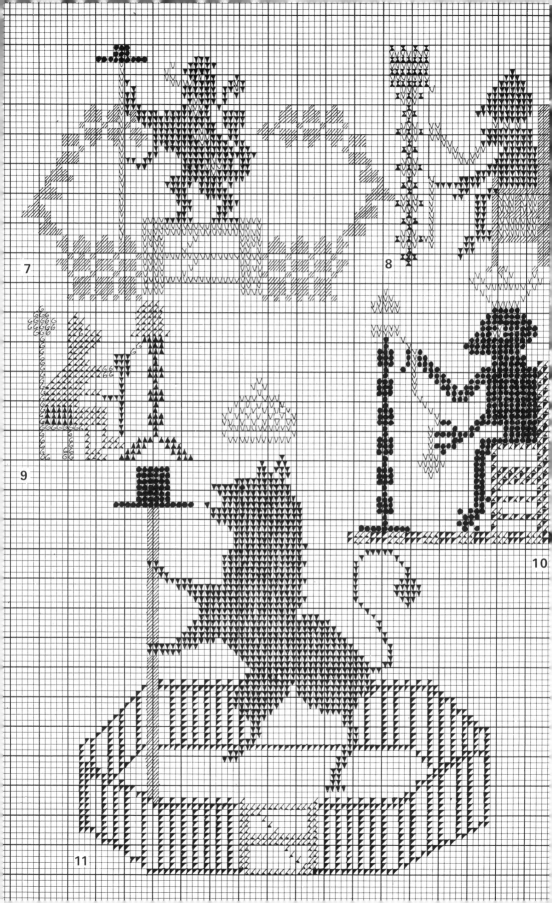

XIII Borders

Borders of vine branches bearing leaves and bunches of grapes occur on many samplers (No. 1). John 15:1 and 5: 'I am the true vine, and my Father is the husbandman'. 'I am the vine, ye are the branches: He that abideth in me, and I in him, the same bringeth forth much fruit: for without me ye can do nothing'.

On some samplers, especially those from the provinces of Groningen, Friesland, and North-Holland, one finds many different types of border. The embroidering of borders on samplers was of considerable practical importance, particularly in North-Holland in the seventeenth century, since they were subsequently used on clothes and linen. For example, they appear on the pillow-covers made at Marken, while in costume there they are used round the necks and sleeves of linen shirts, on cap and apron strings and on the embroidered ribbons which formed part of the women's intricate muslin headdresses composed of twelve different pieces. In the first half of the present century new border patterns came into use for these ribbons, designs incorporating the words, Faith, Hope, and Charity, or motifs such as angels, bells, dragons or crows (see Fig. 9 facing p. 145 and bibliography under M. van Hemert).

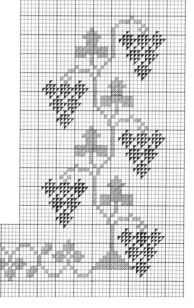

In the seventeenth century one also finds samplers with a border round all four sides. From the eighteenth century onwards borders were used to frame the various motifs (Nos. 37, 38).

LIST OF MOTIFS ILLUSTRATED

1 Vine branch with bunches of grapes – Undated sampler, F.M.E.K., Lievelde.

2 Border – Undated sampler, private collection.

3 Zig-zag border – Undated sampler, private collection.

4, 5 Borders – Undated sampler, Central Museum, Utrecht.

6 to bottom of page. *Borders* – Sampler, seventeenth century, private collection.

7 Border – Sampler, 1807, L.v.M.M., Delft.

8 Zig-zag border – Undated sampler, private collection.

9 Border – Neck of shirt, private collection.

10-14 Borders – Sampler, 1640, private collection.

15-17 Borders – Sampler, seventeenth century, private collection.

18 Border – Sampler, 1752, Frisian Museum, Leeuwarden.

19, 20 Borders – Sampler, 1640, private collection.

21 Flower border – Sampler, 1807, L.v.M.M., Delft.

22 Flower border – Sampler, 1795, private collection.

23 Flower border – Beadwork, private collection.

24 Flower border – Sampler, 1800, NOM, Arnhem.

25 Scrolling stem border – Sampler, 1845, private collection.

26 Zig-zag border with carnations – Sampler, 1790, NOM, Arnhem.

27 Acorn border – Undated sampler, private collection.

28 Acorn border – Sampler, c. 1800, private collection.

29 Zig-zag border – Sampler, c. 1800, private collection.

30 Border – Undated sampler, private collection.

31 Border with hearts – Sampler, 1752, Frisian Museum, Leeuwarden.

32 Border – Embroidered ribbon for a headdress, private collection.

33 Border – Sampler, 1875, private collection.

34 Border with roses – Sampler, 1843, K.M.A., Beverwijk.

35 Zig-zag border – Undated sampler, private collection.

36 Flower border – Sampler, 1708, private collection.

37 Border with carnations, roses, tulips and parrots – Sampler, 1843, K.M.A., Beverwijk.

38 Border with bunches of grapes, birds, cocks, human figures, dogs and lions – Sampler, 1728, NOM, Arnhem.

39-42 Borders – Sampler, seventeenth century, private collection.

43 Border with trees of life and peacocks – Pillowcover, 1837, private collection.

44-49 Marken borders – Sampler, seventeenth century, NOM, Arnhem.

50 Border with s-scrolls* – Sampler, eighteenth century, Town Museum, Zutphen.

51 Border* – Sampler, eighteenth century, Town Museum, Zutphen.

* This sampler, dating from the first quarter of the eighteenth century and embroidered in red and green, was probably lost in the Second World War. Maria van Hemert made a drawing of it in its entirety.

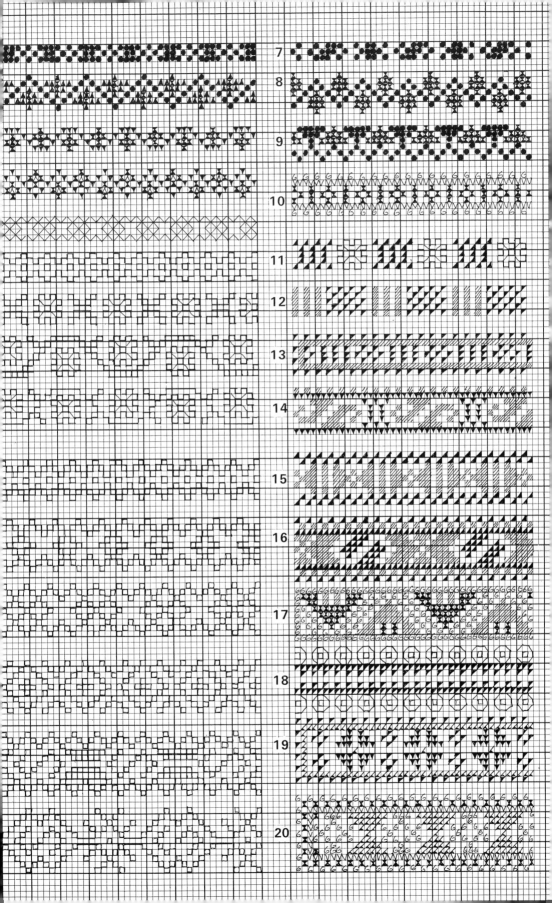

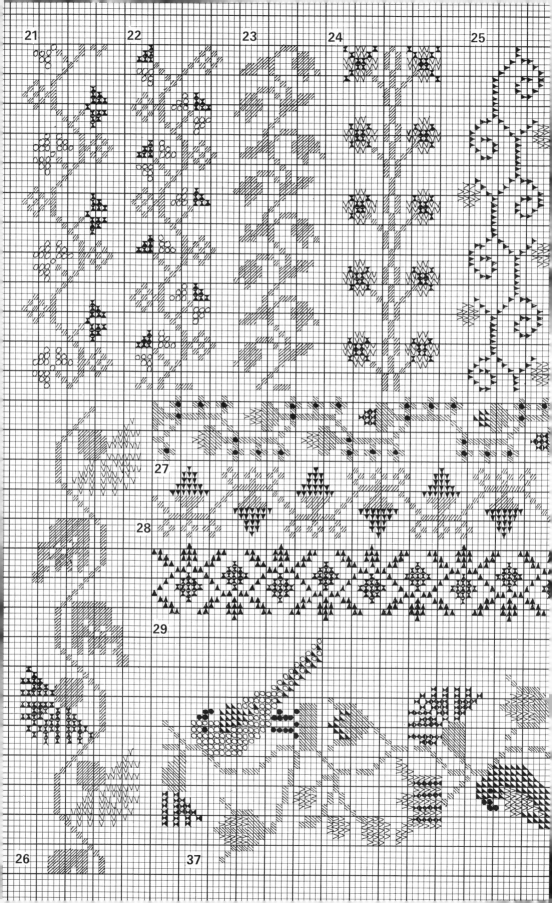

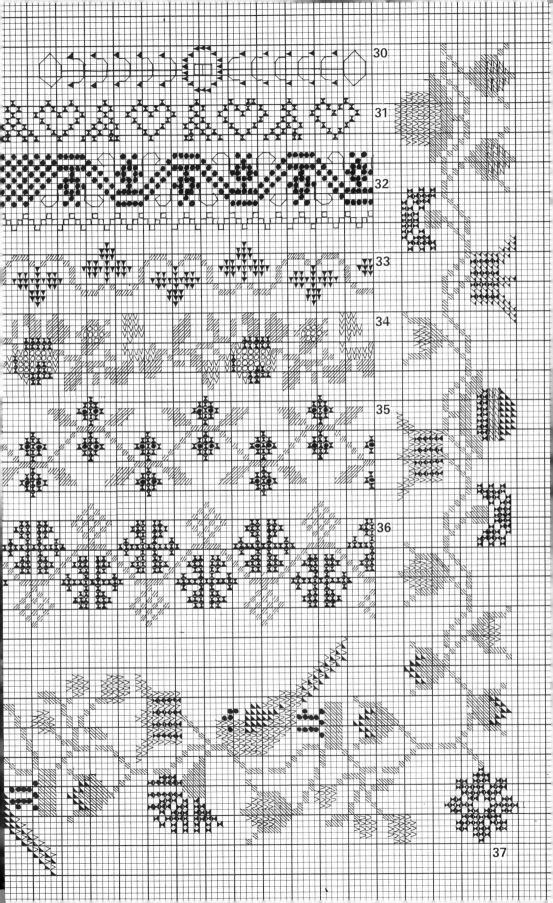

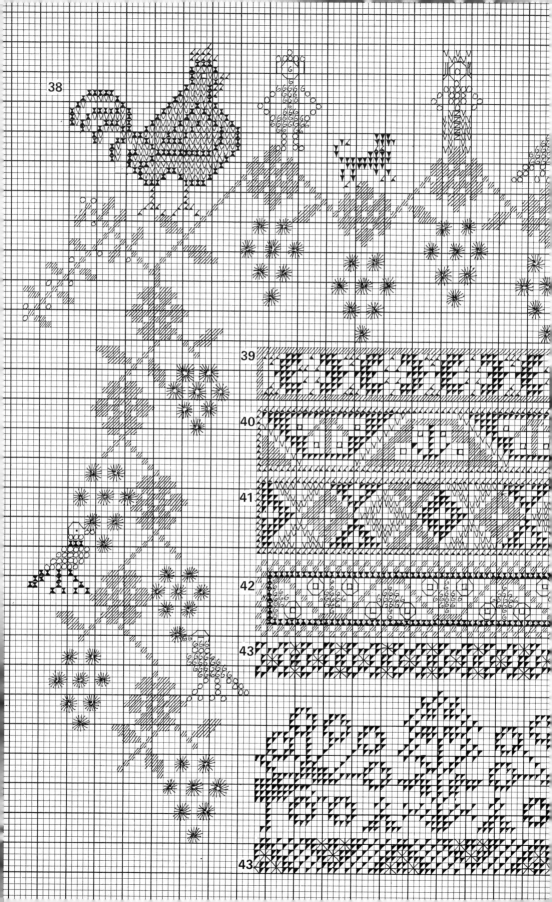

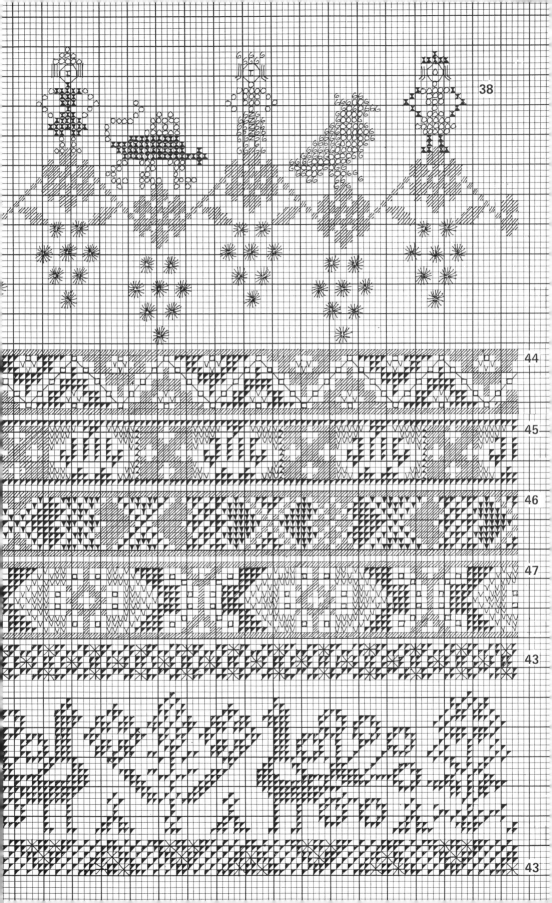

38

44

45

46

47

43

43

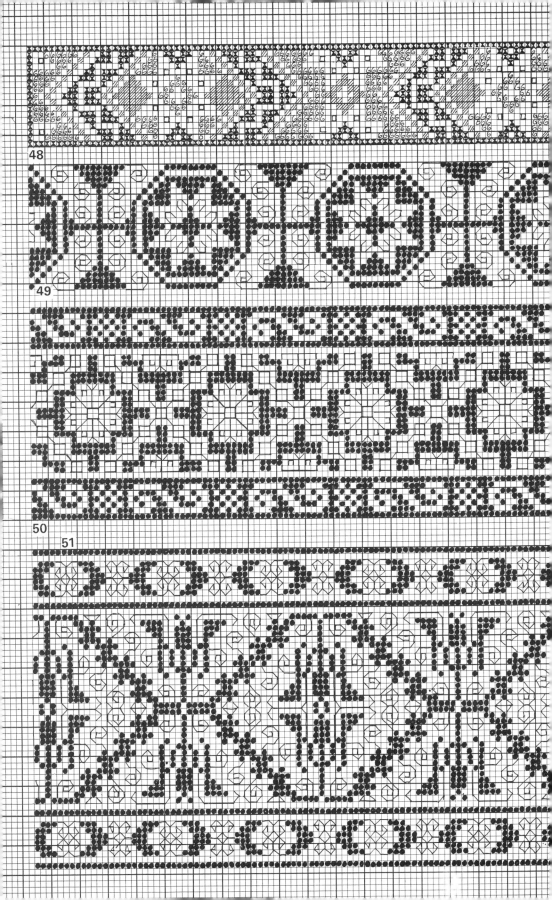

48

49

50

51

XIV Horses, riders and carriages

The *horse* has an important place in Teutonic mythology where the shining, sacred steed of the god of heaven is a symbol of the sun and of male potency and fertility. It also occurs frequently in folklore, where it stands for high-spiritedness, pride, speed and ardour.

The two natures of Christ, the human and the divine, are symbolized by a *horse and rider* respectively.

LIST OF MOTIFS ILLUSTRATED

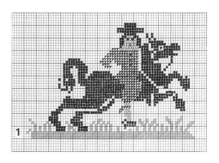

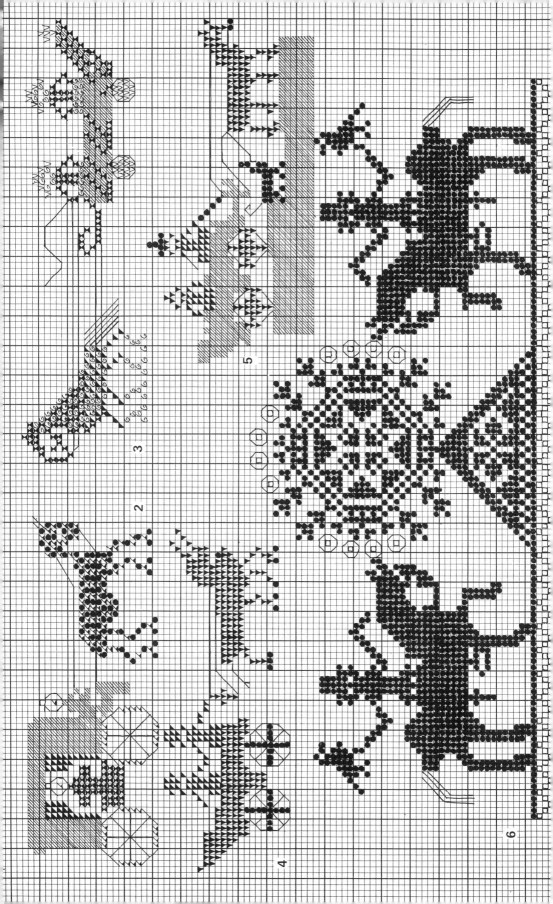

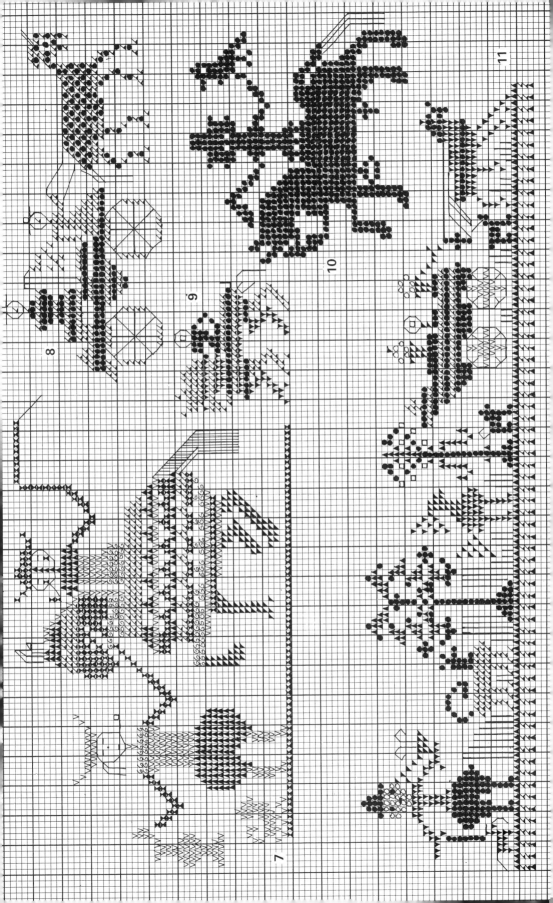

XV Ships and mermaids

Ships and lighthouses are depicted on early Christian gravestones as symbols of the soul's journey to the safe haven. A ship was also a symbol of hope, especially in the Middle Ages, while a ship crewed by Christ and the four Evangelists signified the church. A ship was also frequently used as a marriage emblem. On a Marken clock cover of 1921 the following rhyme is worked:

THIS SHIP IS BUILT

NEITHER OF STONE, NOR OF WOOD,

NOR OF IRON, NOR OF COPPER,

SO THE SHIP-BREAKER NEEDS NO HAMMER.

A *mermaid* with a comb and a mirror in her hand (Nos. 16, 17, 21) symbolizes vanity. The mermaids of northern folklore are very like the sirens of Greek mythology, beautiful creatures who lived on the island of Sicily and who, by their seductive singing, lured sailors to their shores where their ships foundered on the rocks. Mermaids were particularly popular in the Middle Ages (see, for example, the Book of Hours of Catherine of Cleves). Subsequently belief in them began to decline, although it in fact survived until the nineteenth century.

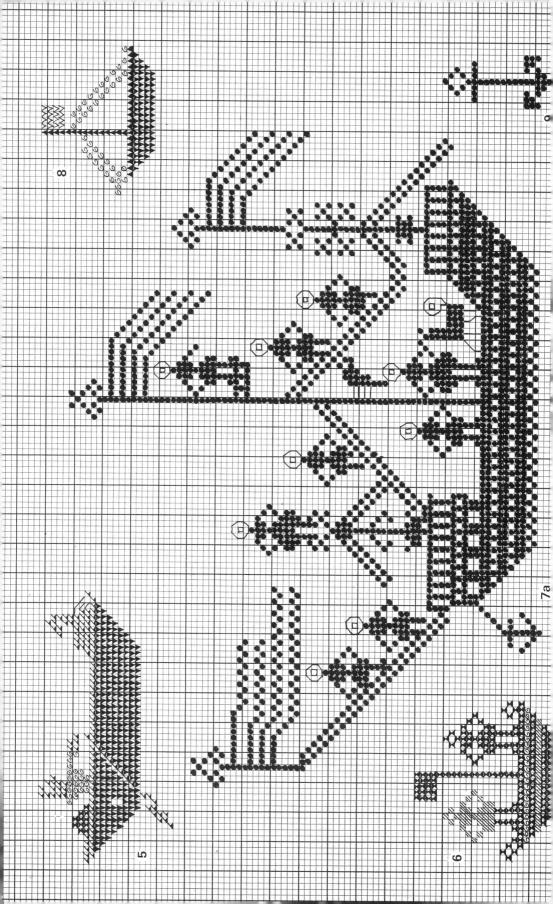

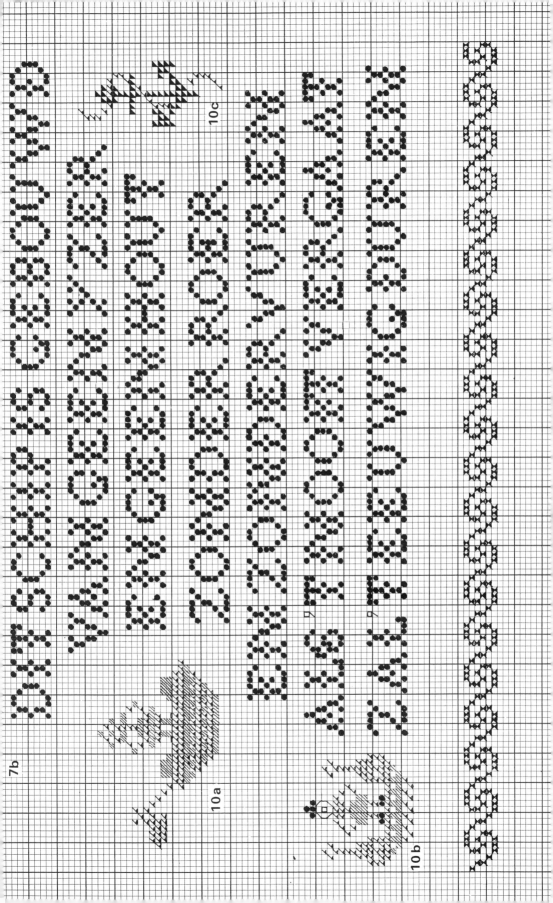

7b

10a

10b

10c

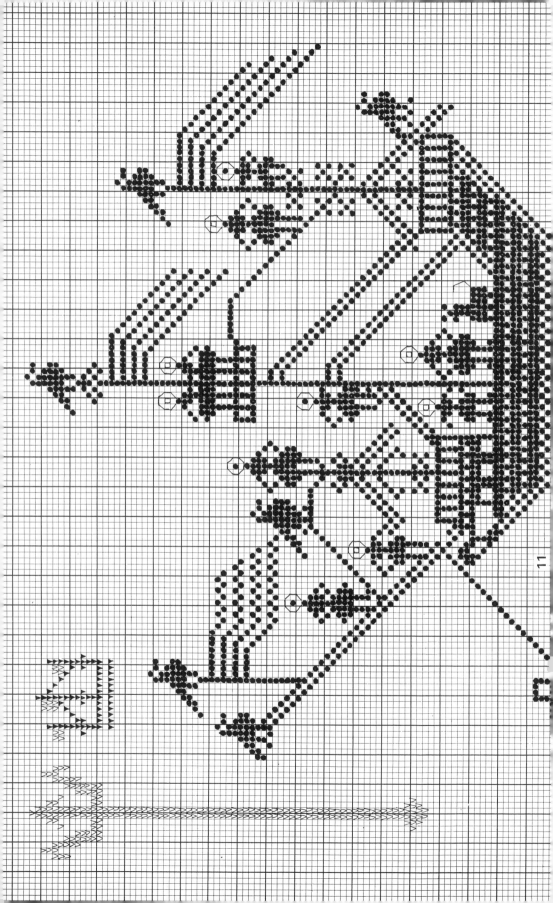

11

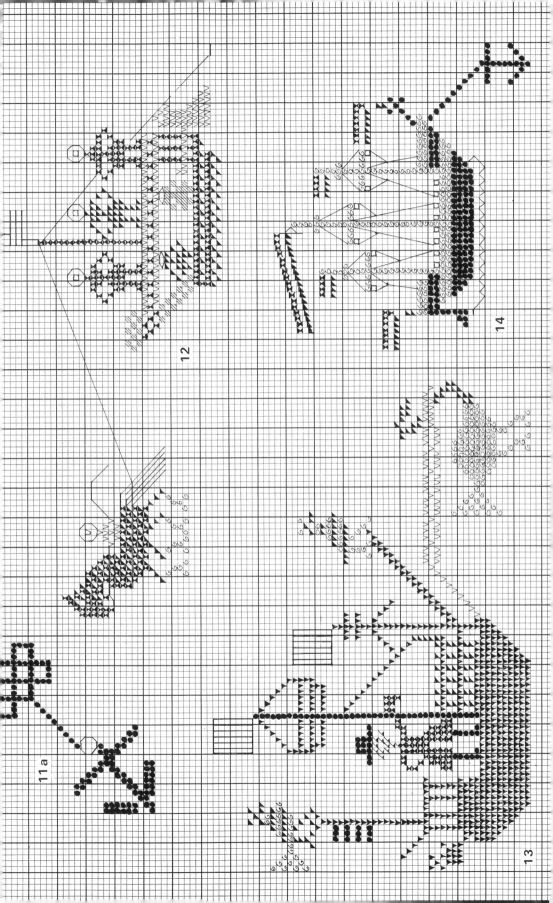

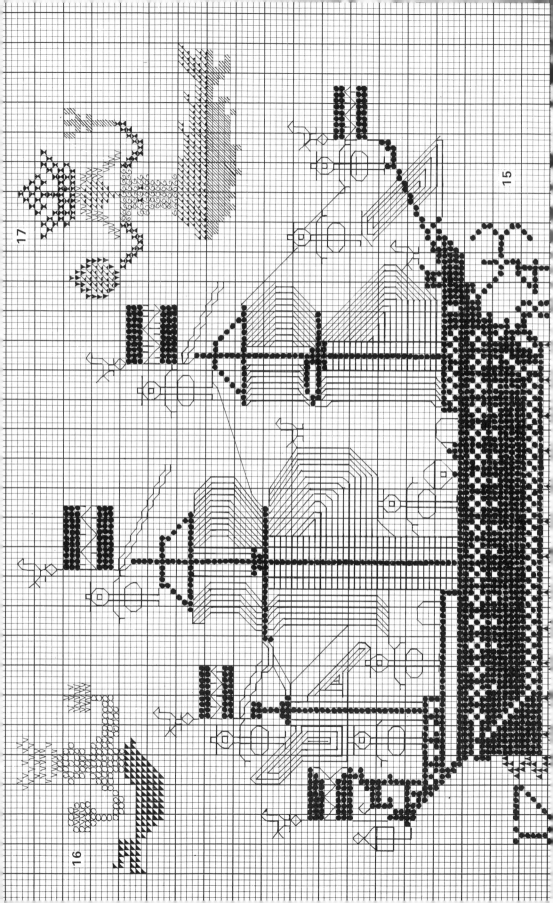

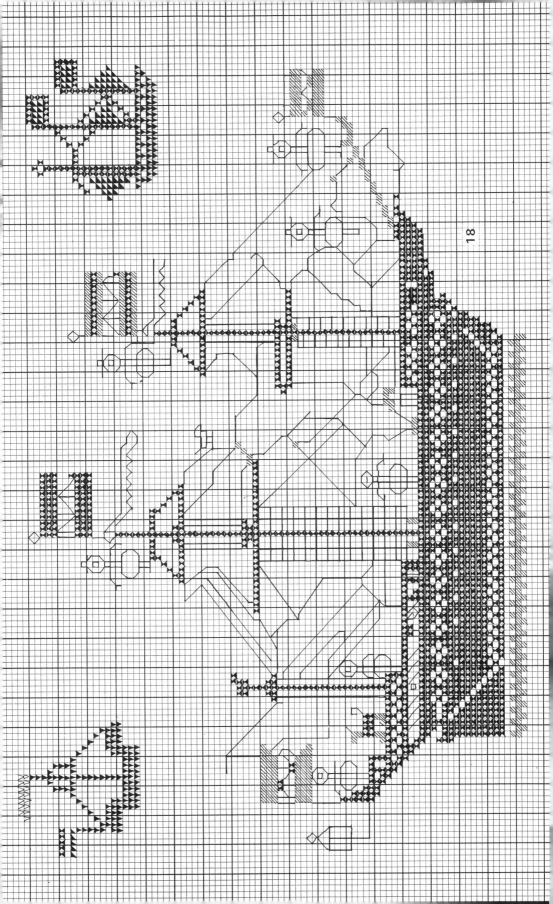

18

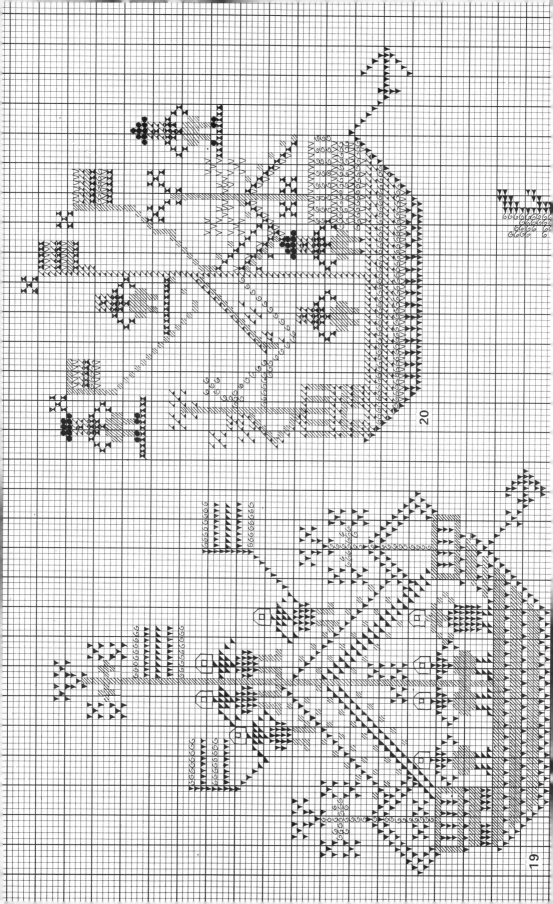

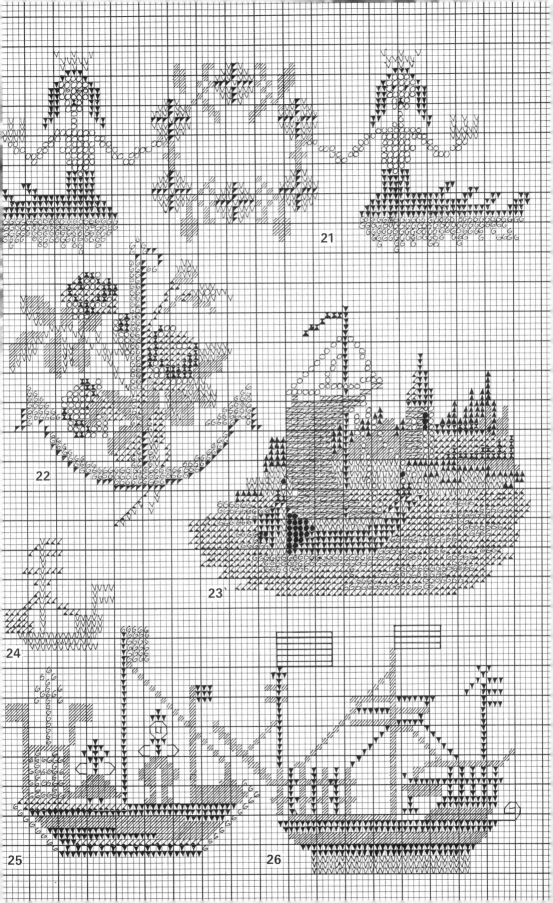

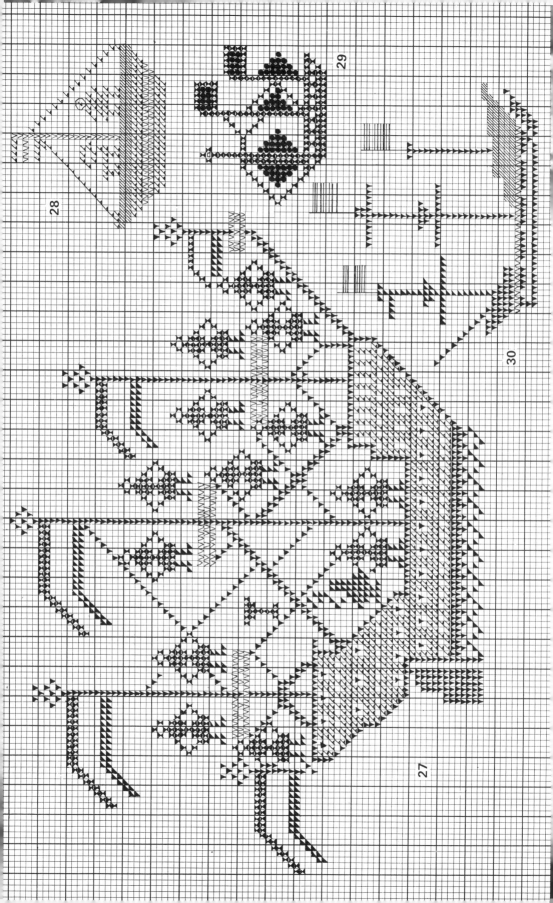

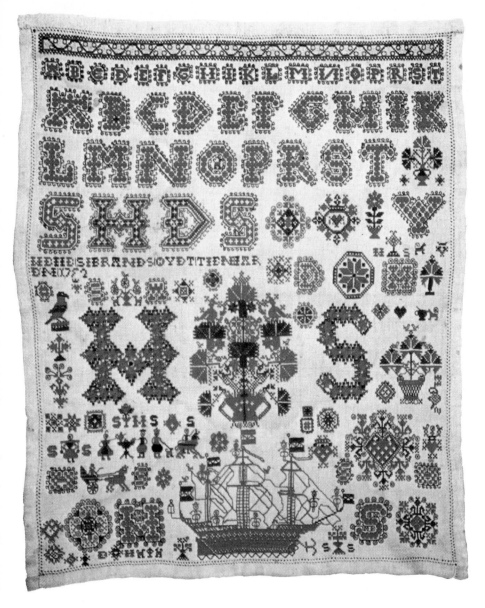

V Sampler, 1752, beige, green and red thread on linen; cross, back and trellis hem stitches and eyelet holes; 32.5 × 39 cm. Frisian Museum, Leeuwarden. Translation of text: HEIIE SIBRANDS TEN YEARS OLD 1752

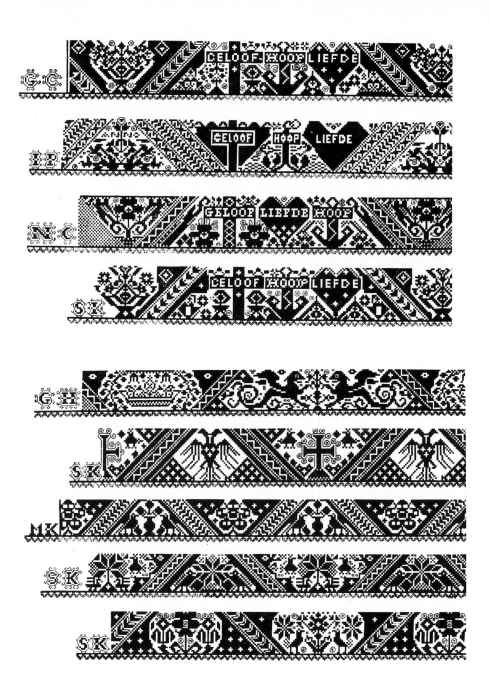

9 Cross-stitch patterns from embroidered ribbons for headdresses, 1st half of the twentieth century, Marken

LIST OF MOTIFS ILLUSTRATED

1 Three-master with a woman and child, five men, a bird, a dog and three flags – Sampler, 1782, NOM, Arnhem.

2 Three-master with a crew of eight – Sampler, 1670, private collection.

3 Three-master with two men and a flag – Undated sampler, Frisian Museum, Leeuwarden.

4 Three-master with her captain and four flags – Sampler, 1856, private collection.

5 Rowing boat with two people in it – Sampler, 1705, private collection.

6 Small boat with a flag and two men – Sampler, 1726, private collection.

7a, b Three-master with three flags, a crew of nine and a dog with text: This ship is built of neither iron nor wood. Without rudder or lights, if it never goes down it will last for ages. – Undated bedspread from Marken, private collection.

8 Small boat with flag flying from the mast – Sampler, 1830, private collection.

9 Anchor – Embroidered ribbon from Marken, private collection.

10a, b, c Two boats with men and an anchor – Sampler, 1726, private collection.

11, 11a Three-master with three flags, a crew of ten, six birds, a dog and an anchor – Undated bedspread from Marken, private collection.

12 Passenger barge being towed by a horse, with three men on deck and two children below – Sampler, 1772-3, private collection.

13 Ship drawn by a swan (from *Lohengrin*) *–* Sampler, 1677, private collection.

14 Three-master with five flags – Sampler, 1713, Frisian Museum, Leeuwarden.

15 Three-master in full sail with a crew of eight, five flags, a ship's lantern and six sea-gulls – Sampler, 1784, Frisian Museum, Leeuwarden.

16, 17 Two mermaids – Undated sampler, private collection.

18 Three-master with three flags, a crew of seven, a ship's lantern and a dog – Sampler, 1785, Frisian Museum, Leeuwarden.

19 Three-master with a crew of eight – Undated sampler, private collection.

20 Three-master with three flags and a crew of five – Sampler, 1764, NOM, Arnhem.

21 Garland of roses held by two mermaids – Sampler, 1771, private collection.

22 Anchor with flowers – Sampler, c. 1860, private collection.

23 Sailing ship and landscape – Sampler, 1844, NOM, Arnhem.

24 Small ship with two flags – Sampler, 1726, NOM, Arnhem.

25 Small ship with four flags, a man and a woman – Undated sampler, NOM, Arnhem.

26 Three-master with flags – Sampler, seventeenth century, NOM, Arnhem.

27 Three-master with five flags and a crew of thirteen – Undated sampler, Zaanland Museum of Antiquities, Zaandijk.

28 Small ship with a flag, a man and a dog – Sampler, 1716, NOM, Arnhem.

29 Three-master in full sail with two flags – Undated sampler, private collection.

30 Three-master with three flags – Sampler, 1705, private collection.

XVI Scenes and human figures

A simple symbolic explanation can be given of some of the motifs included in this section. The *beehive* with bees flying around it (No. 3), for example, has a symbolic meaning, although this is not actually in question when it is used on samplers. The bee was already extolled by Virgil as an example of chastity, because she never surrenders herself and knows neither the union of the sexes nor the pangs of childbirth. In the Middle Ages the Virgin Mary was often likened to a bee. The beehive is an emblem of the monastic or church community. Just as the bees in the hive are subordinate to their queen and together form a strong natural unity, so the monks in the monastery or the faithful in the church or bishopric form an indivisible unity, strong in their common obedience to their head, the abbot, the bishop or the Pope. It is not surprising, therefore, to find that the beehive and the bee are very popular motifs in ecclesiastical heraldry. The beehive may also be used as the head-dress and attribute of hope.

Nos. 11-17 are related to *marriage*. The meaning of marriage is clearly conveyed by No. 11 (see Pl. II, facing p. 25), a wreath encircling a crowned heart pierced by two arrows and held by a man and a woman. In Early Christian art Christ is

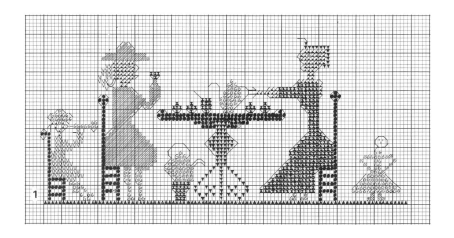

shown holding wreaths over a couple as they are married. The crowned heart pierced by two arrows signifies Divine Love, while the crown itself symbolizes fidelity (see Revelations 2:10). Marital fidelity is also one of the meanings of the dove, (see Chapter III), seen here perched on the man's hand. The woman holds a palmbranch, symbol of life (see also No. 10 and the first reference to A. J. Bernet Kempers in the bibliography). The clasped hands in Nos. 12, 13 and 14 symbolize unity and fidelity. This motif was very common in the later Middle Ages. It is also found in combination with a tree of life, a palmbranch, a flower or a flower with a heart. No. 15 shows a man and woman holding a crowned heart beneath which is a child. No. 17 shows two figures playing chess, a game that is thought to have originated in India and to have come into Europe via Persia. The word check as used in chess is probably a derivation of the Persian word *shah* = king. Chessboards often appear on samplers. The number of squares shown is variable: 8 × 8, 9 × 9, 10 × 10, 7 × 7 or 5 × 5. A square divided into 8 × 8 small squares and shown diamond-fashion is also found in tree of life motifs (see Chapter X, No. 27).

The *stairway of life or age* (Nos. 18 and 25). There are various versions of the ages of man, each with a different number:

a. three: youth, man, old man;
b. four: child, youth, man, old man, these being, in accordance with the Medieval symbolism of numbers, connected with the four seasons of the year;
c. six: child, boy, youth, young man, mature man, old man, these being likened to the six epochs in the history of the world;
d. seven, these being different for men and women:

1 a boy with a hobby horse	1 a little girl with a doll
2 a youth studying	2 a girl learning to spin
3 a young man out hawking	3 a young woman in bridal array
4 a man in festive attire	4 a woman with a baby in swaddling clothes
5 a man with a money bag	5 a woman at her spinning-wheel
6 a man on crutches	6 a woman with a rosary
7 an old man in an armchair	7 an old woman poking the fire

In the later Middle Ages life was divided into 10-year periods, each of which was associated with an animal or bird:

Man	*Woman*
10 a child with a hoop – cow or dog	10 a child with a doll – quail
20 a young man with a bird – goat	20 a girl with a wreath – dove
30 a man holding a drinking-glass – bull	30 a young woman with a mirror – magpie

40 a man with a falcon in his hand – lion	40 a woman with a bunch of keys – peacock
50 a man with a money bag – fox	50 a woman with a rosary – hen
60 a man leaning on a stick – wolf	60 a woman with a ewer and basin – goose
70 a man on crutches being helped along by a boy – tomcat or dog	70 a woman with a distaff – vulture
80 a man on crutches with a bag – tomcat or dog	80 a woman on crutches – owl
90 a man with crutches or a folding-chair – donkey	90 a woman with a folding-chair – bat
100 a man on a bier – death	100 a woman on a bier – death

The following verse appears on a sampler of 1808:

and this one is on a sampler of 1856:

10	*are the years of childhood*	*10*	*is a child*
20	*you start saving up*	*20*	*is a youth*
30	*you ought to be married*	*30*	*is a man*
40	*you're too old for it*	*40*	*brings power*
50	*you start to decline*	*50*	*is time to stand still*
60	*infirmities set in*	*60*	*is time to go forward*
70	*you're going downhill*	*70*	*is wise*
80	*you've got one foot in the grave*	*80*	*is grey*
90	*you can still live a bit longer*	*90*	*brings your second childhood*
100	*is given to God*	*100*	*is time to go to eternity*

The stairway of life is also found with eleven times of life, beginning on the left with a child in a walking-frame and ending on the right with a figure in a coffin (No. 25). It is accompanied by the following rhyme:

There is also a Flemish version of this rhyme which is used by children learning their tables:

1	*you wear skirts*	*1*	*is the first years*
10	*are the years of childhood*	*10*	*are the years of childhood*
20	*you start saving up*	*20*	*you start saving up*
30	*you are married*	*30*	*you ought to be married*
40	*you become old*	*40*	*you're too old for it*
50	*you start to decline*	*50*	*you start to decline*
60	*infirmities set in*	*60*	*infirmities set in*
70	*you go downhill*	*70*	*you can still live a bit*
80	*you can't work any more*	*80*	*is allowed us*

Nos. 21 and 22 originally had a swan and a rabbit in the centre respectively, but these have been left out so as to allow readers to choose a motif for themselves or insert their initials or name.

Nos. 44, 45 and 48 show Justice, the Roman *Justitia* who was the equivalent of the Greek Themis, the goddess of law and order, daughter of Uranus (heaven) and Gaea (earth). She is shown as a blindfolded woman with stern features. Her attributes are a pair of scales, a sword, a cornucopia and a palmbranch.

LIST OF MOTIFS ILLUSTRATED

1 *A couple drinking tea with their son and daughter* – Sampler, 1751, Frisian Museum, Leeuwarden.

2 *Hay-barrack with a child on the ladder and two birds* – Sampler, nineteenth century, NOM, Arnhem.

3 *Beehives* – Sampler, 1780, A.H.M., Dokkum.

4 *Farmer and his wife with a churn* – Sampler, 1772-3, private collection.

5 *Horse-driven mill with horse, farmer's wife and churn* – Sampler, 1819, private collection.

6 *Farmer with yoke and pails* – Sampler, 1674, NOM, Arnhem.

7 *Farmer's wife with yoke and pails* – Sampler, 1780, private collection.

8 *Farmer's wife with yoke and pails* – Sampler, 1780, private collection.

9 *Horse-driven mill with horse, farmer, farmer's wife and churn* – Sampler, 1827, private collection.

10a, b *Girl and boy with palmbranches* – Undated sampler, private collection.

11 *Wreath of roses encircling a crowned heart pierced with arrows and held by a man and woman* – Sampler, 1670, private collection.

12 *Clasped hands with branch of life* – Sampler, seventeenth century, private collection.

13 *Clasped hands* – Sampler, seventeenth century, NOM, Arnhem.

14 *Clasped hands with branch of life* – Sampler, 1691, private collection.

15 *Crowned heart held by a man and woman with a child* – Undated sampler, Zaanland Museum of Antiquities, Zaandijk.

16 *Chessboard with three flower-sprigs held by two figures* – Undated sampler, private collection.

17 *Branch of life held by a man and woman* – Sampler, 1802, Central Museum, Utrecht.

18 *Stairway of life* – Sampler, 1807, K.M.A., Beverwijk.

19 *Woman with a dog* – Sampler, 1772-3, private collection.

20 *Man with a dog and the initials A.V.* – Sampler, 1731, private collection.

21 *Rectangular arch of flowers in a grassy meadow* – Sampler, 1831, NOM, Arnhem.

22 *Arch of flowers with fuchsia in the centre* – Sampler, 1841, NOM, Arnhem.

23 *Flowerpot under a rectangular arch of flowers* – Sampler, 1831, NOM, Arnhem.

24 *Crown* – Sampler, 1845, NOM, Arnhem.

25 *Stairway of life with numbers* – Sampler, 1850, NOM, Arnhem.

26 *Farmhouse with hay-barrack* – Sampler, 1716, private collection.

27 *Tree of life with three acorns* – Sampler, first half of the eighteenth century, NOM, Arnhem.

28 *Man and woman* – Undated sampler, private collection.

29 *Table with a jug on it and a cat under it* – Undated sampler, private collection.

30 *Woman* – Undated sampler, private collection.

31 *Man and woman beside a tea-table* – Sampler, 1752, Frisian Museum, Leeuwarden.

32 *Man* – Undated sampler, private collection.

33 *Woman* – Undated sampler, private collection.

34 *Man and woman beside a tea-table with a bird, surrounded by acorns and tulips* – Sampler, 1802, private collection.

35 *Dovecote with a bird on it* – Sampler, 1737, NOM, Arnhem.

36 *Dovecote* – Sampler, 1848, NOM, Arnhem.

37 *Dovecote with a bird on it* – Sampler, 1737, NOM, Arnhem.

38 *Dovecote with two doves* – Sampler, 1800, NOM, Arnhem.

39 *Man and woman* – Undated sampler, private collection.

40 *Dovecote with three doves* – Sampler, 1715, NOM, Arnhem.

41 *Dovecote with two doves* – Sampler, 1777, private collection.

42 *House with a bird on the roof, pavement, cock and oak tree with acorns* – Sampler, 1845, NOM, Arnhem.

43 *Dovecote* – Sampler, 1750, NOM, Arnhem.

44 *Justitia* – Undated sampler, Frisian Museum, Leeuwarden.

45 *Justitia* – Sampler, 1713, Frisian Museum, Leeuwarden.

46 *Man with ducks* – Sampler, 1833, private collection.

47 *Man in a chapel* – Undated sampler, private collection.

48 *Justitia* – Sampler, 1728, NOM, Arnhem.

49 *Woman with a bird on her hand, a girl and a boy* – Sampler, 1812, private collection.

50 *Woman with a bird on her hand* – Undated sampler, private collection.

51 *Woman with a staff in her hand* – Undated sampler, private collection.

52 *Woman beside a plant bearing a tulip and four small flowers* – Sampler, 1747-72, private collection.

53 *Two men and four dogs hunting a stag* – Sampler, 1762, Frisian Museum, Leeuwarden.

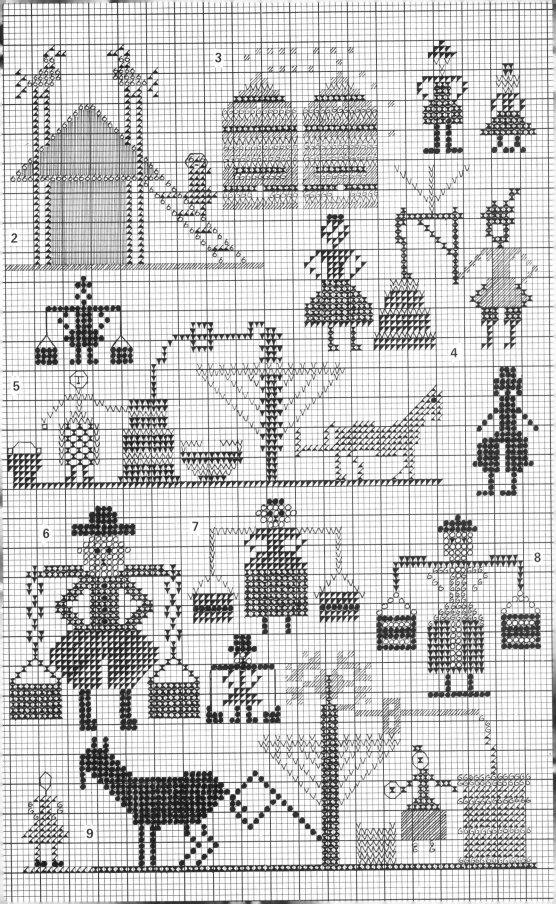

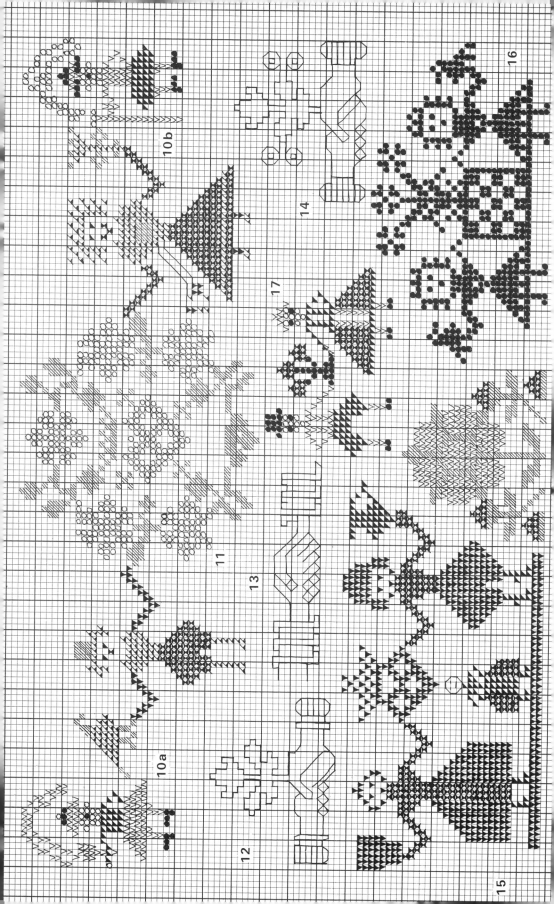

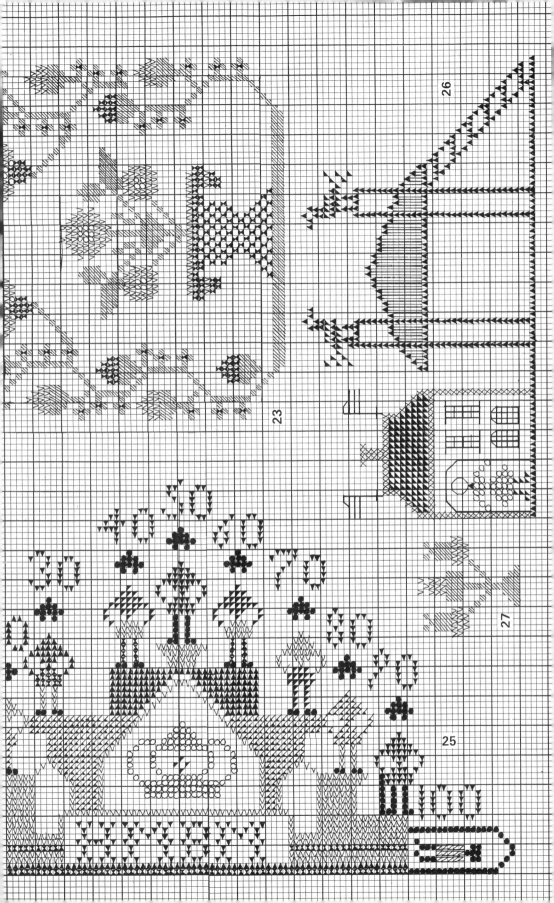

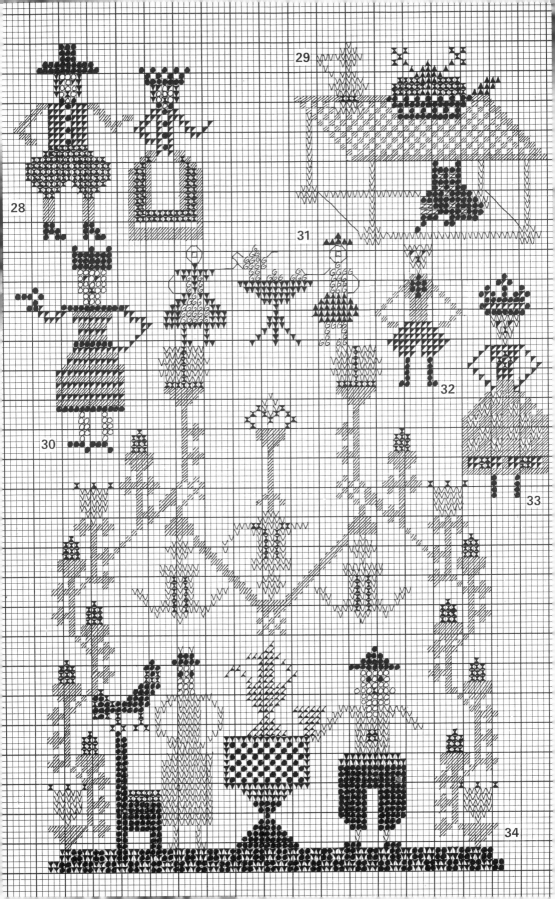

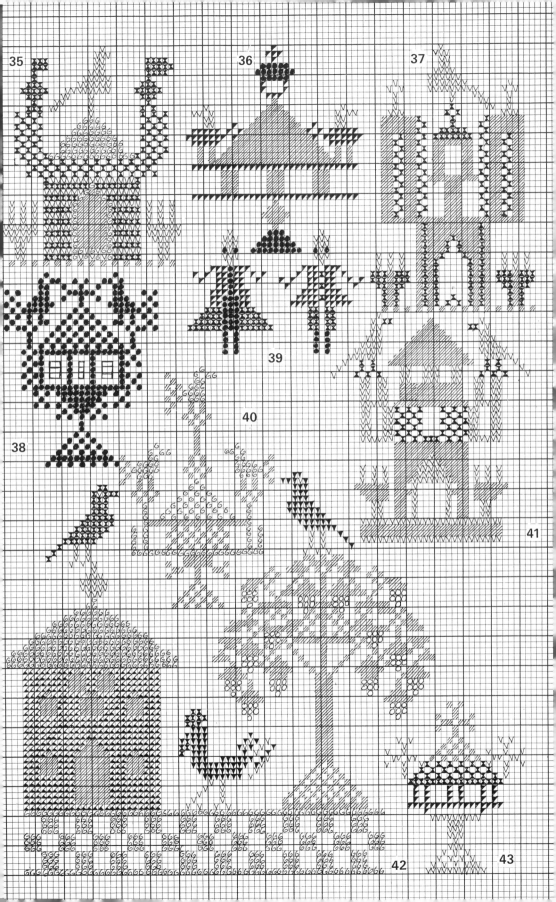

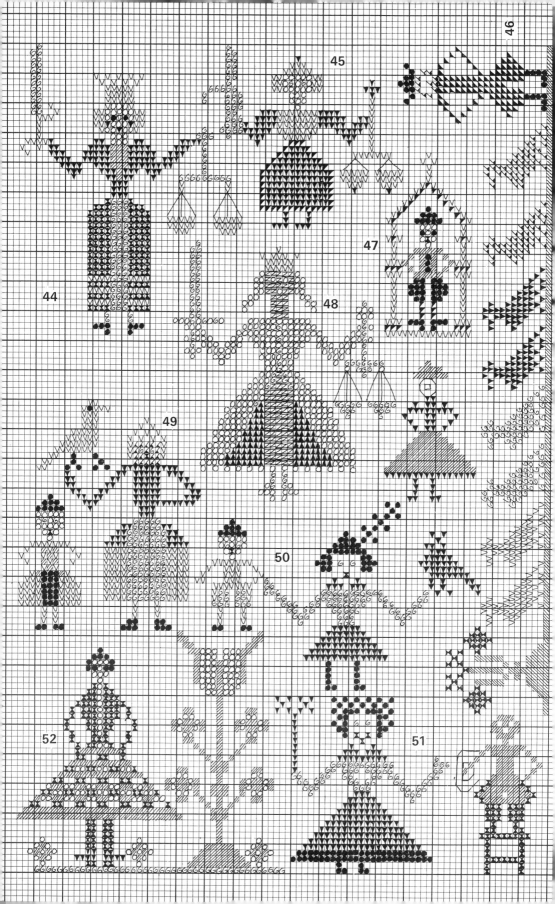

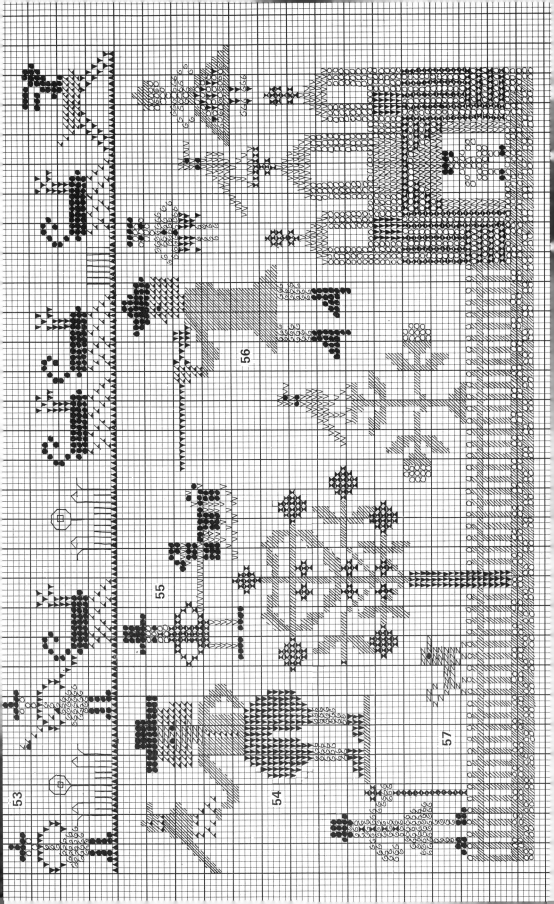

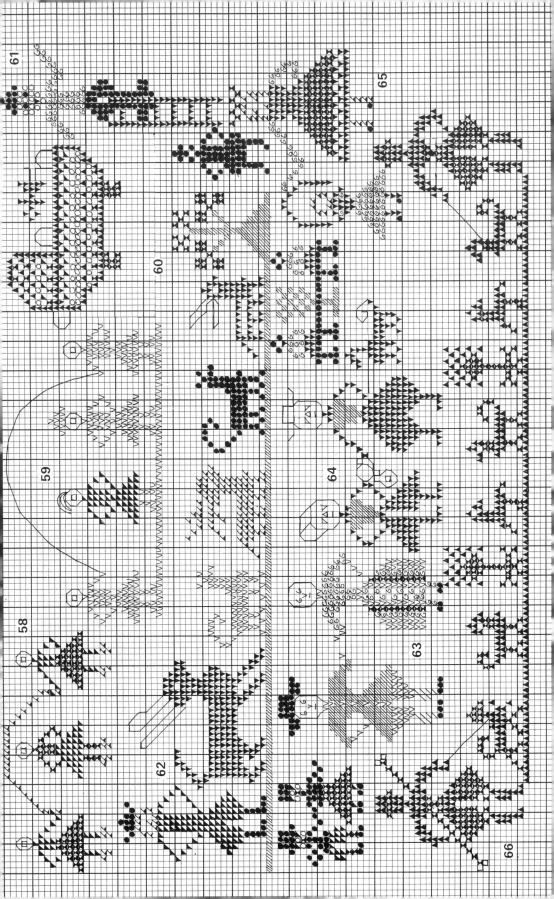

10a Cross-stitch border patterns from Schönsperger's pattern-book of 1523

10b Cross-stitch border from Peter Quentel's pattern-book of 1529, reprinted in 1882

10c Embroidered ribbon for a headdress, 1st half of the twentieth century, Marken; black silk on linen; cross stitch. Private collection

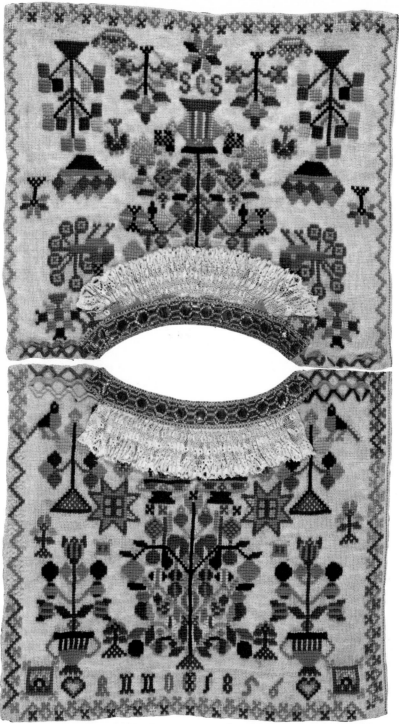

VI Woman's yoke, 1856, Walcheren; wool on canvas; cross stitch; front: 24 × 26.5 cm, back: 24 × 27.5 cm

54 Man with a falcon – Undated sampler, private collection.

55 Man with a dog – Sampler, 1780, private collection.

56 Man with a rifle – Undated sampler, NOM, Arnhem.

57 Church with palings, a tree, a dog and a man with a walking-stick – Undated sampler, NOM, Arnhem.

58 Three girls skipping – Undated sampler, private collection.

59 Four girls skipping – Sampler, 1716, NOM, Arnhem.

60 Cradle with baby above it – Sampler, 1822, private collection.

61 Man on a ladder – Sampler, 1827, private collection.

62 Man with dogs, a stag and a tree – Sampler, 1839, private collection.

63 Man and woman – Sampler, 1778, NOM, Arnhem.

64 Man and woman – Sampler, 1704, private collection.

65 Woman and a child with a skipping-rope – Undated sampler, private collection.

66 Huntsmen with dogs – Sampler, 1733, Frisian Museum, Leeuwarden.

XVII Squares, stars and octagons

The number two stands for the two strains that met in Christ: Jewry and Christendom.

The number three is the symbol of perfection in, for example, the three wise men and their gifts and, above all, the Holy Trinity.

The *square* (Nos. 2a, 5, 7) is the symbol of the world of nature, while the number four has various associations, including:

the four evangelists – Matthew, Mark, Luke and John;

the four major prophets – Isaiah, Jeremiah, Elijah and Daniel;

the four rivers of Paradise – Pison, Gihon, Hiddekel (Tigris) and Euphrates. The water that flowed from the source in Paradise spread out in four streams over all the earth in order to make it bring forth life and be fruitful. This leads us to some of the other things connected with the number four:

the four elements – earth, air, fire and water;

the four seasons – spring, summer, autumn and winter;

the four points of the compass – north, south, east and west.

The number five stands for the Pentateuch, the first five books in the Bible or the Books of Moses; the Five Wise and the Five Foolish virgins; the five senses. It is also to be found in the Liturgy, *e.g.* the five signs of the Cross that are made during the preparation of the altar at Mass.

The number six symbolizes work (the six workdays). It also stands for the six ages of man, the six epochs in the history of the world, the six vestments worn by the priest

at Mass (amice, alb, girdle, maniple, stole and chasuble).

The number seven is the symbol of completion and the seven gifts of the Holy Spirit (see Chapter XIX, p. 177).

The *octagon* (Nos. 13-23). Eight is the number of perfection in the sense that if seven is the number of the Creation, then eight is that of the Regeneration brought about by Christ. This is also why fonts and baptisteries are so often octagonal in form.

The number nine stands for the nine punishments of Hell, the nine choirs of angels, the nine ages of man.

The number ten is the symbol of Christian perfection.

The *star* (Nos. 25, 30). An eight-pointed star is the emblem of Bethlehem. The six-pointed star is a Jewish symbol, *Magen David* (the Shield or Star of David). A five-pointed star announced the birth of Christ.

LIST OF MOTIFS ILLUSTRATED

1 Square – Sampler, 1788-90, NOM, Arnhem.

2a Centre motif – Dowry kerchief, seventeenth century, Frisian Museum, Leeuwarden.

2b Corner motif – Dowry kerchief, seventeenth century, Frisian Museum, Leeuwarden.

3 Square with flowers – Sampler, seventeenth century, Zaanland Museum of Antiquities, Zaandijk.

4 Square with four lilies – Sampler, 1640, private collection.

5 Square with flowers – Sampler, 1708, Frisian Museum, Leeuwarden.

6 Octagon with heart – Sampler, 1802, private collection.

7 Square divided into four with four birds – Sampler, 1700, private collection.

8 Square with a star-shaped flower in the centre – Undated sampler, Zuider Zee Museum, Enkhuizen.

9 Square with a star-shaped flower, eight birds and four seagulls – Undated sampler, Frisian Museum, Leeuwarden.

10 Eight-pointed star – Sampler, c. 1800, private collection.

11 Eight-pointed star – Sampler, 1802, private collection.

12 Octagon with an eight-pointed star in the centre and diagonal ornaments – Pillowcover, 1737, NOM, Arnhem.

13 Octagon containing a tree of life with a man and woman – Sampler, c. 1800, private collection.

14 Octagon – Undated sampler, Zuider Zee Museum, Enkhuizen.

15 Octagon containing an eight-pointed star – Sampler, 1802, private collection.

16 Octagon containing an eight-pointed star – Sampler, 1802, private collection.

17 Octagon containing a heart – Sampler, c. 1800, private collection.

18 Octagon – Sampler, 1802, private collection.

19 Square arranged diamond-fashion – Sampler, seventeenth century, private collection.

20 Octagon – Sampler, 1802, private collection.

21 Octagon – Sampler, 1802, private collection.

22 Circle containing a square – Undated sampler, Zuider Zee Museum, Enkhuizen.

23 Octagon – Sampler, 1802, private collection.

24 Four fleurs-de-lys arranged in a square – Sampler, seventeenth century, NOM, Arnhem.

25 Star with diagonal ornament and four fleurs-de-lys – Sampler, 1772-3, private collection.

26 Square arranged diamond-fashion with a rose in the centre – Undated sampler, Zuider Zee Museum, Enkhuizen.

27 Square – Sampler, 1670, private collection.

28 Square – Sampler, seventeenth century, NOM, Arnhem.

29 Square – Sampler, 1670, private collection.

30 Star with fleurs-de-lys and eight birds – Sampler, 1670, private collection.

31-43 Various small motifs – Sampler, 1802, private collection.

44 Circle – Sampler, seventeenth century, NOM, Arnhem.

45 Heart – Sampler, 1802, private collection.

46 Square with rounded corners – Sampler, c. 1800, private collection.

47 Rose – Sampler, c. 1800, private collection.

48 Circle containing a cross – Sampler, 1802, private collection.

49 Square containing a cross – Sampler, 1802, private collection.

50 Square containing an eight-pointed star – Sampler, seventeenth century, private collection.

51 Square containing a cross – Sampler, seventeenth century, private collection.

2b

3

2a

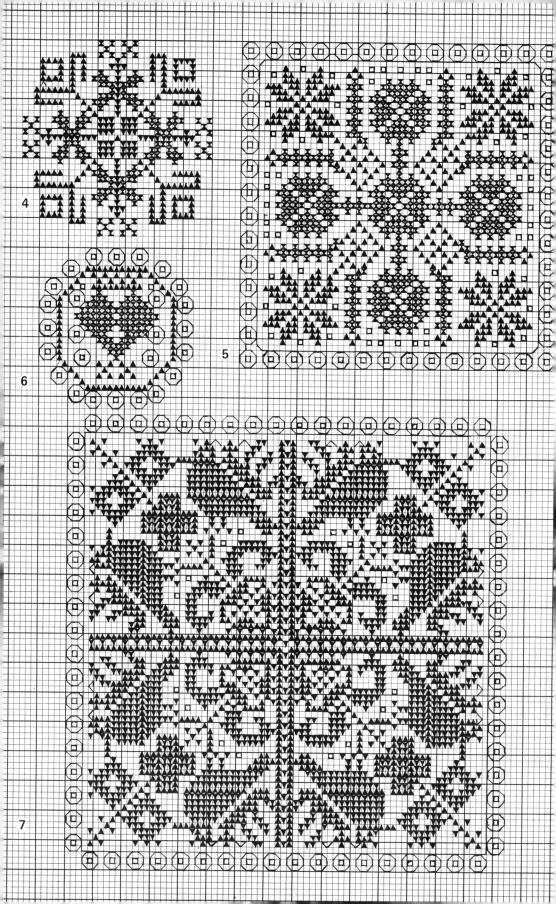

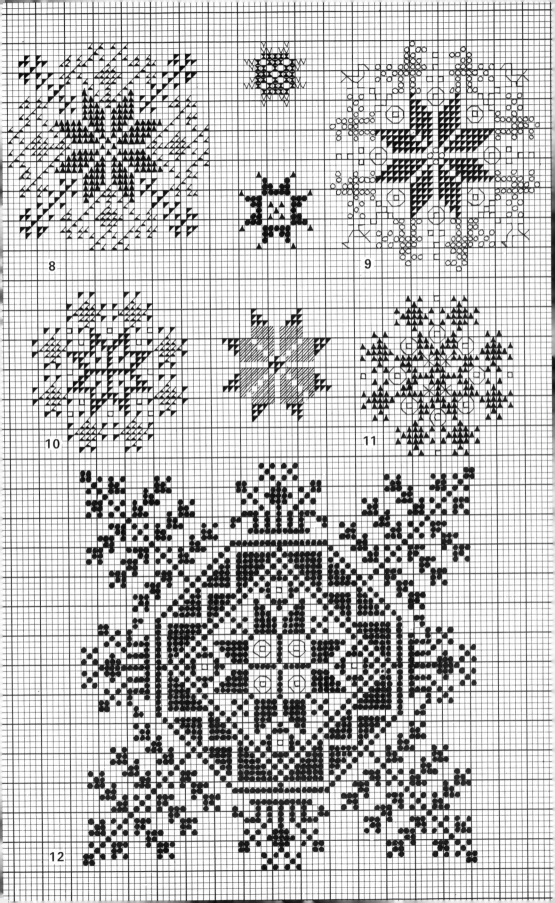

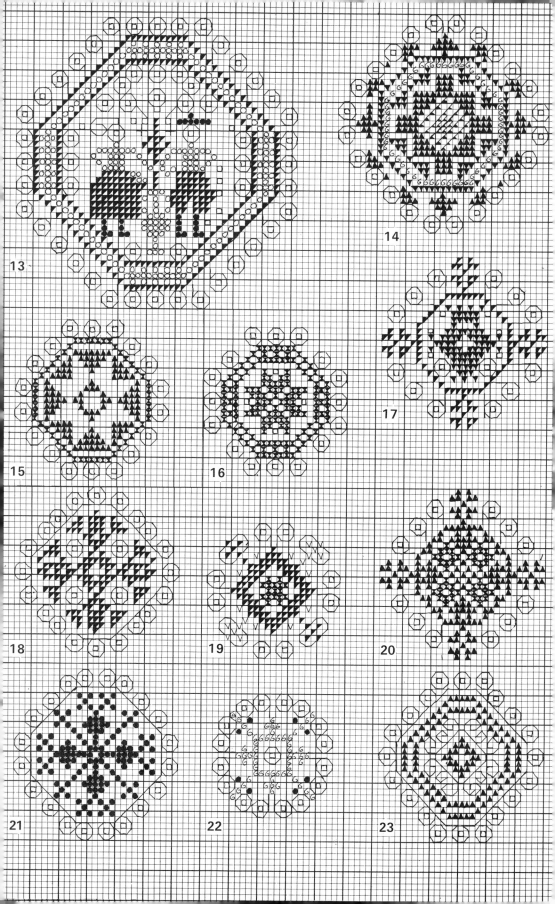

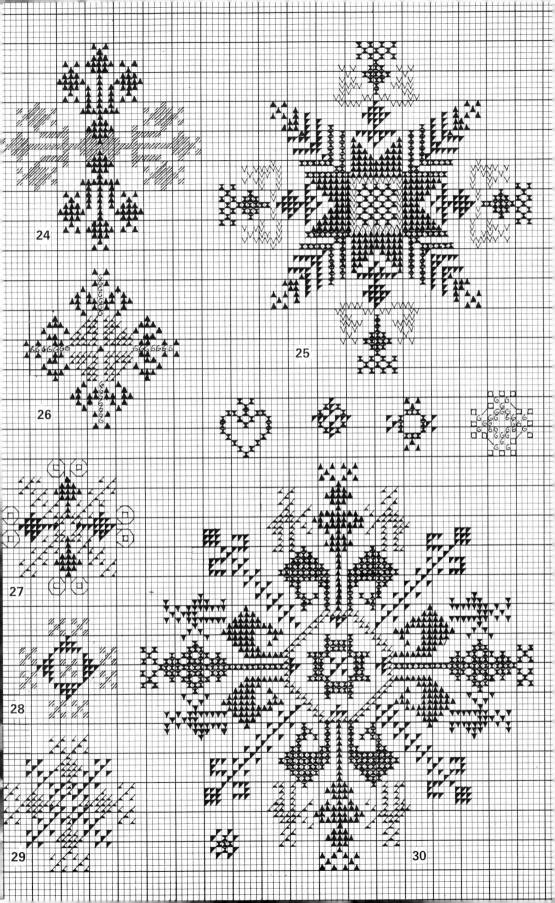

24

25

26

27

28

29

30

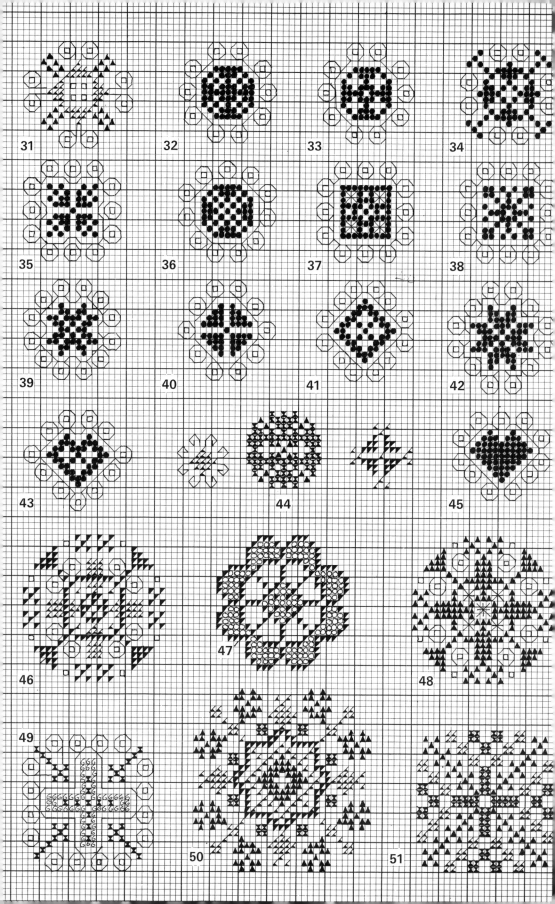

XVIII *Fruit and fruit trees*

In antiquity the *apple*, because of its sweetness and beauty, was the symbol of love and fertility. The offer or gift of an apple served as a declaration of love (*cf.*, for example, the Judgement of Paris). In Christian art, however, it represents temptation and evil, both because of its role in the story of the Fall and because the Latin word for apple, *malum*, also means evil. The serpent representing Satan carries an apple in its mouth. The apple sometimes held by the Virgin or by the Christ-child in her arms should perhaps be regarded as a symbol of triumph over evil.

LIST OF MOTIFS ILLUSTRATED

1 Lemon tree – Sampler, 1674, NOM, Arnhem.
2 Pear tree – Sampler, 1674, NOM, Arnhem.
3 Apple tree – Sampler, 1674, NOM, Arnhem.
4 Dish of fruit – Sampler, 1810, NOM, Arnhem.
5 Apple tree – Sampler, 1715, NOM, Arnhem.

6 *Basket of fruit* – Sampler, 1827, M.v.H.B., Arnhem.

7 *Fruit on a stand* – Sampler, 1748, private collection.

8 *Apples and pears on a fruit stand* – Sampler, 1841, NOM, Arnhem.

9 *Spray of red currants* – Sampler, 1772, NOM, Arnhem.

10 *Basket of fruit* – Sampler, 1817, NOM, Arnhem.

11 *Lemon tree in a tub* – Sampler, 1813, NOM, Arnhem.

12 *Tree with acorns* – Sheet, 1778, NOM, Arnhem.

13 *Basket of fruit* – Sampler, 1831, NOM, Arnhem.

14 *Basket of fruit* – Sampler, 1737, NOM, Arnhem.

15 *Tree with acorns and flowers in a tub* – Sampler, 1852, NOM, Arnhem.

16 *Sprig with red berries* – Sampler, 1851, NOM, Arnhem.

17 *Pear on a stalk* – Sampler, 1772, NOM, Arnhem.

18 *Basket of fruit* – Undated sampler, NOM, Arnhem.

19 *Bunch of grapes* – Sampler, 1778, NOM, Arnhem.

20 *Bunch of grapes* – Sampler, 1816, NOM, Arnhem.

21 *Horseshoe-shaped spray with two bellflowers, a carnation, two birds and a bunch of grapes* – Sampler, 1750, NOM, Arnhem.

22 *Orange tree* – Sampler, 1770, private collection.

23 *Tree with acorns and a bird* – Undated sampler, private collection.

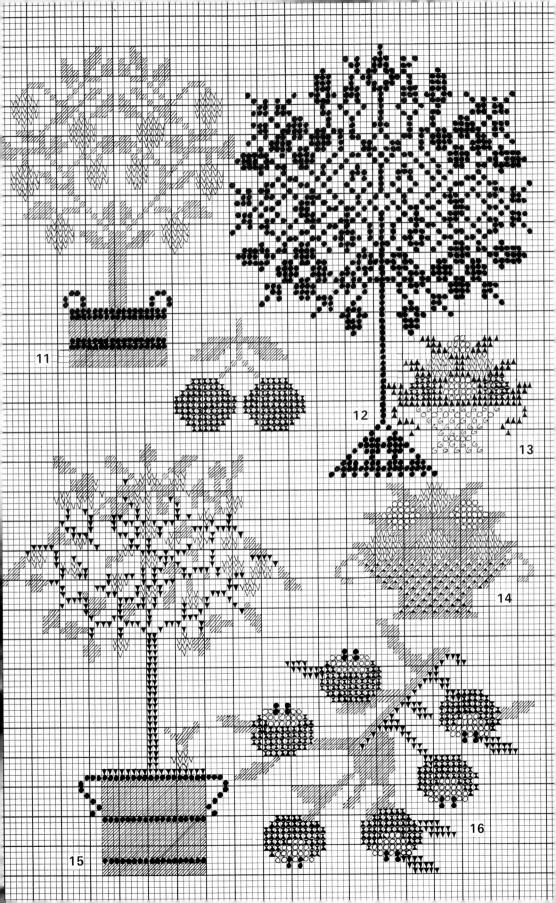

11

12

13

14

15

16

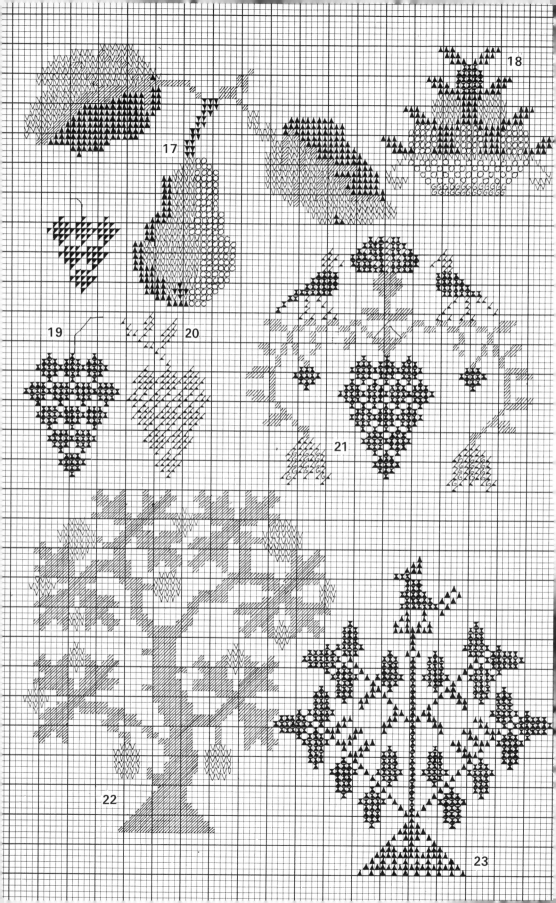

XIX Miscellaneous

In this chapter will be found various motifs that could not be fitted in elsewhere.

The *seven-branched candlestick* (No. 1; see Exodus 25:31-40) is the symbol of the seven gifts of the Holy Spirit: wisdom, understanding, counsel, strength, knowledge, devotion, the fear of God.

The *harp* or *lyre* (No. 6) stands for purity, sublimity and music. The mellow sound of these instruments is conducive to tranquility of mind.

Tombs with urns and weeping willows or other trees (Nos. 7 and 9) are particularly common on nineteenth-century samplers. The weeping willow is the tree of the kingdom of the dead and of unhappiness, the willow being already regarded as the tree of sorrow in the Old Testament (Psalm 137:2). But the willow also gives comfort and, in spite of its trunk being hollow, gnarled and crooked, it manages to grow in the most unfavourable circumstances.

Epiphany or the Star of the Kings. The version of this motif shown at No. 15, which comes from a sampler of 1792, features three men, two of whom are holding a star on a pole, but generally on samplers we see only two men with the star (see Pl. 1, facing p. 16). In Brabant and Limburg it is the custom on January 6 (Epiphany or Twelfth Night; elsewhere it is done around Christmas Day) to go round with a star singing carols to commemorate the coming of the wise men from the East to Bethlehem, led by a star, to worship the King of the Jews and to offer him their gifts of gold, frankincense and myrrh (Matthew 2:1-12). From the number of gifts it was later concluded that there were three of them, while from references in Psalm 72:10 and Isaiah 49:7 they came to be seen as kings. They were given the names Melchior, Balthazar and Caspar and in art they appear countless times clad in kingly raiment. There is a characteristic Medieval rendering at Notre-Dame in Paris. There *Melchior* appears as an old man with long grey hair and beard. He has taken off his crown in order to kneel and offer the Christ-

child gold, symbol of Divine Kingship. *Balthazar* is in the prime of life with brown hair and a full beard. His offering is myrrh, symbol of death, signifying that the Son of God must die. He stands behind Melchior pointing to the star. *Caspar* is young and beardless with a dark complexion (he is a Moor). He offers the Redeemer frankincense, symbol of prayer, as a tribute to His Divinity.

One of the carols children sing on January 6 as they go round from house to house dressed up and carrying a star is:

There came three Kings with a single star.
They came from near and they came from far.
They came to the top of a high hill
And there they found the star stood still.
Now star thou must not stand still so,
Thou must with us to Bethlehem go,
To Bethlehem, into that town so fair
Where Mary and her little baby are.
They gave that little child gifts manifold
Of frankincense and myrrh and fine red gold.

The *Sun* and the *Moon* (Nos. 12 and 14) were already personified in the Old Testament. They were said to retreat into their tents before the flash of the arrows of God or the lightning sheen of His Spear. The personifications of the sun and moon used in Early Christian art were taken over directly from Antiquity: Sol, the sun, is a male figure with a Phrygian cap or an aureole; Luna, the moon, is a woman and is characterized by a crescent. From the thirteenth century onwards a new type of representation appears: the human forms disappear and the sun and moon are shown as a disk and a crescent with male and female faces respectively.

The *flower border* at No. 16 is taken from an embroidered ribbon for a headdress (see Fig. 10c facing p. 160) which dates from the first half of the present century and is still in the possession of a Marken family (see Chapter XIII). Remarkably enough this same border is already to be found in Schönsperger's pattern-book of 1523 (see Fig. 10a facing p. 160). The motifs and borders in the latter were used again by Peter Quentel in his 'new pattern-book' of 1529, which was reprinted in 1882 (see Fig. 10b, facing p. 160). The motif with two *parrots* bowing to each other (No. 17), which comes from a sampler of 1795, also appears as a border pattern in an old pattern-book, this time Sibmacher's *Schön neues Modelbuch*, which was first published in 1601 and was reprinted in 1877.

The cross that appears in the circular motif at No. 18 is probably a development of a very similar cross on a sampler of 1670 (see Pl. II, facing p. 25). It may be compared with the Burgundian cross or the *cross fourchée* of heraldry. Another

form of it can be seen on the breast of the reading child in Fig. 1, p. 4).

LIST OF MOTIFS ILLUSTRATED

1 Seven-branched candlestick – Sampler, 1836, private collection.

2 Flowerpot with lilies – Sampler, 1841, NOM, Arnhem.

3 Angels with a palmbranch – Sampler, 1707, private collection.

4 Chicken-run – Sampler, 1845, NOM, Arnhem.

5 A tulip flanked by two swans on a base from which grow flowering branches – Sampler, 1827, NOM, Arnhem.

6 Lyre with crossed palmbranches – Sampler, 1894, private collection.

7 Tomb with urn and weeping willow – Sampler, 1841, NOM, Arnhem.

8 Plant with a carnation, flanked by two lions – Sampler, 1708, NOM, Arnhem.

9 Tomb with cedar – Sampler, 1841, NOM, Arnhem.

10 Cornucopia – Sampler, 1827, NOM, Arnhem.

11 Ship with text: I built this ship when I was ten years old – Sampler, 1793, private collection.

12 Moon – Darning sampler, 1828, private collection.

13 Carriage with horse, driver and passenger – Sampler, 1797, T.M.H.H., Harlingen.

14 Sun – Darning sampler, 1828, private collection.

15 The Star of the Kings – Sampler, 1792, private collection.

16 Flower border – Embroidered ribbon for a headdress, first half of the twentieth century, private collection.

17 Flower with two parrots – Sampler, 1795, private collection.

18 Circular motif with a cross and a border of birds – Sampler, 1763, private collection.

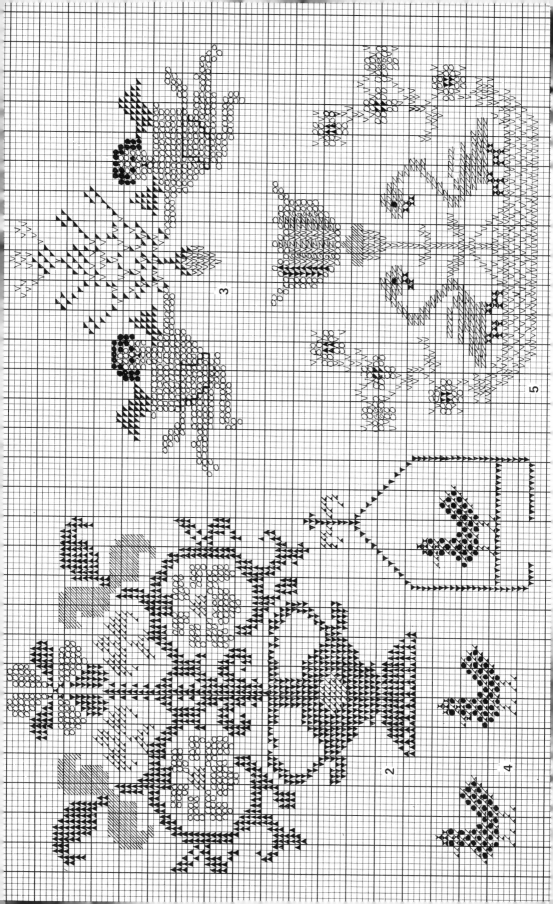

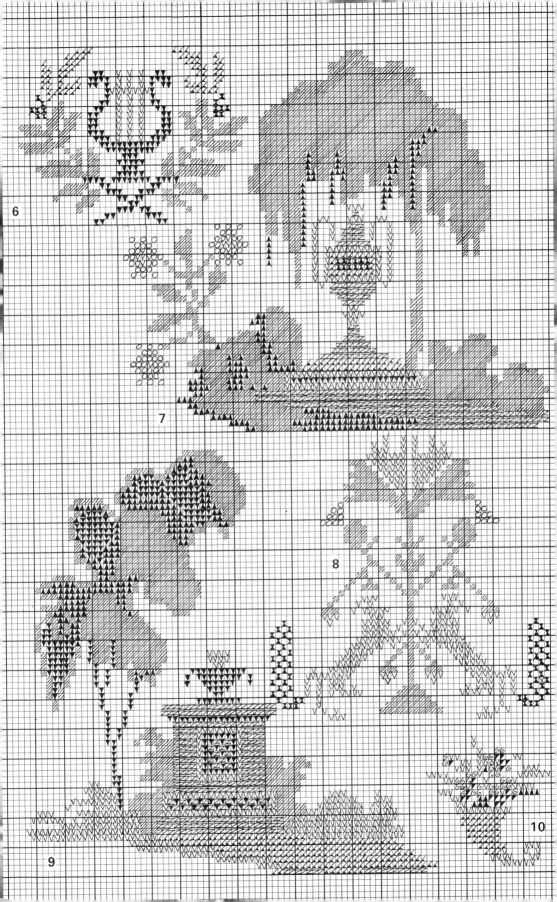

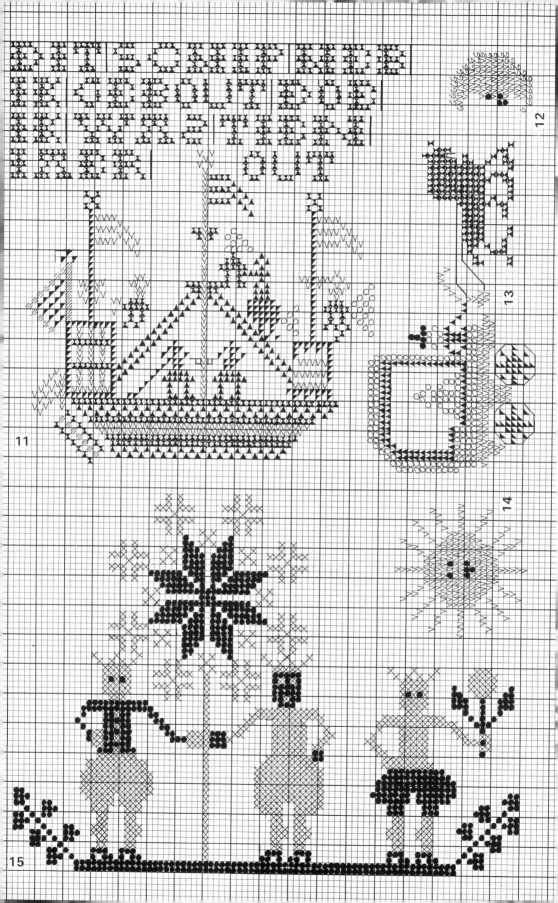

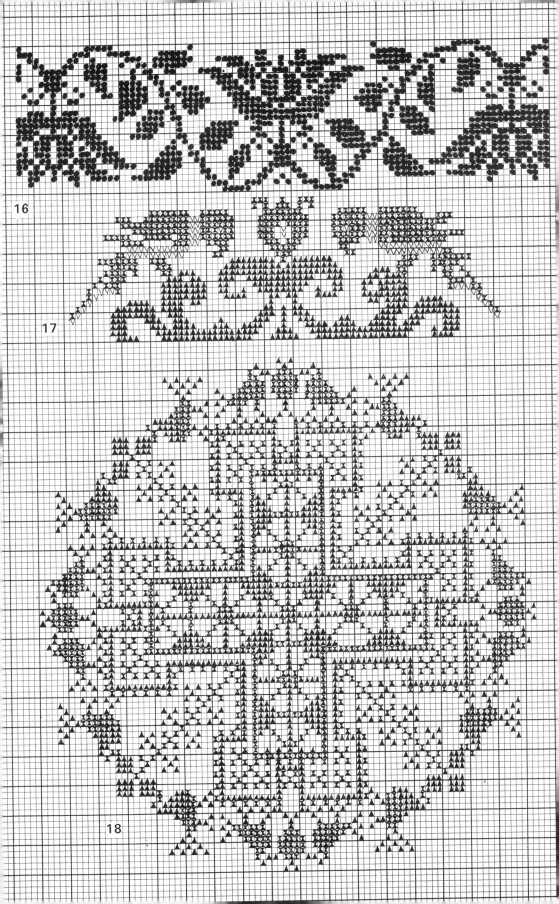

XX Directions for making a sampler

I have often been asked, 'How does one make a sampler?', or people have said, 'I wanted to make a sampler for the wedding of my son (or daughter), but...'. So I propose to give here a few guidelines and suggestions that may stimulate or assist readers to make a sampler. It must, however, be stressed that a great deal will depend on your own imagination and skill with the needle.

First of all you must decide why and for whom you want to make the sampler, whether for the birth of a baby, the wedding of a son or daughter, a silver or golden wedding anniversary, as a memento for a relation or friend or a hanging for a child's room, or simply for yourself because you find certain motifs attractive. The motifs given here can also be used on numerous other objects such as book-covers, tablecloths or mats, sheets and pillowcases, greetings cards, bell-pulls and clock-covers. (When making a clock-cover, it is important to find out the exact length and breadth of the clock-case, since they can vary considerably in size and thus no precise measurements can be laid down. You should, however, always remember to add 40 cm to the length of the case in order to achieve the correct length for the cover.)

Before you buy your materials, sit down with pencil and paper and make a list of:

a. the motifs to be used on the sampler (noting page and number);
b. the names or initials of the parents, child or couple in question;
c. the date and place of the birth, wedding, etc.;
d. your own name, age and place of birth;
e. when and where you began (or intend to begin) the sampler.

N.B. You should always embroider on a sampler exactly when you finished it.

Having made these notes, the next thing to decide is precisely how you are going to make the sampler, whether square, oblong or long and narrow, with or without a border. The size of the sampler will depend on the number of motifs, the text and, in particular, the closeness of the weave of the material, for the finer the weave, the smaller will be the sampler. What sort of weave you choose will depend on how good your eyesight is.

To get an idea of what your sampler will be like, it is advisable first to make

a sketch. For this you will need a sheet of tracing-paper roughly 59 × 84 cm (obtainable at any stationer's). On this draw the outline of your sampler, say a square 55 × 55 cm, or a rectangle 55 × 65 cm or with the long side longer or shorter, as you like. Cut out the paper to this size. Then fold it in half first vertically and then horizontally. Draw a line 5 cm inside the edge all round the paper to indicate the margin. If you want to put your text actually in the margin at the bottom, then make the bottom line 6 cm from the edge. Otherwise all your motifs and borders will go inside this line.

Measure the width of the border or borders you have chosen (for methods of making a border see below under *Embroidering the sampler*), and once more draw lines, inside those you have already drawn, to mark where it will come. Then arrange motifs, such as a tree of life, a pot of flowers, a ship or a garland with angels, down the vertical line in the centre, tracing them in outline in pencil from the illustrations given here. If necessary remember to allow for any text that may come underneath a motif or elsewhere. Then put a motif in each of the four corners and motifs or texts along the central horizontal line. The space left over can be filled in any way you like. Texts, *i.e.* inscriptions, dates, place names, etc., should be worked out on squared paper. Obviously there are numerous ways of arranging the motifs and texts: one way of dividing up a sampler for a couple, for example, would be to put the things the man had been concerned with before or during marriage on the left side and those relating to the woman on the right.

The choice of materials, their fineness and colour, will depend on your own judgement, but care should be taken to see that the colours of the fabric and the threads form a harmonious whole. There are various possibilities: a sampler may be worked in monochrome black or dark brown, or in a few shades of the same colour, or in several different colours (see the colour-chart on the back flap).

Some suitable fabrics are:

a. embroidery linen or scrim;

b. woollen or wool mixture embroidery material;

c. canvas or hardanger linen.

Suitable threads are:

a. stranded cotton,

b. linen,

c. thin woollen yarn.

When you go to buy your materials, take your sketch and the pattern-book with you so that the assistant in the shop can advise you on the choice of materials (unless you prefer to make your own choice) and on the amounts you will need. It is recommended that you should buy a little more than you actually think you will need.

Four-sided stitch *Cross stitch*

Back stitch *Long-armed cross stitch*

Embroidering the sampler

The sampler will be worked mainly in cross stitch, but you will no doubt have noticed that in some of the motifs back stitch or four-sided stitch are also used (see Chapter VIII, for example). Back stitch can also be used for the texts. Seventeenth-century samplers are often worked in a combination of cross and long-armed cross stitches and this is also something you might like to try.

Before you start on the sampler itself, it may be advisable to work a small trial piece first in order:

a. to decide what thickness of thread to use (*e.g.* two strands of cotton for the motifs, one for the text);

b. to try out the stitches and decide which to use;

c. to decide which way to work the cross-stitch: from right to left or left to right working each cross complete, or working the two halves of the crosses separately proceeding upwards and then downwards or *vice versa*;

d. to work out the corner for your border if this should be necessary (see below);

e. to try out the text in back stitch.

The first thing to do when you come to the sampler itself is to mark the central vertical and horizontal lines of the material by lines of tacking stitches in red thread (this will, of course, be removed when the sampler is finished). If you are going to work a text in the bottom margin and have chosen a border with a corner motif, begin working from the corner, starting 5-6 cm from the side and 6-7 cm from the bottom. Work the border towards the central vertical and horizontal lines and check if it is going to fit in properly. If not, you may have to alter the central lines (it depends on the type of border).

186

If you have chosen a border without a corner motif, then begin at the central line 5-6 cm from the top or bottom of the sampler. Proceed to left or right until you have almost reached the corner, sticking a pin 5-6 cm from the edge of the sampler as a guide. You can see how to turn the corner by placing a little mirror on the pattern at an angle of 45°. To mark the place on the pattern, take a piece of tracing-paper 10 cm square and fold it across diagonally, making a sharp crease. Place the triangle of paper thus formed on the pattern with one of the short sides along the edge of the border and the creased side passing through the point on the pattern where you wish to make the corner. Place the mirror against the crease in the paper so that you can see the uncovered part of the border. You can then mark the exact place in the border by drawing a line along the creased edge of the tracing-paper.

Other ways of making borders are:

a. to use two different border patterns, one for the side borders, one for those at top and bottom;

b. to use four different borders of equal width, in which case you can place a corner motif in each corner;

c. to arrange a number of border patterns in short lengths (10-12 cm) underneath one another on the right or left side of the sampler (see Pl. II, facing p. 25).

Once the borders have been completed, the motifs may be worked in the same order as you drew them on your sketch.

Bibliography

Aken, A. R. A. van, *Elseviers mythologische encyclopedie*. Amsterdam, etc. 1961.

Bergema, H., *De boom des levens in schrift en historie*. Hilversum 1938.

Bernet Kempers, A. J., *Om een struik die palm werd*. Arnhem 1966.

Bernet Kempers, A. J., Randversieringen van de meester van Katherina van Kleef. In: *Bijdr. & Meded. Openluchtmus.* 30 [1967] 25-47. With illus.

Bicker Caarten, A., *De molen in ons volksleven*. Leiden 1958.

Boo, J. A. de, *Heraldiek*. Bussum 1967.

Cirlot, J. E., *A Dictionary of Symbols*. London 1962.

Colby, A., *Samplers*, London [1964].

Constantinus, Pater, *Liturgie en kerkelijke kunst*. [2nd enlarged ed.] Antwerp, etc. 1950.

Doering, O. von, *Christliche Symbole*. Freiburg 1933.

Eliade, M., *Images et symboles*. Paris 1952.

Eliade, M., *Die Religionen und das Heilige*. Salzburg 1954.

Engelmeier, P. *Westfälische Hungertücher vom 14. bis 19. Jahrhundert*. Munster [1961].

Goblet d'Aviella, [E.], *De wereldreis der symbolen*. The Hague 1912.

Hemert, M. van, *De handwerken op het eiland Marken*. Arnhem 1960.

Holm, P. J., Navne-óg andre laereklude i 'Den Gamle By'. In: *Arbog [af] Købstadtmuseet 'Den Gamle By'* 1957/58; 36-112. With illus.

Jong, J. de, *Weef- en borduurkunst*. Rotterdam 1933.

King, D., *Samplers*. Victoria & Albert Museum, London 1960.

Kits Nieuwenkamp, N. W. M. J., *Encyclopedie van de heraldiek*. Amsterdam, etc. 1961.

Knappert, L., *Verloving en huwelijk in vroeger dagen*. Amsterdam 1914.

Kraemer, H., De Boom als object van godsdienstige verering. In: Boerhave Beekman, W., *Hout in alle tijden*. Deventer, etc. 1949, Vol. 2: 53-84.

Kruizinga, J. H., *Levende Folklore in Nederland en Vlaanderen*. Assen 1953.

Laan, K. ter, *Folkloristisch woordenboek van Nederland en Vlaams België*. The Hague, etc. 1949.

Landergren-Blomqvist, K., Märkdukarnas alfabet. In: *Kulturen* 1962; 99-118.

With illus.

Lehner, E. and J., *Folklore and symbolism of flowers, plants and trees*. New York [1960].

Lotz, A., *Bibliographie der Modelbücher*. Stuttgart 1963.

Lurker, M., *Bibliographie zur Symbolkunde*. Baden-Baden 1968.

Mâle, E., *L'art réligieux du XIIIe siècle en France*, Etude sur l'iconographie du moyen-âge et sur les sources d'inspiration. Paris 1910. Published in English as: *Religious Art in France: XIII Century*. London (J. M. Dent & Sons) 1913.

Molen, S. J. van der, *Levend volksleven*. Assen 1961.

Quentel, P., *Musterbuch für Ornamente und Stichmuster* 1529. Reprinted Leipzig 1882.

Roes, A., *Symbolen uit het oude oosten*. The Hague [1946].

Schouten J., *De slangestaf van Asklepios als symbool van de geneeskunde*. [Gouda] 1963.

Smits, W. C. M., *Symboliek van de kleur*. Amsterdam 1967.

Thienen, F. W. S. van, *Acht eeuwen Westeuropees costuum*. Zeist 1960.

Timmers, J. J. M., *Symboliek en iconographie der christelijke kunst*. Roermond 1947.

Vlaanderen, A., *Teekens en symbolen*, Amsterdam 1946.

Vriezen, T. C., *Onderzoek naar de paradijsvoorstelling bij de oude semitische volken*. Wageningen 1937.

Wassenbergh, A., Van getijdenboek tot merklap. In: *Antiek* 4 (1970) 353-360. With illus.

List of abbreviations

c. = circa
Gld. = Gelderland
N.H. = North-Holland

Museums and collections
A.H.M. = Admiralty House Museum
F.M.E.K. = Farmhouse Museum 'Erve Kots'
K.M.A. = Kennemer Museum of Antiquities
M.v.H.B. = Maria van Hemert Bequest
NOM = Netherlands Open-Air Museum
L.v.M.M. = Lambert van Meerten Museum
T.M.H.H. = Town Museum Hannema House

Notes on the references to the illustrations
Coloured illustrations are referred to by plate (Pl.) numbers in Roman numerals, black-and-white by figure (Fig.) numbers in Arabic numerals. The motifs are referred to in each chapter by their numbers (No.) in Arabic numerals.

List of photographic illustrations

Sources of photographs

Pls. I-VI and Figs. 3, 4, 6, 6a, 7, 8, 9, 10c: Netherlands Open-Air Museum. The copyright of these illustrations belongs to the Netherlands Open-Air Museum

Figs. 2, 10a: after Arthur Lotz, *Bibliographie der Modelbücher*, Stuttgart 1963

Fig. 5: after Paul Engelmeier, *Westfälische Hungertücher*, Münster 1961

Fig. 10b: after Peter Quentel's pattern-book of 1529, reprinted Leipzig 1882

Fig. 1: after *Van Eyck en zijn tijdgenoten*, Amsterdam 1942

Illustrations on p. 87; after J. A. de Boo, *Heraldiek*, Bussum 1967